and

the weather has been so hot and
humid that it tired me all out
and I could not write to you be-
fore last night when I began this.

It seems rediculous, and quite a
joke on me to think of my com-
ing back to the same building after
hunting everywhere — however it
likes me very well and as I have
worked on it yesterday arranging
this print on the wall or putting
up shelves etc and that it is
beginning to look like a studio,
my dear little girl.

You may come in

More Than Words

PUBLISHED BY

PRINCETON ARCHITECTURAL PRESS

37 EAST SEVENTH STREET

NEW YORK, NEW YORK 10003

FOR A FREE CATALOG OF BOOKS, CALL 1.800.722.6657.

VISIT OUR WEB SITE AT WWW.PAPRESS.COM.

EDITING: NANCY EKLUND LATER

EDITORIAL ASSISTANCE: DOROTHY BALL

DESIGN: DEB WOOD

SPECIAL THANKS TO: NETTIE ALJIAN, NICOLA BEDNAREK, JANET
BEHNING, MEGAN CAREY, PENNY (YUEN PIK) CHU, RUSSELL
FERNANDEZ, JAN HAUX, CLARE JACOBSON, JOHN KING, MARK
LAMSTER, LINDA LEE, KATHARINE MYERS, LAUREN NELSON,
JANE SHEINMAN, SCOTT TENNENT, JENNIFER THOMPSON, PAUL
WAGNER, AND JOSEPH WESTON OF PRINCETON ARCHITECTURAL
PRESS —KEVIN C. LIPPERT, PUBLISHER

LIBRARY OF CONGRESS CATALOGING-IN-PUBLICATION DATA

KIRWIN, LIZA.

 MORE THAN WORDS : ARTISTS' ILLUSTRATED LETTERS FROM
THE SMITHSONIAN'S ARCHIVES OF AMERICAN ART / LIZA KIRWIN ;
WITH A FOREWORD BY RICHARD J. WATTENMAKER.—1ST ED.

 P. CM.

 INCLUDES BIBLIOGRAPHICAL REFERENCES AND INDEX.

 ISBN 1-56898-523-1 (ALK. PAPER)

 1. ARTISTS--UNITED STATES--CORRESPONDENCE. 2. ART,
AMERICAN--19TH CENTURY. 3. ART, AMERICAN--20TH CENTU-
RY. 4. ARCHIVES OF AMERICAN ART. I. ARCHIVES OF AMERICAN
ART. II. TITLE.

 N6536.K56 2005

 741.973--DC22

 2005017176

More Than Words

ILLUSTRATED LETTERS FROM
THE SMITHSONIAN'S ARCHIVES
OF AMERICAN ART

Liza Kirwin

With a foreword by Richard J. Wattenmaker

Smithsonian
Archives of American Art

PRINCETON ARCHITECTURAL PRESS, NEW YORK

"*Letter writing is probably the most beautiful manifestation in human relations, in fact, it is its finest residue.*"

..

John Graham
to his third wife, Elinor
7 July ca. 1958
JOHN GRAHAM PAPERS, 1891—1985

Contents

Foreword

This year marks the fiftieth anniversary of the Smithsonian Institution's Archives of American Art. Founded in 1954 by art historian E. P. Richardson and art collector Lawrence A. Fleischman, the archives is devoted to collecting, preserving, and making available primary source material documenting the history of art in the United States. More than fifteen million items strong, its collections comprise the world's largest single source for letters, diaries, financial records, unpublished writings, sketchbooks, scrapbooks, and photographs created by artists, critics, collectors, art dealers, and art societies—the raw material for scholarship in American art. The archives has served as a catalyst for research that has enlarged the scope of American art history.

The illustrated letters celebrated in this book constitute some of the true gems within the archives' collections. The selection of individual items evolved from a series of exhibitions held at our New York Research Center that explored the art of the illustrated letter. These letters are vital to scholars for the information they communicate about the lives of artists, but the public infrequently has an opportunity to see them.

I wish to thank the many Smithsonian colleagues who have contributed their expertise to producing this volume, particularly Garnett McCoy, curator emeritus at the Archives of American Art, Richard N. Murray, senior art historian at the Smithsonian American Art Museum; Merry A. Foresta, senior curator for photography at the Smithsonian; Wendy W. Reaves, curator of prints and drawings at the National Portrait Gallery; and Smithsonian research fellows Kelly Quinn and David McCarthy. Ms. Quinn was in residence at the archives for the duration of this project. Her clever insights were great contributions. We are thankful for the work of our interns Arlene Fletcher, Laura Orgon, Emily Nemens, and Angela Lowe Margetts, whose research has enlivened many of the book's captions. We appreciate Marv Hoffmeier's technical expertise with digital imaging and Jennifer Dismukes's sound editing advice. I also wish to thank Smithsonian volunteers Mara Egger and Monica Konaklieva, as well as Catherine Brand, chief curator of the libraries of the Institut National d'Histoire de l'Art, for their assistance with translations.

We are grateful to the many individuals who provided information and granted permission to publish letters, including Clayton Bailey; Frances Beatty, for the Ray Johnson estate; Ken Clark, for Dale Chihuly; C. J. Dallett; Dominique Deroche, for the Fondation Pierre Bergé; Yves Saint Laurent; Dohlov Ipcar; Toni Dove; Katherine Degn; Red Grooms; Mimi Gross; Dodie Kazanjian; Lois Kozlow; Michael Lucero; Musa Mayer;

Gladys Nilsson; Jim Nutt; Elisse Pogofsky-Harris; Lisa Ponti; William P. Rayner and Christopher Schwabacher, for the Betty Parsons estate and foundation; Edith Schloss; Bernarda Bryson Shahn; Société pour l'Œuvre et la Mémoire d'Antoine de Saint-Exupéry; David Soyer; Virginia Bush Suttman; Dorothea Tanning; Calvin Tomkins; William Wegman; J. Kathleen White; and Andrew Wyeth.

The archives is indebted to its singular curator of manuscripts, Liza Kirwin, whose imaginative conception, comprehensive knowledge of our collections, and initiative have brought this publication to fruition. Her task was shared with Joan Lord, whose research and dedication made its realization a happy experience. We also thank Nancy Eklund Later, our editor at Princeton Architectural Press, for her guidance and enthusiasm.

As we mark the fiftieth anniversary of the archives, my hope is that its collections will continue to surprise, delight, and inform researchers. This book not only provides a sample of the types of materials the archives holds but also an introduction to the world of American art. Let it serve as an invitation to interested readers to become better acquainted with the archives, whose mission has always been and remains to foster interest and investigation into the great legacy of American art.

Richard J. Wattenmaker, Director
Archives of American Art, Smithsonian Institution
April 2005

ton to paint the President. The portrait i
the Union League, ~~It and~~ and I am to
it according to my own notions. as to
position. It pleases me very mu
nothing of their intentions til
me the order while other
~~through~~ to do.

I make
brick shaped
case yo

which mo
the end elevat
you first draw it,
draw its side elevation
with the change introduc

Then you can tilt it up on
g. This motion takes place in
the elevation. Therefore you make the
in that plane & then deduce its ground pla

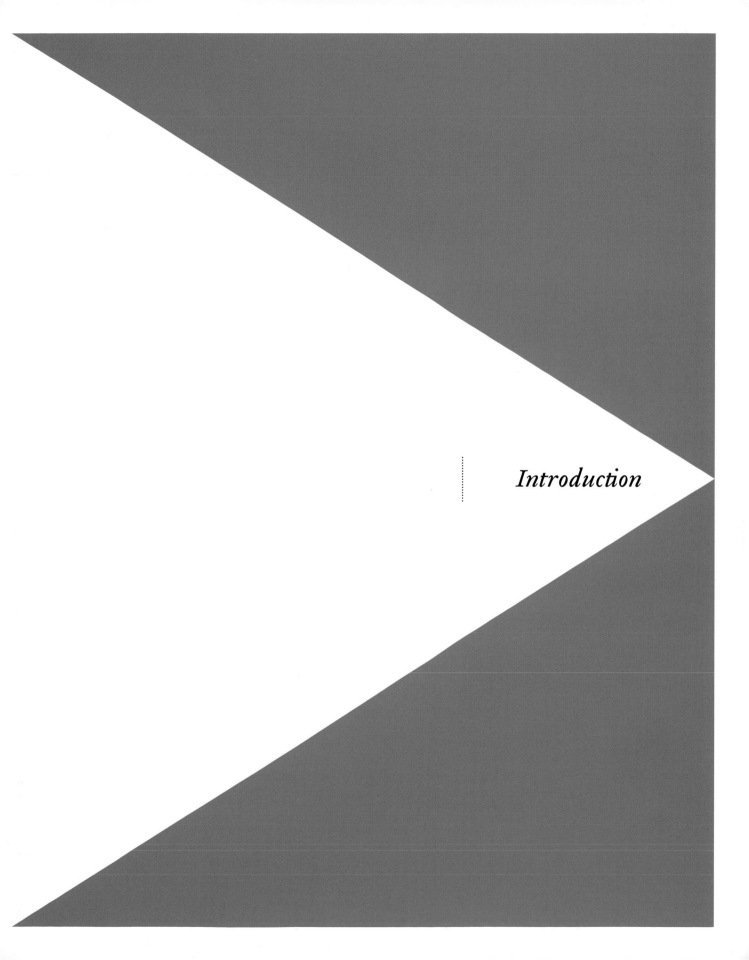

Introduction

much but its to the point.
I've gotten so used to this
performance that I've lost
the relish and the novelty
all worn off. I do it now
to fill in time. I'm not
doing a thing. Oh if you
could just see such weather
I'm writing now at half
past two oclock near the
window and I can hardly
see it is so gloomy. I feel
like an outcast. Let the
natives dont seem to mind
it. The hand organ with
its cheerful walzes toots and
groans its hacking
and rheumatic
notes through
it all. I hear
it now.
 Yesterday
was St. Nicholas
(they can't wait till
the 24th like we do)
I got this!
 Good bye
 Yrs as ever

"ITS FATAL TO BE AFFLICTED WITH INSPIRATION THAT WONT BE CONTROLLED," joked painter Robert Frederick Blum to his friend Minnie Gerson in a letter dated 1884. On the top of the page, Blum sketched his idea for the Gerson family Christmas card—Julius Gerson, Minnie's father, and the manager of the art department at Louis Prang and Company, a successful Boston chromolithographer that had popularized the American Christmas card, posing with his son and three daughters, all outfitted in Dutch costume. Blum was writing from Haarlem, in the Netherlands, at half-past two on a gloomy afternoon. Through his open window, he noted a "HAND ORGAN WITH ITS CHEERFUL WALZES TOOTS AND GROANS ITS HACKING AND RHEUMATIC NOTES THROUGH IT ALL." He signed off with a sketch of the organ grinder's monkey popping out of a box—his Christmas gift to Minnie [CAT. NO. 1].

Illustrated letters are inspired communications. They have the power to transport the reader to another place and time—to recreate the sights, sounds, attitudes, and imagination of their author. The more than ninety illustrated letters from artists presented in this volume include exuberant thank-you notes, winsome love letters, graphic instructions, reports of remarkable events, and other personalized communiqués from Winslow Homer, Thomas Eakins, Andrew Wyeth, Alexander Calder, Dorothea Tanning, Andy Warhol, and many more, some equally well known and others less remembered today. The letters, culled from the collections of the Smithsonian's Archives of American Art, provide an intimate view of the artists' world—their family lives and friendships, passions and heartbreaks, business relations, travels, and artistic training. For these artists, words were not enough: they added drawings, caricatures, watercolors, and collages to create personal missives that are as visually engaging as they are verbally.

1. (left and right)
Robert Frederick Blum
to Minnie Gerson
6 Dec. [1884]

for transcription, turn to p. 193

Illustrated letters offer immediacy. When Frederic Edwin Church pauses to sneeze, we pause with the break in his prose; when Samuel F. B. Morse falls asleep while writing to his young cousin, we slow with the heaviness of his attenuated script; and when Walt Kuhn in mid-ocean aboard the S.S. *Amerika* pitches and rolls, we sense his queasiness in his tortured penmanship.

In most cases, these individual items are part of a long series of correspondence that provide bundles of biographical details about the author's life unmatched by other sources. Painter William Cushing Loring was studying in London and Paris from 1900 to 1904, and he wrote home to his parents once a week. His papers include hundreds of high-spirited reports of his artistic progress. His letters describe visits to the studios of such important figures as Francis Davis Millet and Lawrence Alma-Tadema, trips to museums and galleries, copying excursions in the Louvre and the London National Gallery, art classes, evening entertainments, accounts of daily expenses, and other aspects of student life—everything from attending a production of *Romeo and Juliet* at the Paris Opera to his problems poaching eggs. "I HAVE MET THE MASTER," wrote Loring, referring to John Singer Sargent, then, a forty-five-year-old expatriate living in Fairford, England, "HE IS LARGE AND GROWING FAT. HEAVY MOUSTACHES, BEARD AND HAIR—NOT A STREAK OF GRAY IN SIGHT." In this brief encounter, Loring learned the principles of color and construction. Sargent, a workhorse of a painter, not surprisingly encouraged him to study hard in Paris—"TO BRACE UP AND KEEP CONTINUALLY IN THE HARNESS."

Walt Kuhn's papers include thousands of letters, both personal and professional, that document his role as an organizer of the International Exhibition of Modern Art of 1913, known as the Armory Show, as well as his career as a painter, etcher, lithographer, and artistic consultant to the Union Pacific Railroad. Kuhn also worked as a cartoonist for popular magazines, and the letters to his wife Vera display his characteristic flair for caricature.

The epistolary styles of the various artist/writers provide clues to their creative personalities. In life as in art, Thomas Eakins was formal and exacting, quick to give instruction; modernist Arthur Dove was friendly but cryptic; the highly emotive Frida Kahlo was passionate in her prose, sealing one letter with red lipstick kisses. The letters also confirm aesthetic sensibilities. Sculptor Alexander Calder made a map to his home that looks every bit like one of his mobiles—the connecting roads, in bold strokes of color, could spin in the wind if lifted from the page. Howard Finster, known for his *horror vacui* approach to the painted surface, covered his letter with an organic flow of words and images. And Rockwell Kent's precise pen and ink sketches mimic the crisp lines of the wood engravings that brought him fame.

Like Kent, many artists made a steady income from their illustrations. George Luks, Everett Shinn, John Sloan, Walt Kuhn, Alfred Frueh, Robert Blum, Otto Bacher, Lyonel Feininger, and Andy Warhol all worked as illustrators at one time or another, so it comes as no surprise that they would add a sketch or two to their letters. What is remarkable is the frequency, variety, and ingenuity of their illustrated words. The intimate form of a letter seems to have offered them greater freedom to express themselves.

Feininger tried to convince his pen pal Alfred Churchill to illustrate his letters:

I WILL...MAKE ONE MORE DEMAND UPON YOUR FRIENDSHIP, ALSO IT IS YOU[R] PROMISE TO ME BEFORE WE PARTED. VIZ: TO ILLUSTRATE YOUR LETTERS! IF IT IS ONLY A LITTLE LANDSCAPE OR A SIMPLE FIGURE, OR ANY LITTLE SKETCH OR SKETCHES ILLUSTRATING THE TEXT OF YOUR LETTERS, IT WILL BE JUST AS WELCOME AND WILL DO YOU VERY CONSIDERABLY GOOD IN HELPING YOU ON IN PENWORK OR READY INTERPRETATION OF ANY LITTLE CONCEPTION YOU MAY WISH TO PUT ON PAPER [CAT. NO. 2].

While we do not know if Churchill reciprocated, Feininger's sentiments hold true: illustrating letters appears to have sharpened the artists' drafting skills and stretched their powers of observation.

2. *(right)*

Lyonel Feininger
to Alfred Churchill
20 May 1890

for transcription, turn to p. 193

The letters in this book are arranged around six themes. The first, "bon voyage," includes letters written to and from travelers. Travel tends to heighten our awareness of the extraordinary qualities of ordinary life. Many of these letters offer deep reflections on sensory experience, from the novelty of new modes of transportation, to the thrill of foreign surroundings, to the psychological unease of finding yourself captive aboard a ship with a peculiar slice of humanity. John Frazee's first trip on a railroad train of 1834; John Sloan's precarious climb in an early model Ford up a mountain in New Mexico in 1922; and Allen Tupper True's awe-inspiring view up the side of New York City skyscrapers in 1927: the artists' adventures recounted in these letters give us new appreciation for what have become everyday occurrences today.

Journalist Janet Malcolm wrote, "Letters are the great fixative of experience. Time erodes feeling. Time creates indifference. Letters prove to us that we once cared. They are the fossils of feeling."[1] The second theme of this collection, elucidated throughout but in greatest concentration in the chapter "I do," concerns love letters of all kinds. Sent from man to woman, father to son, friend to friend, and written from the heart, these remnants of affection are made more poignant by the inclusion of pictures.

Reading the passionate exchanges between intimates brings out the voyeur in most of us, but the interplay of word and image in illustrated love letters engages us all the more. On his second trip to Europe in 1912 and 1913, caricaturist Alfred Frueh wrote more than two hundred letters to his fiancée Giuliette Fanciulli in New York, all illustrated and each one a charmer. With cut-outs, pop-ups, and pasted-in photographs, he chronicled his travels through Italy, Switzerland, Belgium, Holland, Scotland, Ireland, and France. In hilarious self-portraits and in carefully composed prose, he mimics the local customs at each stop. "HOOT, BONNY BIRN," he hailed Giuliette from Scotland, picturing himself in a tartan kilt, dancing the Highland Fling over crossed swords. His letter from Besançon, France, shows Frueh striding across the page carrying a bouquet of actual edelweiss, stuck through the paper [CAT. NO. 3]. Frueh used all

3. (right)
Alfred Joseph Frueh
to Giuliette Fanciulli
17 Sept. 1912

for transcription, turn to p. 194

of his powers of whimsy to hold Giuliette's attention throughout their long separation. It worked, as they were married in London in June of 1913.

Waldo Peirce, painter and four-time groom, made no pretense of his divided affections when he wrote to his friend Sally Davis in 1943. Davis was serving in the Women's Army Auxiliary Corps (WAAC) in Louisiana. In an Easter poem, Peirce sends his love to Sally and to two of her fellow WAACs. On the bottom of the page, he pictures the three military women, each happily eating a piece of his heart. His picture and flirty poem work in tandem to make his message plain: Peirce was *not* a one-woman man.

Peirce's imaginative scene leads to the third theme of this book, involving plays on words—the combination of text and illustration to form metaphors, puns, and picture puzzles. Winslow Homer, who felt that his dealer was selling him short, boasted about the value of his paintings, adding a sketch of himself hiding his light under a bushel. For Homer, the inclusion of this Biblical reference is the visual equivalent of an exclamation point at the end of a sentence, suggesting that it would be a sin for his dealer to undervalue his work. In a less literary conceit, Oscar Fabrès uses his sharpened pencil to "fish" for a graphic idea [CAT. NO. 4].

Rebuses, or picture puzzles, are fun to read and often challenging to decipher. Sculptor H. C. Westermann and painter Jim Nutt often sent rebus letters, substituting pictures for words in clever ways that leave room for interpretation. Their letters are games: they would like their readers to play and win but not without some creative effort. Westermann's and Nutt's art operates largely the same way: both artists make complicated works that function on their own terms, and reward viewers who invest the time to engage in their personal logic and embrace their ambiguities.

"A visual event may reproduce itself in the realm of touch (as when the seen face incites an ache of longing in the hand, and the hand then presses pencil to paper), which may in turn then reappear in a second visual event, the finished drawing." So

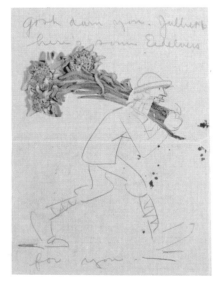

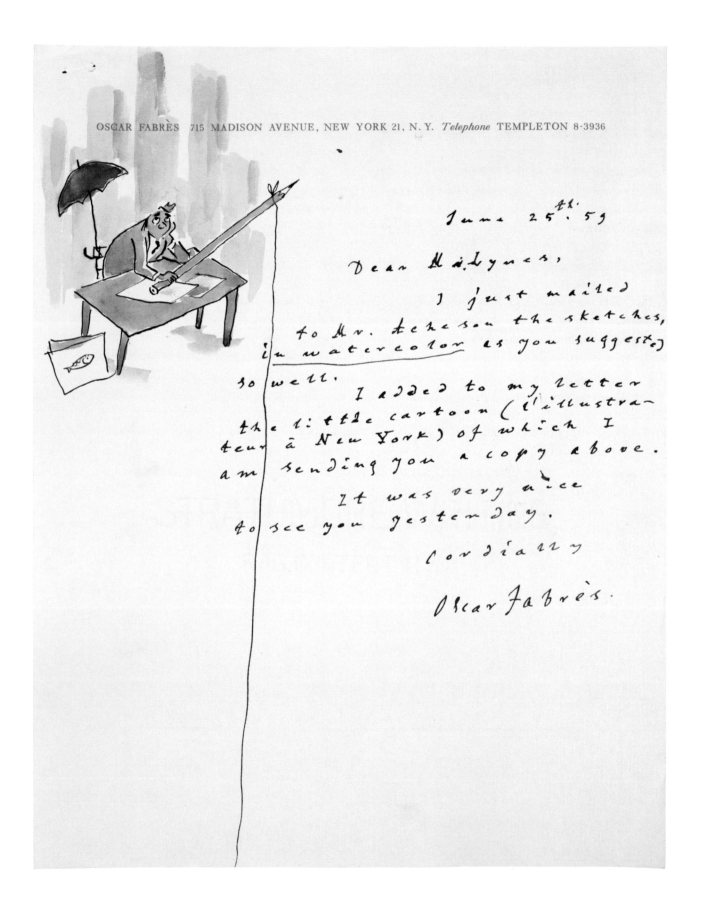

OSCAR FABRÈS 715 MADISON AVENUE, NEW YORK 21, N. Y. *Telephone* TEMPLETON 8-3936

June 25th. 59

Dear Mr. Lynes,

I just mailed to Mr. Acheson the sketches, in watercolor as you suggested so well.

I added to my letter the little cartoon (l'illustrateur à New York) of which I am sending you a copy above.

It was very nice to see you yesterday.

Cordially

Oscar Fabrès.

wrote literary critic Elaine Scarry in *On Beauty and Being Just*.[2] The fourth chapter of this book takes up the theme of visual events and presents letters that capture an artist's vision about personal, professional, and political events. "I WISH YOU COULD COME TO WHAT I HAVE SEEN," writes Max Bohm to his mother, referring to the formal opening of the 1889 Universal Exhibition in Paris. More expressive than a snapshot, Bohm's sketches of gentlemen in white tie and tails and ladies in their finest gowns communicate not only what the artist saw but how it affected him. Be they personal life passages, such as when Rutherford Boyd, in a letter to his fiancée, takes her on a visual tour of his new studio in New York and shows her the sights from his window; or events of broad, national significance, such as when Gio Ponti writes to Esther McCoy about the civil unrest in America following the assassination of Martin Luther King, Jr., the occurrences chronicled here tell us much about the artist's life and times.

When asked how to find a painting in his studio, John Sloan apparently found it easier to draw a picture than to describe the location in words. The graphic instructions contained in the fifth chapter of this book support the assertion that "a picture is worth a thousand words." There are simple directives, driving directions, and complicated instructions, many of which are related to the artist's craft, such as how to build a camera, make a portable easel, or mix a paint medium. In his letter to William Trost Richards, an exacting painter, Thomas Eakins provides a model for drawing a yacht sailing [CAT. NO. 5]. For Eakins, the diagram constituted the most articulate means of communicating his idea. There are also letters about the business of art, for instance, explaining, with graphic clarity, which painting was picked up from the gallery by including a sketch of the composition. Such clues provide art historians with solid evidence of a painting's title, date, and exhibition history, but they also suggest that "visually oriented" artists have a greater comfort level with images over words.

A thank-you note is very likely the first letter that one learns to write. While thank-you letters have a traditional form, in the hands of these artists they take on

4. *(left)*
Oscar Fabrès
to Russell Lynes
25 June 1959
for transcription, turn to p. 195

5. *(right)*
Thomas Eakins
to William Trost Richards
19 June 1877
for transcription, turn to p. 195

whimsical qualities. Architect Gio Ponti presents his thanks in the form of a floral bouquet; painter Edith Schloss wraps her sentiments into a spiral, symbolizing her ever-expanding gratitude to the people she met on her trip to the United States. These expressions of thanks become tangible gifts, exchanged between the artists and their friends and loved ones.

In a letter to his wife, painter Walt Kuhn writes, "ONE SHOULD NEVER FORGET THAT THE POWER OF WORDS IS LIMITED" [CAT. NO. 6]. Indeed, his illustrations—and those of other artists—add a vivid dimension to delight and inform the reader. Whether thank-yous or I dos, instructions or travelogues, these personal missives give insight into the artist's creative process and personal habits, their personalities and perceptions. They enrich our understanding of the artist's biography, providing firm dates, locations, and vivid details of his or her career. They tell us how artists share their ideas and assert their authority. Speaking in their own voice, with their own handwriting, with its unique line weight and rhythm and pressure, they communicate with us directly, just as they did with their original recipients. They allow us present-day readers to connect with artists on new levels, bridging the historical distance between us.

In an era when personal communication more than likely travels through the ether than through the post office, and the postman is relegated to delivering bills, store catalogs, and junk mail, this epistolary art might serve a purpose. Illustrated letters are rare, and handmade communications are liable to become even rarer in the coming era. Let this book celebrating the fine art of the illustrated letter serve as a reminder that a material treasure is all but disappearing from our culture and as a call for more thoughtful and inspired communications in the future.

1. Janet Malcomb, "The Silent Woman," *The New Yorker*, 23 & 30 August 1993, 123.

2. Elaine Scarry, *On Beauty and Being Just* (Princeton, N.J.: Princeton University Press, 1999), 4.

6. (*right*)

Walt Kuhn

to Vera Kuhn

20 July 1913

for transcription, turn to p. 195

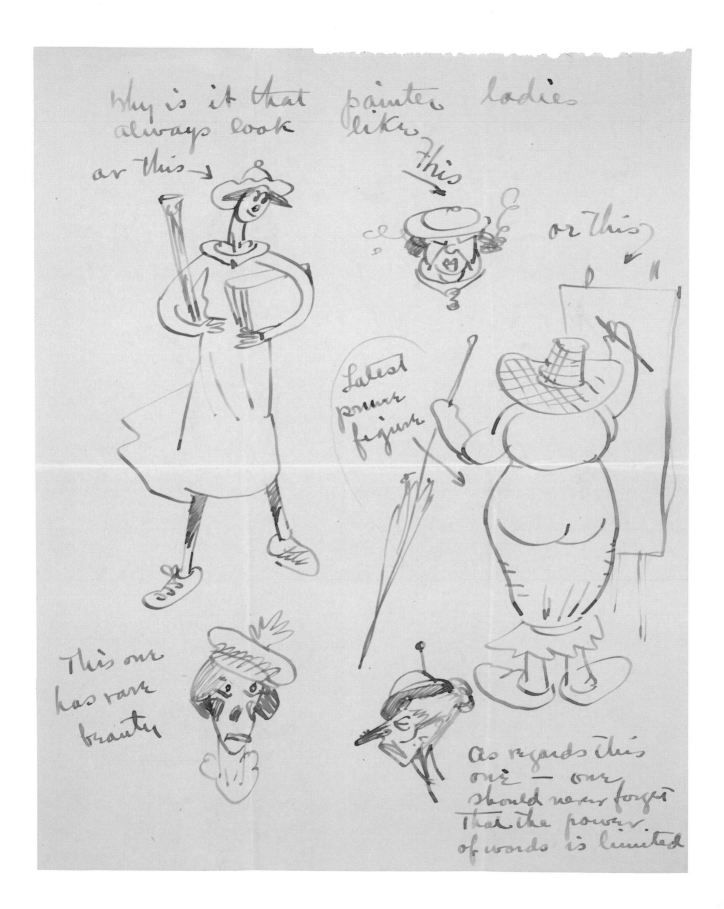

ART WAS BY THE OTHER DAY AND RECORDED
ME SINGING AND PLAYING MY BANJO
GETTAIR. HE IS PLANNING ON TAKING
UP WHEN HE GOES SO IF NOT
HAPPENS WE WILL BE B
YOU PEOPLE IN WASHIN
HAVE A GREAT T
EXCITING BE
N 2 UNIVER
DENVER
IN
LA
AND
IN NORT
THEM WA
REALY HAD
I WILL SOON BE
TENNESEE FOR
A BIG ART SHOW SO
THE SAME THERE WITH
WILL BE GREAT I AM NOW
ON THE GARDEN ON A WALK A
3 HUNDRED FEET LONG FOR A WALK
MY NEW GALLERY 19 81

a laugh remem ber
the know ele
of countries
all ocean is
hunk of
the
the

CHAPTER I *"Bon Voyage"*

7	George Benjamin Luks *to* Everett Shinn 18 May 1900	1 PP., HANDWRITTEN, ILL. *for transcription, turn to p. 196*

Painter George B. Luks (1867–1933), who began his career as a magazine and newspaper illustrator, sent this bon voyage message on the occasion of Everett Shinn's departure for Europe in 1900. Luks and Shinn studied at the Pennsylvania Academy of the Fine Arts and had been colleagues at the *Philadelphia Press* from 1894 to 1895. Luks left the press in 1895, and Shinn in 1897. In 1900, they were both living in New York. They subsequently became part of the Ashcan school, a loosely constituted group of artists who focused on subjects of urban street life.

May 18th 1960

Snow
Scenes

E SHINN
WOODSTOWN
&
NEW YORK

I suppose that
you will have to wade
out in the river to
board the boat

My dear Shinn —
Bon Voyage!
what a pity — you must put up at Hoboken
for the night — by "put up" I don't mean
pawn things — simply try and sleep bug—
less Au revoir success — Geo B Luks

8	Betty Parsons *to* Henry Ernest Schnakenberg ca. 1939	2 PP., HANDWRITTEN, ILL. *for transcription, turn to p. 196*

On her way home to New York from a painting trip in Mexico in the late 1930s, Betty Parsons (1900–1982) made a stop in Colorado. In this letter to her friend Henry Schnakenberg, Parsons's vibrant watercolor depicts the ranch where she stayed. Parsons is the tiny figure in the lower right, holding a bucket. An artist himself, Schnakenberg would influence the course of Parsons's life when he, and several others, loaned Parsons money to open the Betty Parsons Gallery in 1946. Parsons, for her part, would influence the course of American art, when she used the gallery to promote the work of a new generation of painters that included Jackson Pollock, Mark Rothko, Barnett Newman, and Hans Hofmann, today known as the New York School.

Colorado King Et Ranch View from y room

Dear Henry —

Very happy
to hear from you — We certainly
had a fast, and beautiful Mexican
trip — We were given a little
house for two weeks in Texas,

| 9 | John Frazee
to Lydia Frazee
18 May 1834 | 4 PP., HANDWRITTEN, ILL.

for transcription, turn to p. 196 |

In May of 1834, John Frazee (1790–1852), one of
America's first professional sculptors, traveled by train
from his home in New York City to Richmond,
Virginia, to model a sculpture of Supreme Court Justice
John Marshall (1755–1835). On the way, he wrote this
letter to his wife Lydia detailing his first train trip,
taken only a few months after the inaugural run of the
Camden & Amboy Railroad, America's earliest successful
passenger line. Frazee describes this new experience
in vivid detail: "A FEW MINUTES AND WE WERE
OFF LIKE A SHOT, AT THE RATE OF 15 MILES
AN HOUR." The sensation of "high speed train travel"
was "AT FIRST QUITE DISAGREEABLE," and he
reports that "for several miles I WAS CHUCK FULL
OF <u>FEARS</u>, <u>FITS</u>, AND <u>STARTS</u>!" Although Frazee
made it to Richmond in one piece, he never got used
to "THE ETERNAL AND DEAFENING ROAR" of
the train's engine, which rang in his ears like a
"CONTINUAL THUNDER" and gave him a headache.

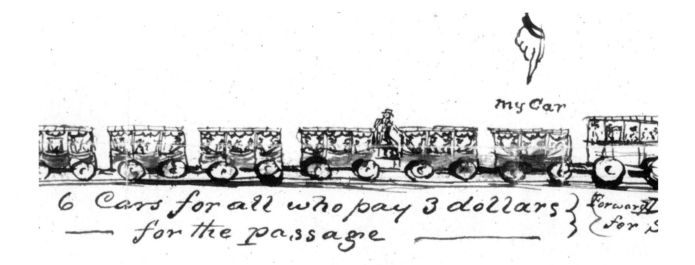

where we were unboated and stowed away in the
Rail Road Cars, — and I, you know, for the first time.

I give you a view of what is called a *Train* of
Cars, all chained together

my Car

Baggage Car. / Rear Deck Car / 6 Cars for all who pay 3 dollars for the passage / Forward Deck Cars (for Straglers) / Engine Car 8 wheels

The Deck Cars carry those who wish to go cheap,
they are more open and more corsely made than those in
the middle; and those forward are subject to more
noise and smoke and to greater danger in case the
Boiler bursts. — The 6 small Cars are very neatly
and comfortably made, and each one carries 24
Passengers without the least crowding! — The other
3 Cars will carry nearly double that number, —
So when this Train is full they will take about
150 persons; — and if there are more they can hitch
on more Cars. — A few minutes and we
were off — like a Shot, at the rate of 15 miles
an hour. — The sensation to me, in this new
Conveyance, was, at first, quite disagreeable
and for several miles I was chuck full of
fears, fits, and Starts! — But a person will get
used to anything; and, as I could not help my-
self, I was compelled to get used to this, and am
now pretty well reconciled to the Rail Car, except
the eternal and deafening roar which the whole Train
makes upon the ear! — this I dont like, it made
my head ache some all the way; — Past 9 Oclk

10 Howard Finster
 to Barbara Shissler
 1981

1 P., HANDWRITTEN, ILL.

for transcription, turn to p. 197

In 1981 visionary artist and Baptist preacher Reverend Howard Finster (1916–2002) wrote to curator Barbara Shissler about his trip to Washington, D.C., for the opening of the exhibition she organized called More Than Land or Sky: Art from Appalachia (held at what is now the Smithsonian American Art Museum). Finster, a self-taught artist who first gained national exposure with guest spots on the Johnny Carson Show and Late Night with David Letterman, illustrates his letter to Shissler with a pantheon of notable figures— Abraham Lincoln, Thomas Jefferson, William Henry Harrison, Andrew Jackson, William Shakespeare—and humbly includes himself within their ranks. He explains, "I FEEL SO UNWORTHY TO LIVE IN A WORLD OF LUXURY AND THESE GREAT MEN PAVED OUR WAY." Though a celebrity himself, Finster never lost touch with the common man.

DEAR BARBARA I AM EXCITED TO BE COMING TO
WASHINGTON WHERE THESE GREAT MEN ONCE HAD

OUR FUTURE RESPONSIBILITY UPON THEM
I FEEL SO UNWORTHY TO LIVE IN A WORLD
OF LUXERY AND THESE GREAT
MEN PAVED OUR WAY I AM
COMING WITH ART ROSENBAUM AND
ANDY NASSIAS OF THE
UNIVERSITY OF GA THEY ARE
GOING TO BRING ME UP TO
BE WITH YOU ALL WILLIAM HENRY HARRISON
THEY SAID THEY MIGHT
HAVE A MOVY FILM OF ME AND PARODISE

ABRAHAM LINCOLN 1868 THOMAS JEFFERSON 1860 SLIDE LECTURE

GARDEN INSTEAD OF A FULL OF SLIDES
I HAVE A ROUND PROJECTOR SLIDE HOLDER I MIGHT
I CAN BRING IT IN CASE PROJECTOR
HAFTO USE YOUR ANDY AND
IF WE USE SLIDES AND SLIDES
ART ROSENBAUM HAVE MOVYS THAT OUT
SO THEY WILL WORK SO BUISY
I AM SORRY I HAVE BEEN YOU SO
I HAVENT WROTE WILLIAM SHAKESPEAR HAVE THE
I AM VERY HONORED TO
CHANCE ANDREW JACKSON 1801 TO BE WITH YOU ALL
IT IS LIKE A DREAM THEY SAID I WOULD BE
STAYING IN THE BOON HOUSE UP THERE
I UNDERSTAND IT WOULD BE OCT. 31 SO
PLEASE CHECK WITH ART ROSENBAUM
AND ANDY NASSIAS THEY NOTIFY ME
WHEN TO COME TO ATLANTA AND
I MEET THEM THERE HOWARD TO BARBARA SHISLER TO FLY UP
 TO WASHINGTON

| 1 1 | Maynard Dixon *to* William Macbeth 26 June 1923 | 2 PP., HANDWRITTEN, ILL. *for transcription, turn to p. 198* |

for transcription, turn to p. 198

California painter and muralist Maynard Dixon (1875–1946) was known for his western subjects—cowboys and Indians—which he painted with depth and dignity. In 1923, he and his wife, photographer Dorothea Lange, traveled to Arizona to study the culture of the Hopi Indians, but before he set out from their home in San Francisco he wrote to his dealer William Macbeth about the business of developing a market for his paintings on the East Coast. At the close of the letter, Dixon urges Macbeth to "COME TO ARIZONA & COOL OFF" and sketches himself as a true cowboy-artist, on horseback, painting the great Western plains.

best think that you have a better chance of success than I. Guard this MS — I have no duplicate.

One of the pictures I am now finishing would make a fine color-page with this, & photos of other works will be forthcoming soon.

Just now I am working on a long decoration for the Water Co's new building. Plenty travelling.

Any developments concerning Vallo?

Yrs
Maynard Dixon

Come to Arizona & cool off

<table>
<tr><td>1 2</td><td>John Sloan
to Walter Pach
[postmarked 4 Aug. 1922]</td><td>2 PP., HANDWRITTEN, ILL.

for transcription, turn to p. 198</td></tr>
</table>

Beginning in 1919, painter John Sloan (1871–1951) spent more than thirty summers in Santa Fe, New Mexico, a popular retreat for artists since the turn of the century. In this 1922 letter to artist and critic Walter Pach (1883–1958), Sloan pens a sketch of his Ford "CLIMBING LA BAHADA," a steep dirt road with twenty-three hairpin curves—a hair-raising adventure for even the most experienced motorist. Sloan had only been driving for one month. He writes, "THE SPICY, SPORTY NEW MEXICO ROADS, TRICKY AND DANGEROUS, ARE INSPIRING TO THE DRIVER." Sloan also found artistic inspiration in the New Mexico terrain, his paintings taking on more saturated colors and a deeper sense of spirituality.

Climbing La Bajada (no exaggeration!)

Dear Pach — This is some of the kind of thing I'm doing this
summer. I have my own tin dished Ford and I can
tell you it opens things up! I've been driving a month
now and its great fun. I do it much better than I
had ever thought I would. We had your postal
with the "Big Model" reclining on her back a la Maya
do you know Chas Rumseys sculpture? It's very like it.

| 1 3 | Alfred Joseph Frueh *to* Giuliette Fanciulli Oct. 1912 | 4 PP., HANDWRITTEN, ILL. *for transcription, turn to p. 199* |

Caricaturist Alfred Frueh (1880–1968) was known for his elegant drawings of theater personalities and for his caricatures, which appeared in the *New Yorker* from its first issue in 1925 until 1962. In a series of illustrated letters to his fiancée, Giuliette Fanciulli, Frueh detailed his travels in Europe from 1912 to 1913. At each stop, the artist honed his powers of perception and his theatrical sense of humor by assuming the local costumes, customs, and idioms of the culture that surrounded him. From Scotland he writes, "AN I HAE IN MIND TO GAY TO DANCIN' SCHOOL AND LEARN HOW TO HIGHLAND FLING BUT I HAE ME DOOTS WHITHER I KIN LARN IT." Frueh performs the sights and sounds of Scotland for his bride-to-be.

Hoot. Bonny Bairn :—

Brrrr.... my knees.
they be noo warrum.

But what be that
when yea hae a
bonny pink envelope full
of trash from a bonny little
lassie from over the sea. Dinna
yea ken, that trash from yea
is noo trash to mae? An'

To.wake up this way.
but I haven't yet

| 1 4 | Joseph Lindon Smith *to* his parents 8 Sept. 1894 | 3 PP., HANDWRITTEN, ILL. *for transcription, turn to p. 199* |

for transcription, turn to p. 199

In this 1894 letter to his parents, painter Joseph Lindon Smith (1863–1950) shows the vast quantities of colorful fruit he is consuming in Venice—"MELONS, PEARS, PEACHES, PLUMS, APPLES, FIGS, GRAPES AND OTHER THINGS UNKNOWN TO MY INTERIOR." One turns the page to find the likely outcome of such a diet.

He also mentions the arrival of the Bostonians, his social events, and the sale of his pictures to Isabella Stewart Gardner, one of America's leading art patrons. Though the sale to such a prominent collector was important for his career, it was a disquieting transaction. In describing it, Smith uses the analogy of a one-armed man who, when asked repeatedly to explain how he lost his arm, would only say, "IT WAS BIT OFF." In word and image, Smith cautions against excess: voracious eaters, and patrons, beware.

Venice. 8th September
1894.

Dear Mother and Father,

Behold Jojo eating fruit!
Delicious fruits are here in Venice now. and I
consume vast quantities of it. Melons pears
peaches plums apples figs. grapes and other things
unknown to my interior.

To-day is a grand "festa" and I am
taking a half holiday. The festa has come to a head
in the church opposite the traghetto. and the smell of
frying things comes across the canal from the
little campo. where the booths are. with the big
shiny brass plates. and the steaming things in
the iron kettles.

There is to be music in the piazza to-night. and
on the Grand Canal. and the 22nd of March street
and the campo are to be illuminated.

I eat fruit so much of the time and so much at
a time that I go to bed at night expecting

| 1 5 | Rockwell Kent *to* Frances Kent 16 July 1931 | 3 PP., HANDWRITTEN, ILL. *for transcription, turn to p. 200* |

for transcription, turn to p. 200

Although perhaps most famous for his bold wood engravings, Rockwell Kent (1882–1971) was a man of diverse talents, at various times working as an architect, a carpenter, a painter, a dairy farmer, a political activist, a writer, and an Arctic explorer. In 1931, he wrote to his second wife, Frances, from a remote area in Greenland, where—stranded without any supplies—he was laboring to build a house. Captivated by his surroundings, he writes,

THE VIEW ACROSS THE BAY AT THE WILDERNESS OF MOUNTAINS THAT IS THERE IS UNBELIEVABLY LOVELY. THE ICEBERGS THAT DOT THE WATER ARE ALWAYS CHANGING. ONLY THE WEATHER IS CONSTANT—WARM AND FAIR.... MY HOUSE IS JUST BEHIND THE OTHER HOUSES SO THAT I LOOK DOWN ON THE WHOLE PAGEANT OF VILLAGE LIFE.

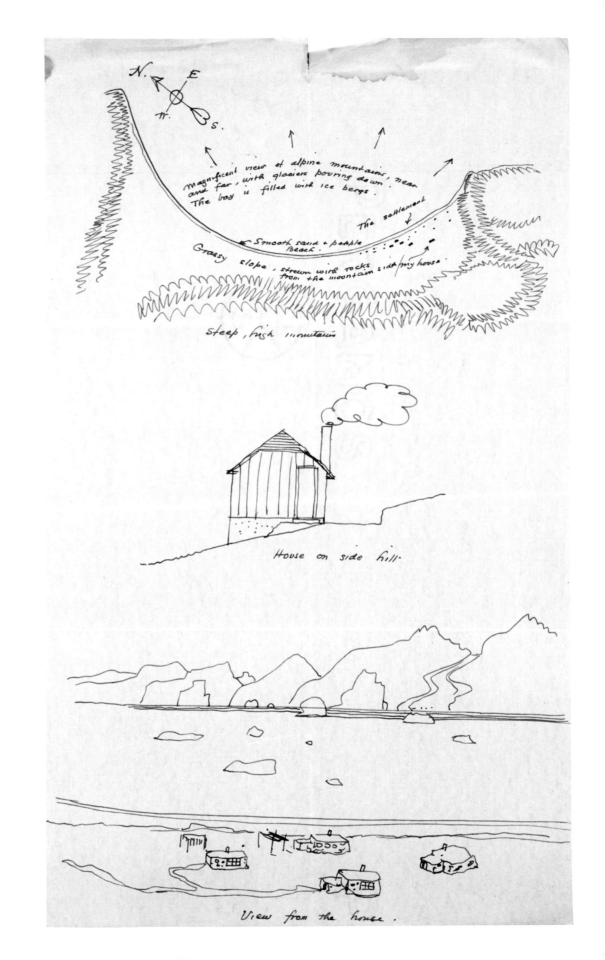

N. E.

W. S.

Magnificent view of alpine mountains, near and far, with glaciers pouring down. The bay is filled with ice bergs.

The settlement

← Smooth sand & pebble Beach.

Grassy slope, strewn with rocks from the mountain side/my house

steep, high mountains

House on side hill.

View from the house.

1 6	Allen Tupper True	1 P., HANDWRITTEN, ILL.
	to Jane True	*for transcription, turn to p. 200*
	[1927]	

In a letter of 1927 to his daughter, painter and illustrator Allen Tupper True (1881–1955) embellishes his hotel stationery with an expression of his awe at New York City skyscrapers. He includes himself in the drawing as a speck on the street.

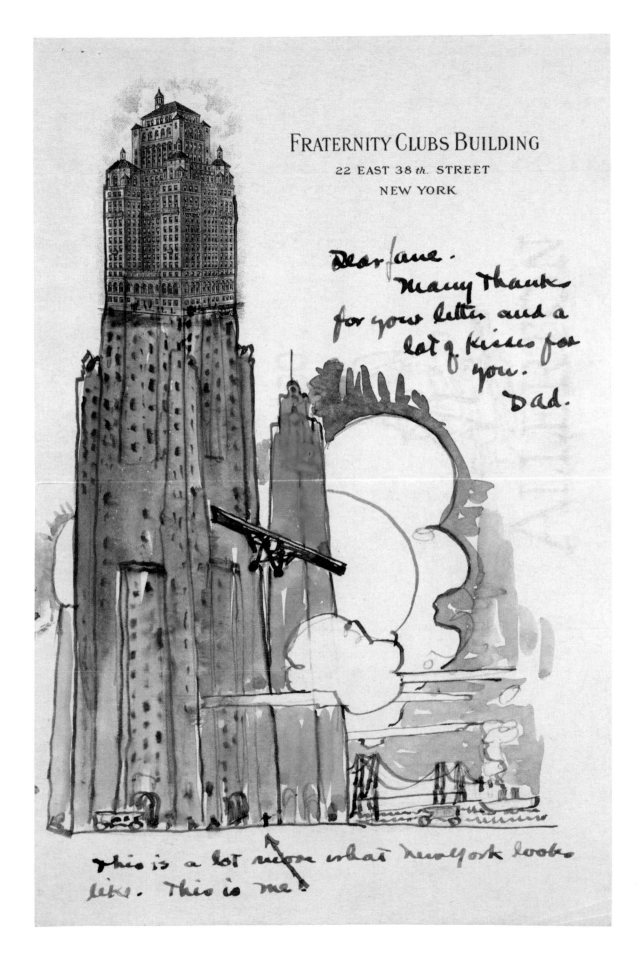

FRATERNITY CLUBS BUILDING

22 EAST 38 th. STREET

NEW YORK

Dear Jane.
Many thanks
for your letter and a
lot of kisses for
you.
Dad.

This is a lot nearer what New York looks
like. This is me.

1 7 William Zorach
 to John Weichsel
 18 Oct. 1917

4 PP., HANDWRITTEN, ILL.

for transcription, turn to p. 200

In 1917 sculptor William Zorach (1887–1966), and his wife, painter and weaver Marguerite (1887–1968), and their two-year-old son, Tessim spent an extended summer on a farm in New Hampshire. In this letter to John Weichsel (1870–1946), a prominent critic and founder of the People's Art Guild, Zorach gives a full description of their life on the farm. While he loves living off the land and tending his animals, he regrets that he is not on hand to help with the guild, an artist-run association in New York, composed of more than sixty members who sold their art directly to the public by holding exhibitions in settlement houses, churches, schools, and union halls. Zorach ends with a sketch of the family and their livestock in a patriotic parade.

success. & I hope the guild will grow & prosper.

Marguerite asked me to remember her & she sends greetings to Mrs. Weichsel & yourself

also best wishes & luck from myself

believe me as ever

Yours Zorach

1 8	Frederic Edwin Church *to* Martin Johnson Heade 7 Mar. 1870	4 PP., HANDWRITTEN, ILL. *for transcription, turn to p. 201*

for transcription, turn to p. 201

In the late nineteenth century, landscape painters traveled great distances in search of exotic terrain. In 1870 Frederic Edwin Church (1826–1900) wrote to fellow painter Martin Johnson Heade (1819–1904), who was on his third trip to South America, where he painted the local flora and fauna against the spectacular backdrop of their tropical habitat. Church teases him for not finding the Sierra Nevada de Santa Marta—the highest coastal mountain range in the world—when Heade was standing at its foothills and playfully suggests that perhaps a cloud of mosquitoes had obscured his friend's view.

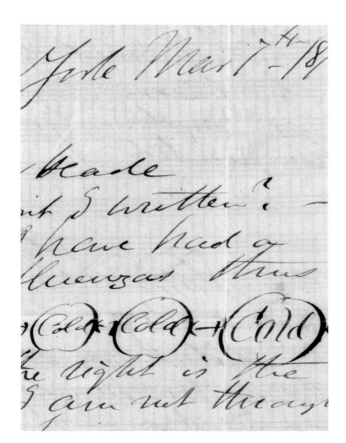
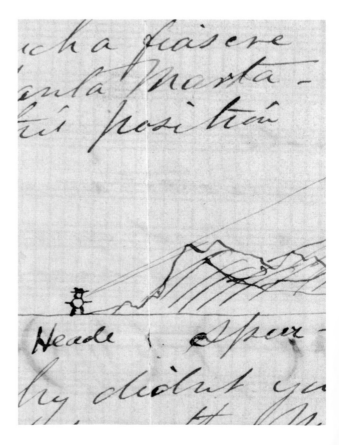

Mosquitoes were in the way
thus —

It's an awfully good joke — and
I wont tell Mrs Bierstadt — only
your good friends
However you have good sketching
in the Isthmus and must
feel repaid for your journey —
I have had two letters from you
this is three so you owe me one —
I am in the Midst of "Jerusalem"
but owing to my staying of influenzas
have really accomplished little
this winter —
I have carefully stored your traps
in the dark room by themselves
and have had one corner and
part of one end of the Studio
Cleaned I shall try to get at the
another corner soon —
There is a great effort making
to get up a great Art Museum
here — I am on four committees
relating to it and thus keep my

1 9	Robert Frederick Blum *to* Otto Henry Bacher 18–23 July 1887	4 PP., HANDWRITTEN, ILL. *for transcription, turn to p. 202*

Painter and illustrator Robert Frederick Blum (1857–1903) wrote this letter to friend and fellow artist Otto Henry Bacher (1856–1909) aboard a ship at mid-ocean, en route to Venice. After caricaturing his shipmates, Blum concludes, "I HARDLY HAVE A CHANCE TO LOSE MY HEART ON THIS TRIP." Blum, who never married, was equally finicky about the men onboard. His observations reveal this seasoned traveler to be an astute judge of character.

this and must
be a Duchess
at least from
the air of
superiority –
with which
it surveys
this little world.
It is French, and a
capital likeness. Then
on my left I have another
gay something of
this order. She is
hardly my style being
a trifle over the middle
age and diseased
with a frivolous desire
to forget it. I think
the pictures will be
"enuf" to go into details
of characteristics is "too

20 John Von Wicht 1 P., HANDWRITTEN, ILL.
 to Will and Elena Barnet *for transcription, turn to p. 202*
 14 Aug. 1956

Painter John Von Wicht (1888–1970) personalized
his letters with colorful abstractions, which closely
resemble his paintings. In this letter to fellow artist
Will Barnet and his wife Elena, Von Wicht takes up a
familiar topic among artists—the difficult trade-off
between teaching and painting.

Aug. 14. 56.
Pownal - Vermont

John

Dearest Helene and Will,

I was very much ashamed to have waited as long with my letter, but we both will know more now than we did a month ago. I hope that you and Helene had a good summer, good swims and a good rest, that your work came off fine and you sold many pictures here, this would help your finances anyway. I hope the summer was so successful that you will do the same during the following years, you have a less busy rest teaching but you will have gained as an artist. One has to have time to work. How long will you stay there?

In any case we always are separated but this time Romi will not be to lonely. She now has joined her sister in Belgium and will stay there for a week or two. Before she saw Paris, went to the Dordogne to see the cave paintings at Montignac-sur-Vézère. She really enjoys her trip, she returns about Oct 1st, glad I'll be back. My the June-July was a great help for me, now resting one month on this farm, then Sept. against Yado, Saratoga Springs - N. Y. - Your canvas was a great help and very good, thanks so much Will, hope I did some good paintings. ~ Please remember me to Mr. Bing and to all friends there, K. Anatol, Botkin and so on, how does exhibition go? I probably never sold, I should have seen there, that without a car it is so hard to do.

All very best wishes and
love to both of you.

John

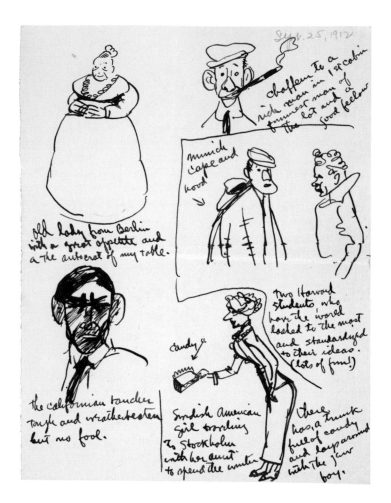

21	Walt Kuhn	9 PP., HANDWRITTEN, ILL.
	to Vera Kuhn	*for transcription, turn to p.*
	25 Sept. 1912	*203*

for transcription, turn to p. 203

On September 25, 1912, Walt Kuhn, a painter who served as secretary of the Association of American Painters and Sculptors, wrote to his wife Vera from on board the S.S. *Amerika* bound for Germany. Although queasy from the rolling of the boat, he was energized by his mission to meet with European artists and dealers and arrange for loans of art for the upcoming Armory Show—the first large-scale exhibit of modern art in the United States. His first stop was Cologne, followed by visits to The Hague, Amsterdam, Berlin, Munich, and Paris. While Kuhn's anti-Semitism surfaces throughout his letters, it is revealed with disquieting clarity here in his caricatures of fellow passengers.

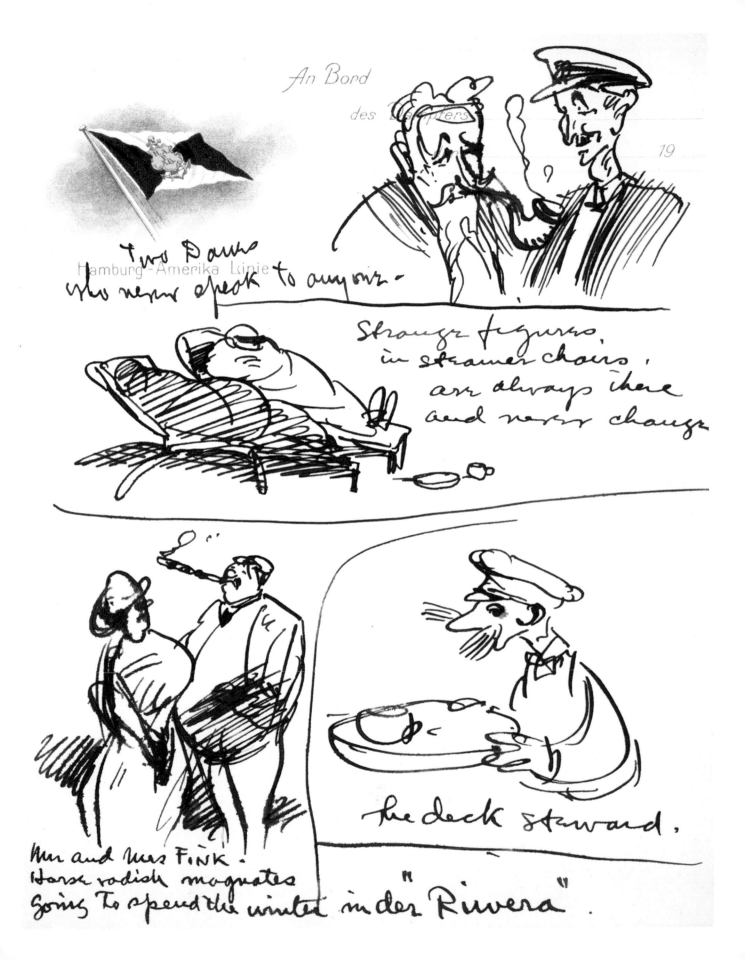

An Bord

des Dampfers

19

Hamburg-Amerika Linie

Two Dames
who never speak to anyone.

Strange figures
in steamer chairs,
are always there
and never change.

Mr. and Mrs. Fink.
Horse radish magnates
Going to spend the winter in der "Riviera".

The deck steward.

| 2 2 | Joseph Lindon Smith *to* his parents ca. May 1891 | 1 P., HANDWRITTEN, ILL. *for transcription, turn to p. 204* |

for transcription, turn to p. 204

In 1891, painter Joseph Lindon Smith (1863–1950) penned a note to his parents announcing his impending arrival at the family home in Dublin, New Hampshire. He sketches himself with good humor as a less-than-savvy traveler returning from an extended stay in Orizaba, Mexico.

My dearest Parents;

Your son — longs for Dublin — He will arrive Wednesday night — or Thursday evening he cant now tell which — if he brings all the things you have asked him to, he will appear like

this

| 2 3 | Richard Kozlow
to Lester and Kittie Arwin
19 Jan. 1961 | 1 P., TYPESCRIPT, ILL.

for transcription, turn to p. 204 |

While on an extended stay in Mexico in 1961, Richard Kozlow (b. 1926) wrote to his friends and dealers Lester and Kittie Arwin, owners of the Arwin Gallery in Detroit, about his paintings for an upcoming show. "I THINK THEY ARE THE BEST GROUP I HAVE EVER DONE," he asserts, "ALL BIG AND BOLD... AND ALL OF THE MOUNTAINS." Kozlow, who sketches himself as a beaming, buoyant tourist in the tropical sun, had good reason to be optimistic: the sale of his Mexican paintings would finance his trip the following year to Majorca, Spain. Kozlow also painted in England, Costa Rica, and Seville, but often returned to Mexico.

january 19
1961

dear lester & kittie,
received your note this a.m.....thank you for the
enclosure....also the news of the scarab blue rib-
bon was good for the ego....as to my show i shall
attempt to get some photos and all t-
he necessary data for use in an arti-
cle.......i am really sorry i sent th-
ose xxxxx slides...because the change
set in just after my sending them....
just imagine in my last six paintings
there is not one kozlow sun...melanie
may want to divorce me....i think they
are the best group i have ever done..
all big and bold....and all of the
mountains...they simply knock me
out...the mountains that is.
just curious to know if
you lovely people have
been thinking of any plans
for what to do with kozlow when
he returns....a show next fall
in detroit seems too soon to
me...what say you ? how about
out of town ?
when are you coming to pay us
a visit ? we'd love to have you
....give the idea a long hard
thought...our rates are very
reasonable....and the foods
good....and look how much you
will save in phone bills.
oh yes...i thought one of those
black & white landscapes would
make a nice present for guy &
nora....by the by did we ever
sell any of those or am i the
only one who liked them ?
what and who is new and exciting
at the gallery ? oh yes ...please
extend my congratulations to
caryl hayeson her show......

i'm sorry i am so late
in sending my wishes..
she's a doll.
must go now...keep well
and happy...we miss you much.
...oh yes i'm forming a "morley
for mayor" committee down here.
give her our love.....

lil richard

2 4	Robert Frederick Blum	3 PP., HANDWRITTEN, ILL.
	to Otto Henry Bacher	*for transcription, turn to p. 204*
	20 Nov. 1890	

From 1890 to 1892, painter Robert Frederick Blum
(1857–1903) lived in Japan, where he illustrated a series
of articles on the life and customs of that country for
Scribner's. In his letter of November 1890, addressed to
his dear friend Otto Henry Bacher in New York, the
artist imagines the new father employing various
Japanese methods of carrying his five-month-old baby,
Robert Holland Bacher. The letter suggests that the
baby was named after Blum.

7"
½
L

Tokio Nov. 20. 90

Dear Otto,
I rec'd your last enclosing
many delightful little note and was pleased
to learn that the little gown proved acceptable.
I had no idea it would cause much bother—
but I guess it didn't worry you too much since

her sail-boat. It was taken by Doctor Bataglia (?) as he sped past in a motor boat and it looked something like this ————— you can see the whole keel and boat's bottom out of water. — it's really quite a picture —

MIDGE

2 5	Paul Bransom	10 PP., HANDWRITTEN, ILL.
	to Kicki Hays	*for transcription, turn to p. 205*
	17 Oct. 1947	

In the 1920s, illustrator Paul Bransom (1885–1979) and his wife Grace built a home and studio at Canada Lake in the Adirondacks, where they were part of a small group of artists and writers including Charles Sarka, also an illustrator; Herbert Asbury, journalist and author of *The Gangs of New York*; Emily Hahn, a staff writer for the *New Yorker*; and writer and cartoonist James Thurber. In this letter to Kicki, the young daughter of friend and writer Helen Ireland Hays, the artist paints himself working on a woodblock book plate for Kicki, while he and his wife dream of diving into the lake.

THE WOOD-BLOCK
BOOK PLATE

That good old
Canada Lake, N.Y.
Oct. 17th. 1947

Dearest Kicki:

At last! I have a chance to really
get down to write to you and to thank
you for your fine letter which gave us
so much pleasure — It is so nice
to hear of all your activities and to
know that you are well and happy
and that you think of us — as we
certainly often do of you — We miss

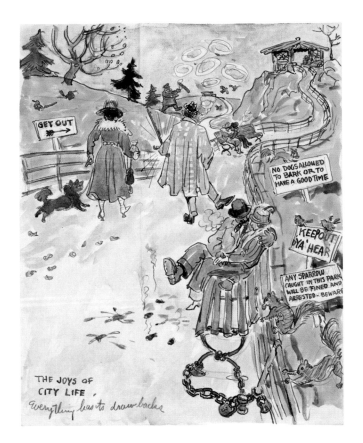

2 6	Charles Nicholas Sarka *to* Paul Bransom 18 Apr. 1917	7 PP., HANDWRITTEN, ILL. *for transcription, turn to p. 206*

For Charles Sarka (1879–1960), both the city life and
the country life had their drawbacks. In a letter to Paul
Bransom (1885–1979) of April 1917 he compares the
small town sameness of Main Street Wyoming, where
Bransom was teaching, to the perversions of Central
Park near Sarka's apartment at 692 Madison Avenue.
Sarka also reports on his visit to an exhibition of the
Independent Artists' Association:

> I WAS THERE THE OTHER DAY, TWO
> OR THREE OTHER PEOPLE WERE
> THERE WANDERING AROUND MAKING
> LOUD ECHOES WITH THEIR FEET. THE
> ADVANCED ARTS HAVE AN ATMOSPHERE
> OF STALENESS, MINGLED WITH A
> FEELING OF 'WHERE HAVE I SEEN
> THAT BEFORE' AND LONELINESS—IT
> IS BECOMING A BORE.

51

Schow is married and quiet, Everything going along as usual. The Coons and Brown Bears eat just as many peanuts as usual. Should peanuts advance in price that would be certainly cruelty to animals, wild animals would no longer be tame.

OH! PAUL LOOK AT THE BOAT!

WHERE AUNT GRACE

BULL BULL

THEY ALL ROLL BULL WHY NOT YOU?

BUY IT NOW

HUH! HUM!

ROLL YOUR OWN BULL NOW

SMOKE BULL DURHAM AND BE HAPPY

BULL DURHAM

POST OFFICE AND CY'S STORE.

THE JOY OF COUNTRY LIFE.
Every thing has it's draw backs

2 7	Marcel Duchamp *to* Jean Crotti 8 July 1918	7 PP., HANDWRITTEN (IN FRENCH), ILL. *for transcription, turn to p. 207*

In 1918 Marcel Duchamp (1887–1968) wrote to his friend and future brother-in-law Jean Crotti (1878–1958) with news of his impending departure for Buenos Aires with Crotti's ex-wife Yvonne Chastel. Duchamp was eager to leave New York. "EVERYTHING HERE HAS CHANGED," he bemoans, "ATMOSPHERE AND ALL. CONSTRAINTS RULE." The post-war shift in New York's artistic climate slowed his progress on one of his most important pieces, *The Large Glass*, also known as *The Bride Stripped Bare by her Bachelors, Even* (1915–1923). In his letter, he provides a sketch of another current project—a readymade that he describes as "A MULTI-COLORED COBWEB," consisting of rubber strips cut from bathing caps, cemented together at random, and attached to the walls with string to form infinite configurations (*Sculpture for Traveling*, 1918, now disintegrated).

Though Duchamp writes that he "HAS A VERY VAGUE INTENTION OF STAYING DOWN THERE A LONG TIME," he was only in Buenos Aires for nine months, honing his chess game, before returning to France in the summer of 1919. The following year he was back in New York.

N.y. 8 juillet 33 W. 67)

mon cher Jean, Yvonne t'a écrit et tu as reçu
le câble que j'allais et probablement Yvonne
aussi partir pour Buenos Aires — Plusieurs raisons
que tu connais : Rien de grave ; seulement une sorte de
fatigue de la part de A. — Des gens malintentionnés
ont probablement arrangé les choses ainsi — J'ai vu
dernièrement Ron qui a été très gentille — Walter
vient de perdre sa mère. Il est à Pittsburgh et je
ne l'ai pas vu depuis un mois. J'ai fini le
grand panneau pour miss Dreier et j'ai recommencé
une autre chose plus intéressante pour elle aussi ;
tu te rappelles les copes de coiffures de bain en
caoutchouc de toutes couleurs = J'en ai acheté,
les ai découpées en petites bandes irrégulières
taillées ensemble, pas à plat, W au milieu (en
l'air) de mon atelier, et attaché par des ficelles
aux différents murs et closes de mon atelier
Ça fait une sorte de toile d'araignée de toutes
les couleurs J'ai pres que
 fini ça —
 Si tout se passe
 comme je l'espère,
 il y a un bateau partant
 le 3 août — ou bien un
 autre vers le 14 août

2 8	Paul Suttman	1 P., HANDWRITTEN, ILL.
	to Red Grooms	*for transcription, turn to p. 209*
	18 May 1963	

In May 1963 sculptor Paul Suttman (1933–1993) wrote
to his good friends Red Grooms (b. 1937) and Mimi
Gross (b. 1940) about his changing accommodations
in Italy. Suttman had received a Fulbright fellowship
to study in Paris. He writes from the bottom of a wine
glass, drunk on the pleasures of Italy, and reports that
his traveling companion, and their mutual friend,
K[atharine]K[ean] fell off a scooter and broke her
collar bone. Suttman settled in a rustic farmhouse near
Impruneta, south of Florence, in the Chianti region
of Tuscany. He made Italy his home until 1976, when
he returned to the United States. He subsequently taught
at the University of New Mexico.

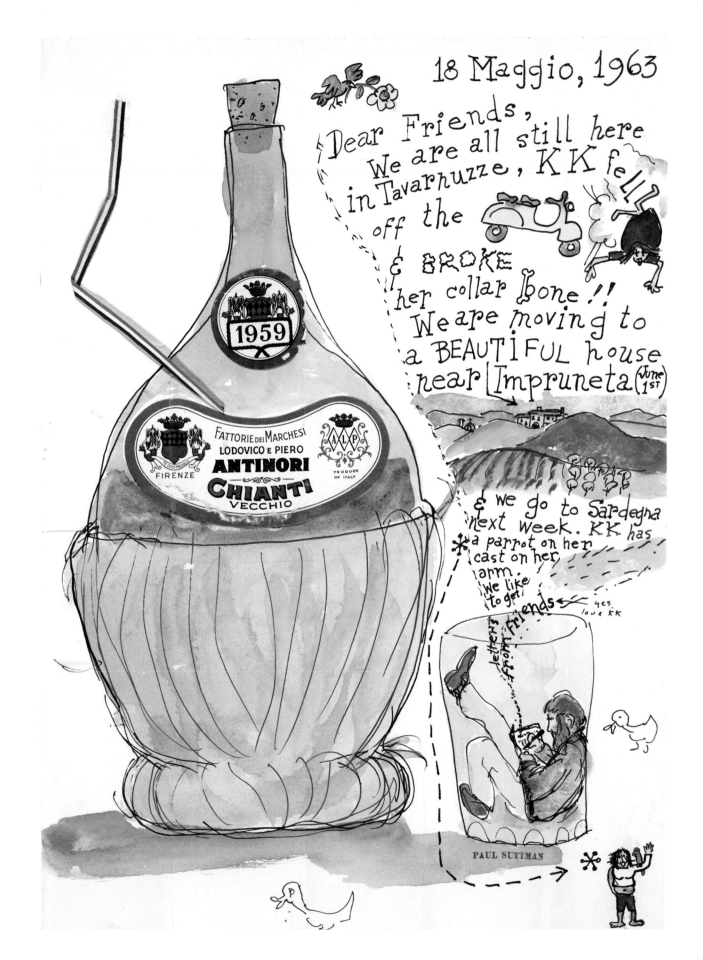

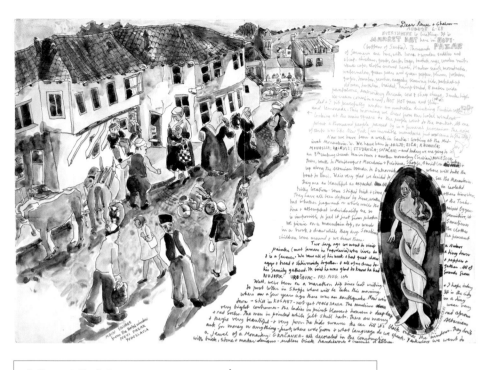

<table>
</table>

29	Mimi Gross	3 PP., HANDWRITTEN, ILL.

29 Mimi Gross
to Reneé and Chaim Gross
6, 10 Aug. and 5 Sept. 1968

3 PP., HANDWRITTEN, ILL.

for transcription, turn to p. 209

In a letter to her parents, Mimi Gross (b. 1940) combined the verbal and the visual to describe a market day in Novi Pazar, in Southwest Serbia. She writes,

THOUSANDS OF FARMERS ARE HERE, WITH HORSES & WOODEN SADDLES AND SHEEP, CHICKENS, GOATS, CARTS, BAGS, BASKETS, RUGS, WOOLEN SUITS, SKULL CAPS, CLOTHS AROUND HEADS...RAGGEDY SCRAWNY KIDS, PATCHED-UP OLD MEN, TOOTHLESS, BRAIDED, HUMP-BACKED, 8 METER WIDE PANTALOONS, EMBROIDERY THREADS, COW & SHEEP CHEESE, 3 METER HIGH ICE-CREAM CONES (IN A ROW), HOT HOT SUN AND SKIES.

She and her then husband Red Grooms also explored medieval monasteries. "THE MIXED BYZANTINE & ATTEMPTS AT INDIVIDUALITY ARE SO SENSITIVE," she notes, "IT IS IMPOSSIBLE TO FEEL IT JUST FROM PHOTOS." She adds her version of a fresco from Sopacani of Eve in the paralyzing grip of a green serpent.

(olive trees where we slept)

...de covered already! What long letters I do write!
...ling: I am so terribly lonely for you. Even the friendliness...
...little house becomes a thing that hurts with you a...
...long until October 9th. And then 8 days!

The weather is too bad to paint. I...
...been working in the house writing...
...t the drama of Tristan and I...
...the first chapter of the book...
NOTHING ON for...
...one. A good title...
...tive. I think will...
...ay and learn sta...

White I...
...mes...
...you...
...cau...

...esterday...
 mrs. mc. G...
...t she had...
...y. It was grand...
...them finished for me...
...another lot of pota...
 God help me!

...eetheart — my thoughts are always...
...ly. But that's because you have...
...wrote all through me with your loveliness...
...always hungry without you. Thy darling.

 Now, my sweet one, I shall go to bed, where
...thing beside me have still a little of you about...
Goodnight, my sweet.

CHAPTER II "I Do"

| 3 0 | Paul Bransom *to* Grace Bond ca. 1905 | 3 PP., HANDWRITTEN, ILL. *for transcription, turn to p. 210* |

In this letter Paul Bransom (1885–1979) depicts himself fixated on a photograph of his sweetheart, actress Grace Bond, who was away in Boston rehearsing a play. He writes, "IN MY MINDS [SIC] EYE I CAN SEE HOLLIS STREET THEATER & THE STAGE DOOR SO PLAINLY. OH! I WISH I WERE THERE WITH YOU." A year later, at age twenty-one, Bransom married Grace; he also sold five covers to the *Saturday Evening Post*, launching his career as a freelance illustrator.

Monday –

My Sweetheart –

No doubt you
are once rehearsing
in Boston – +
thinking of you
boy. between songs
+ I––––––
am simply full
of you, all
my thoughts –
Oh! It was a
dear letter I got from
you this morning + so
thoughtful + considerate of
you to write me from New York –
I certainly do appreciate it
dear heart – am going to take

SIMPLY A PICTURE!

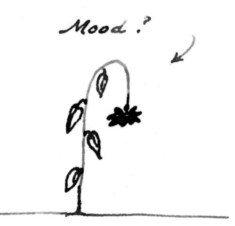

Mood ?

3 1	Rockwell Kent	2 PP., HANDWRITTEN, ILL.
	to Frances Kent	*for transcription, turn to p. 210*
	13 Sept. [1926]	

In this letter to his newly-wed wife Frances, Rockwell Kent (1882–1971) neatly diagrams his change of mood on a rainy day in Ireland. There to paint and to complete advertising commissions, his wife recently returned to New York, he laments, "EVEN THE FRIENDLINESS OF THIS LITTLE HOUSE BECOMES A THING THAT HURTS WITH YOU AWAY." The rain prevented him from painting so he spent the morning writing the first chapter of a book and dictating tasks to his sweetheart, among them "HURRY AND LEARN STENOGRAPHY."

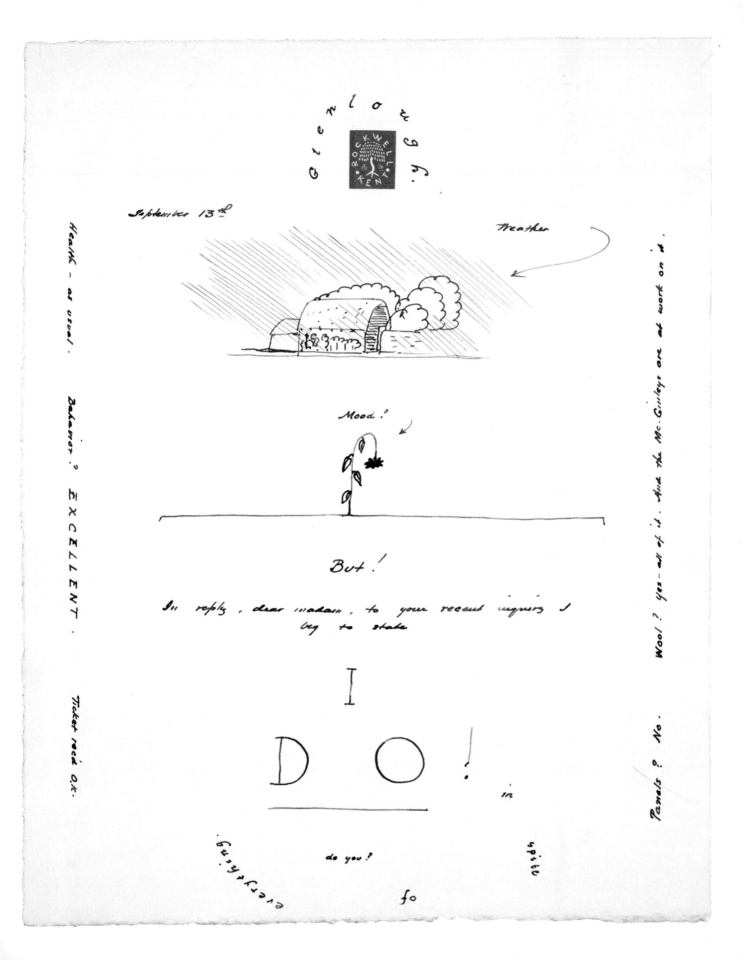

Glenlough.

ROCKWELL KENT

September 13th

Weather

Mood?

But!

In reply, dear madam, to your recent inquiry I beg to state

I
D O !

in

do you!

spite

fo

everything

Health — as usual.

Behavior? EXCELLENT.

Ticket rec'd O.K.

Wool? Yes — all of it. And the McGinleys are at work on it.

Panels? No.

3 2	Eero Saarinen	1 P., HANDWRITTEN, ILL.
	to Aline Bernstein	*for transcription, turn to p. 211*
	[1953]	

Finnish–born architect Eero Saarinen (1910–1961) often illustrated his letters to his second wife, Aline, an art editor and later critic at the *New York Times*. Written in 1953, a year before they married, this note documents his intense productivity; he was then at work on five projects. In the following year, he completed his master plan for the University of Michigan at Ann Arbor. The Michigan Music School, sketched here in plan and elevation, was finished in 1964.

E E R O S A A R I N E N A N D A S S O C I A T E S

EERO SAARINEN F.A.I.A.
JOSEPH N. LACY A.I.A.
J. HENDERSON BARR A.I.A.
WARREN PLATNER A.I.A.
JOHN DINKELOO
BRUCE ADAMS

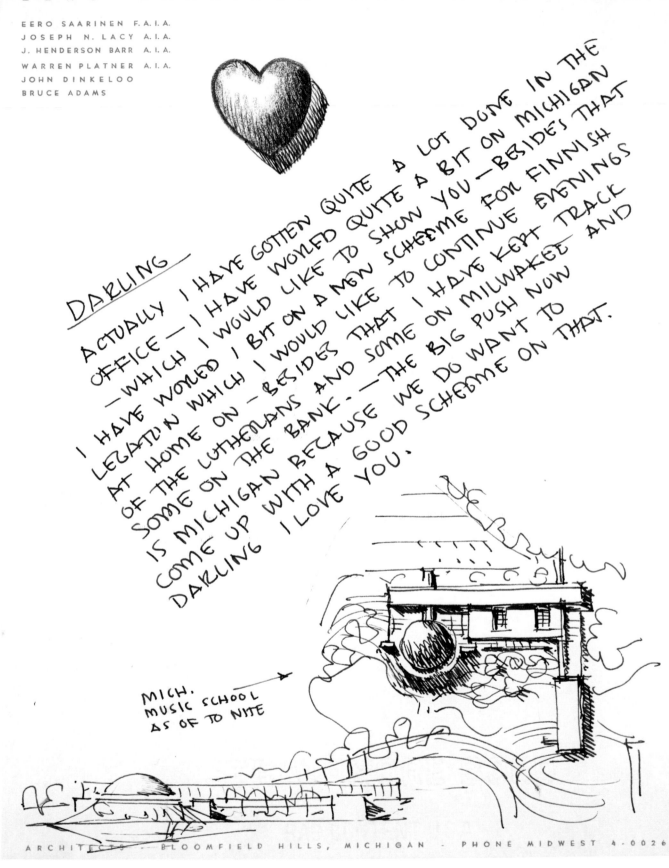

DARLING

ACTUALLY I HAVE GOTTEN QUITE A LOT DONE IN THE OFFICE — I HAVE WORKED QUITE A BIT ON MICHIGAN — WHICH I WOULD LIKE TO SHOW YOU — BESIDES THAT I HAVE WORKED A BIT ON A NEW SCHEME FOR FINNISH LEGATION WHICH I WOULD LIKE TO CONTINUE EVENINGS AT HOME ON — BESIDES THAT I HAVE KEPT TRACK OF THE LUTHERANS AND SOME ON MILWAKEE AND SOME ON THE BANK. — THE BIG PUSH NOW IS MICHIGAN BECAUSE WE DO WANT TO COME UP WITH A GOOD SCHEME ON THAT. DARLING I LOVE YOU.

MICH.
MUSIC SCHOOL
AS OF TO NITE

ARCHITECTS · BLOOMFIELD HILLS, MICHIGAN · PHONE MIDWEST 4-0026

<table>
<tbody>
<tr><td>3 3</td><td>Waldo Peirce
to Sally Jane Davis
25 Apr. 1943</td><td>1 P., HANDWRITTEN, ILL.

for transcription, turn to p. 211</td></tr>
</tbody>
</table>

One in a series of fanciful letters from painter and watercolorist Waldo Peirce (1884–1970) to WAAC Capt. Sally Jane Davis, stationed in Ruston, Louisiana, during World War II, this verse commemorates Easter Sunday 1943. Peirce, who married four times, here divides his affections among three women, each shown happily eating a piece of his heart. Peirce was at this time married to his third wife, Alzira, who was also a painter.

WALDO PEIRCE
POMONA, NEW YORK
PHONE SPRING VALLEY 1869J

For Sally —
Easter Sunday
25 April 43

Oh my hearts in Louisiana —
Wherever my rump may be —
For there on this Easter Sunday
Are my Hracrodils all 3 —

There's a portion for Jenie Belle
And another for Addie Lou
And last but not least, Sally Flashbulb,
A good thick cut for you —

Would you like it well done or tender
Hardboiled or fricasie ?
O my hearts in the land of the Bayous —
cleft in three —

3 4	Moses Soyer	1 P., HANDWRITTEN, ILL.
	to David Soyer	*for transcription, turn to p. 211*
	[1940]	

Social realist painter Moses Soyer (1899–1974)
expressed paternal love in his letters to his only son,
David, who at age twelve was away at summer camp in
1940. David's mother Ida designed needlepoint patterns.
Her employer had a relative, a young boy, who had
recently escaped Vienna. Ida arranged for him to attend
summer camp. In the same way that Soyer's paintings
have an undercurrent of social concern, here he asks his
son to be kind to the young refugee. Whittey and
Brownie, pictured here, are camp horses.

DEAR DAVID—

IT'S TERRIBLY HOT HERE

YOU'RE LUCKY TO BE IN THE

COUNTRY

WE
ENJOYED

PARENTS
DAY VERY MUCH. THE CHILDREN
DID WELL. SO DID THE GROWN-
UPS. IDA IS COMING UP TO
CAMP THIS FRIDAY OR SATURDAY.
SHE IS GOING
TO BRING
WITH HER
A LITTLE
VIENNESE
BOY.
HE IS
A REFU-
GEE.
BE KIND
AND FRIENDLY TO HIM.
MAKE THINGS EASY FOR HIM.
MOSES — LOVE + KISSES.

BROWNIE

WHITEY

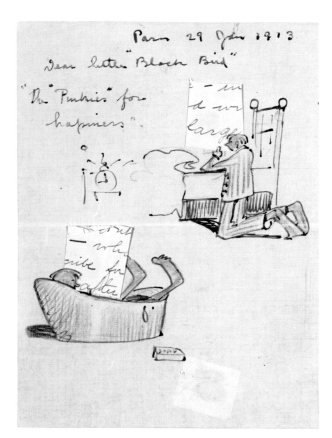

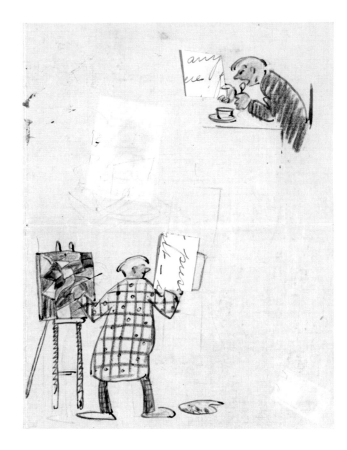

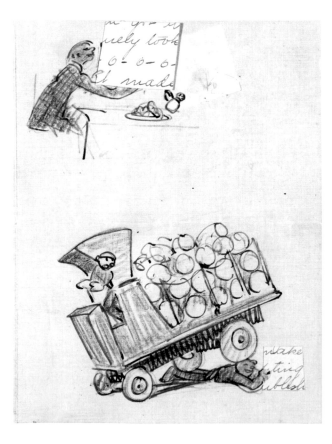

35	Alfred Joseph Frueh *to* Giuliette Fanciulli 29 Jan. 1913	7 PP., HANDWRITTEN, ILL. *for transcription, turn to p. 212*

Caricaturist Alfred Frueh (1880–1968) wrote to his fiancée Giuliette Fanciulli from Paris in 1913, showing how happy he was to receive her letters, which he calls "PINKIES" in light of the fact that they were written on pink paper. If Frueh is to be believed, his every waking moment was consumed with thoughts of Guiliette and the promise of receiving her "PINKIES," or "Ps," which he cut up and pasted into his letter, incorporating her earlier sentiments into his new communication. In one letter he exclaims, "WEEKS WITHOUT 'Ps' ARE AS EMPTY AS CREAM PUFFS WITHOUT CREAM."

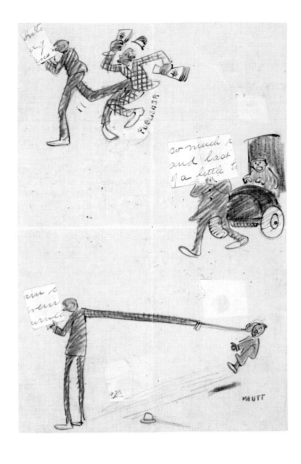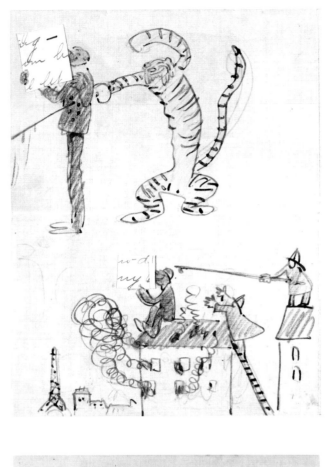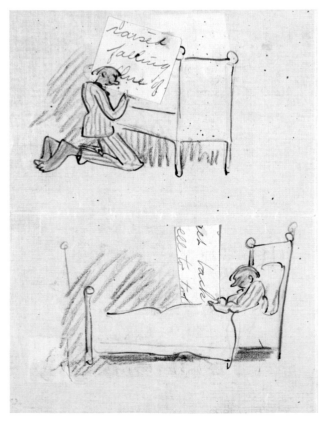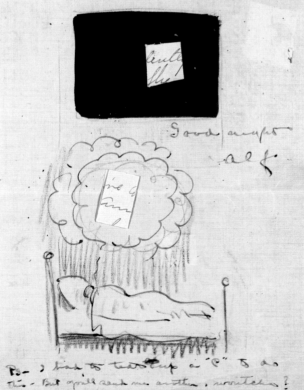

3 6	Gio Ponti	1 P., HANDWRITTEN, ILL.
	to Esther McCoy	*for transcription, turn to p. 212*
	ca. 1978	

In this whimsical note from Italian architect and designer Gio Ponti (1891–1979) to architectural historian Esther McCoy (1904–1989), he articulates her delicate and discriminating senses, using a graceful script to form her features.

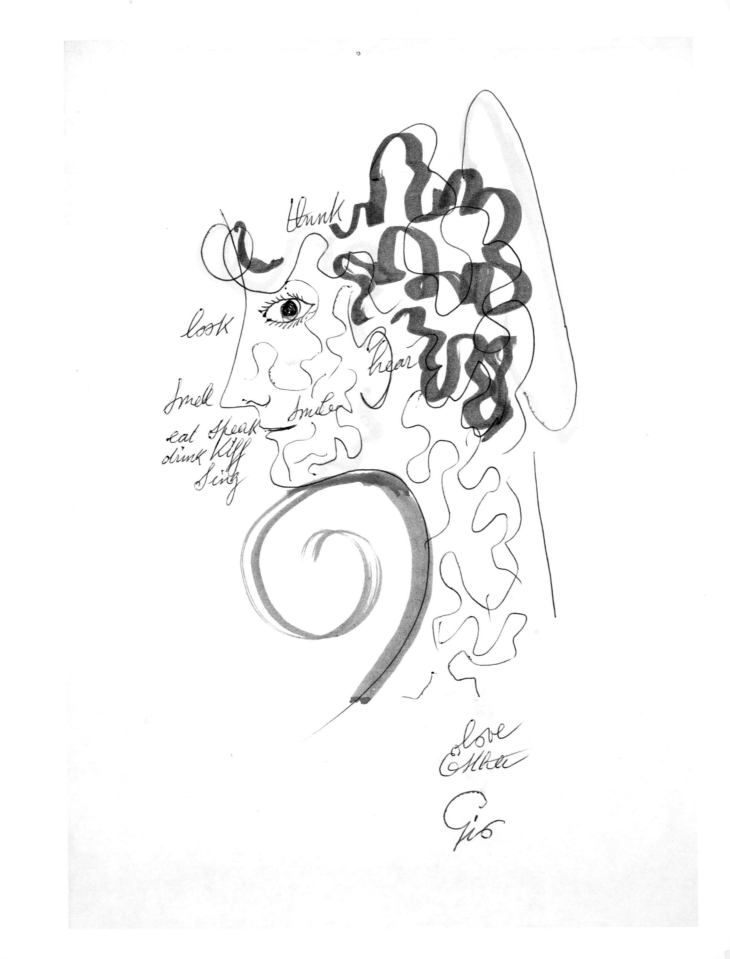

...active and managing to have one who needs you
... then you need him. Of course, I talked ...
... that same category. Often, when I'm angry ...
... it gets a Nobel Prize I say to myself ...
... God's name would be up to expecting ...
... called honor. I recall him ...
... without any politics.

I can't quite ...
... cheerfully ...
... hurry ...

... for the University's ...
... arts. That could be ...
... but the givers have no enthu...
... was a material testament to ...
... the organizations disband and simply ...
... can't help drawing and painting go ahead ...
... certainly there's no excuse to talk about it

CHAPTER III Plays on Words

3 7	Moses Soyer	1 P., HANDWRITTEN, ILL.
	to David Soyer	*for transcription, turn to p. 212*
	[1940]	

Moses Soyer (1899–1974) sent what he called a "puzzle picture" to his son David, who was away at a camp in the Catskills in the summer of 1940. In a watercolor vignette, he pictures the family dog and cat, Tinkerbell and Jester, along with the words "WHERE IS JESTER" (the answer is, hiding under the dog).

Soyer also prominently features baseball great Dizzy Dean, who was about to make a comeback in the minor league. He mentions that the Cincinnati Reds are in the lead. (They would win the World Series that year.) The baseball banter carries over to the margin, where Soyer sends a glove flying from their home at 432 West Street in New York to David's bunk at Camp Quannacut.

DEAR David Monday

THAT WAS A SWELL LETTER
YOU WROTE US. THE ILLUSTRATIONS
WERE SWELL TOO. I GUESS THAT
BY THE TIME YOU
RECEIVE THIS LETTER
YOU WILL HAVE
GONE ~~B~~ SWIMMING
IT'S GETTING VERY WARM
IN THE CITY
THERE'S NOT
NEW ~~THE~~ ~~WAR~~ much that's
EXCEPT THE WAR.
I SEE BY THE PAPERS THAT DIZZY
DEAN WILL TRY A PITCHING COME BACK
IN THE MINORS. THE CINCINATTI
REDS are IN THE LEAD
SO FAR TINKERBELLE
IS STILL GROWING
AND SO IS JESTER.

MAW

DEAR
PAW AND
MAW
DAVID

ARE YOU
GETTING
YOUR INJECTIONS

TINKERBELL

DIZZY DEAN

RUSSEL PICTURE WHERE IS JESTER

MOES

LOVE FROM IDA AND ME.
REGARDS FROM NAT AND EMMA

AM SENDING YOU THE GLOVE TODAY

W.T. CAMP GRANT DUNK O. QUANIACUT

PS SO

432 W. 125 ST

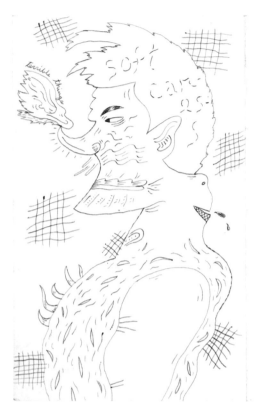

3 8	Jim Nutt	2 PP., HANDWRITTEN, ILL.
	to Don Baum	*for transcription, turn to p. 212*
	ca. 1969	

In February 1966, Don Baum (b. 1922) organized the
first Hairy Who exhibition at the Hyde Park Art Center
in Chicago, featuring a loose association of local artists
with like sensibilities. The group included Jim Nutt
(b. 1938) and his wife Gladys Nilsson, Jim Falconer,
Art Green, Suellen Rocca, and Karl Wirsum. Their
work, which is strikingly graphic in form and content,
favors high-key colors and comic strip imagery. This
letter is personalized with Nutt's arresting images of
"TERRIBLE THINGS"—a menacing two-faced figure,
wild hairs, lesions, and severed body parts—the visual
vocabulary for his paintings at the time. Probably
written in the fall of 1969, it recounts his arrival home
to Sacramento, where Nutt and Nilsson were teaching
at California State University, and their attempt to get
back into the "SWING" of things.

I get home + try to get back in [drawing] of things. I've felt like a zig-zag (ie ⚡) line since getting back. Was nice to sea you all — regretted not getting rap a port (in some rome consorting with 'a ', but Gladys filled me in on train. somehow Rapport familiar to me. [shorthand scribbles] write. Best Jim.

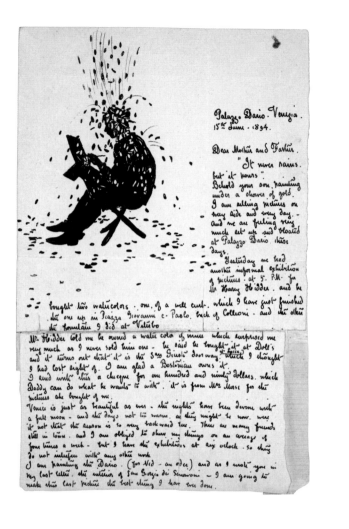

39	Joseph Lindon Smith *to* his parents 15 June 1894	1 P., HANDWRITTEN, ILL. *for transcription, turn to p. 212*

While living in Venice, American painter Joseph Lindon Smith (1863–1950) held an informal exhibition to sell his paintings four times a week at 6:00 p.m. Buyers, mostly visiting Americans, lined up to buy his work. In 1894, the artist writes to his parents of his financial success:

BEHOLD YOUR SON PAINTING UNDER A SHOWER OF GOLD. I AM SELLING PICTURES ON EVERY SIDE AND EVERY DAY—AND WE ARE FEELING VERY MUCH SET UP AND BLOATED AT PALAZZO DARIO THESE DAYS.

4 0	Arthur Garfield Dove *to* Suzanne Mullett Smith 15 Mar. 1944	4 PP., HANDWRITTEN, ILL. *for transcription, turn to p. 213*

When Suzanne Mullett Smith (1913–1989) wrote her Master's thesis on Arthur Dove (1880–1946), she had the advantage of corresponding directly with the modernist painter. It is debatable, however, if his cryptic responses answered her questions. In this letter he explains how he tries to establish the "condition of light" before beginning a painting. He adds,

A CERTAIN RED, A CERTAIN BLUE, A CERTAIN YELLOW FOR INSTANCE THAT IS THE MOTIF FOR THE SKETCH YOU HAVE, AND ALMOST SPELLS MALLARD DRAKE HERE UNDER THE WINDOW. OR RAW SIENNA, BLACK AND WILLOW GREEN, THE WILLOW TREE IN FRONT OF ME. ANYWAY—WHO IS <u>WRITING</u> THIS? I AM JUST THE PAINTER.

The dots denote an object as well as an idea of how an artist might represent a duck.

always tried to establish that before
beginning to paint. a certain
Red, a certain blue, a certain
yellow ● ● ● ● for instance
that is the motif for the sketch
you have. and
● ● ● ● ● almost spells
Mallard drake here under
the window. Or Raw Sienna,
Black and a willow green, the
willow tree in front of me.
Any way — Who is writing this?
I am just the painter.

Snowing hard yesterday
and spring again today.
We are anxious to see you.

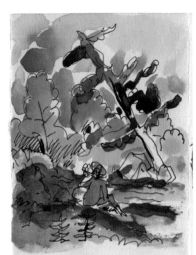

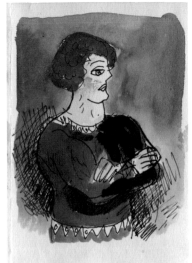

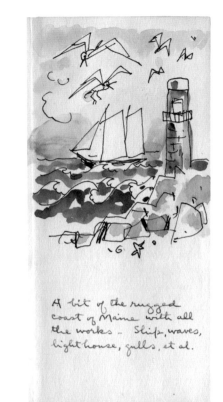

I'm not sure but a sylvan sunset would be more cheering. In the woods with a babbling brook?

Something more robust would really be more appropriate. A burly athlete of the sub-social type might be more the thing, or —

A bit of the rugged coast of Maine with all the works – Ship, waves, light house, gulls, et al.

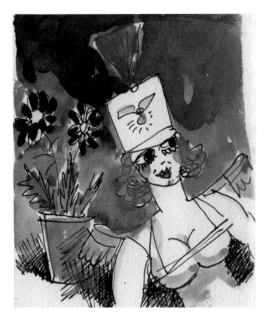

4 1	Walt Kuhn *to* Eloise Spaeth ca. 1940	7 PP., HANDWRITTEN, ILL. *for transcription, turn to p. 213*

for transcription, turn to p. 213

When art patron Eloise Spaeth (1902–1998) was recovering from an illness, painter Walt Kuhn (1877–1949) riffled through his repertoire of subjects—a sylvan sunset, a burly athlete, the Maine sea coast, flowers, a bull fight—to send her good cheer.

When some one's been
laid up for a long time,
pretty sick at that, it's
not going to be easy to put
up with the long pull to
full recuperation, that's
why I feel something
should be done ___
Maybe a little still life like this

4 2 Miné Okubo 1 P., HANDWRITTEN, ILL.

to Roy Leeper *for transcription, turn to p. 214*

18 May [1971]

Painter Miné Okubo (1912–2001) is best known for
her book *Citizen 13660*, a memoir of her experience as
a Japanese-American detained during World War II.
After January 1944, she settled in Greenwich Village
and continued to paint until her death in 2001. This
flag-waving letter is part of Okubo's illustrated
correspondence with collectors Roy Leeper and
Gaylord Hall and dates from the early 1970s.

May 18th.

Dear Roy & Hall:
Your failure to see what I did in Painting stymied me but now all in the bag. a matter of Painting Integration and not design. Wow! — Work.

Wow. No doubts! Doing large. now — all moves & can do

Of course I thought I also B. Burns say "They got foxes by in...

Since Bozbrook Be assured will bring —

Mr. Mitchell opens & closes.

4 3	Dorothea Tanning	2 PP., HANDWRITTEN, ILL.
	to Joseph Cornell	*for transcription, turn to p. 214*
	29 Apr. [1948]	

Dorothea Tanning (b. 1910) met fellow artist Joseph
Cornell (1903–1972) through their mutual art dealer
Julien Levy. After moving to Arizona in 1946, corre-
spondence with Cornell became an important link to
her New York past and a source of inspiration. In this
letter dated April 1948, she reacts to a story that
Cornell had sent to her about a character named Lucie
Le Merle. A dreamy young girl (presumably Lucie)
draws back a curtain upon which Tanning writes,
"I AM SURE SHE WILL INSPIRE ME TO SOME
EFFORT TO CONVEY HER DRIFTING POETRY,
HER INNOCENTLY MAGICAL DESTINY." In his
diary entry for May 4, 1948, Cornell writes, "Received
beautiful letter from Dorothea in morning mail illus-
trating story of old Paris with jeune fille of the 1840s.
Exquisite surprise."

Apr. 29.

Dear Joseph:

You are quite right in wondering about the fate of your lovely book and I want to say at the very outset that I responded deeply to the story of Lucie Le Merle and her anguished papá. I am sure she will inspire me to some effort to convey her drifting poetry, her innocently magical destiny.

I am sorry to have to tell you that shortly after hearing from you I became ill and was obliged to go to the hospital and undergo a most grimly disagreeable operation. On the other hand, I am happily

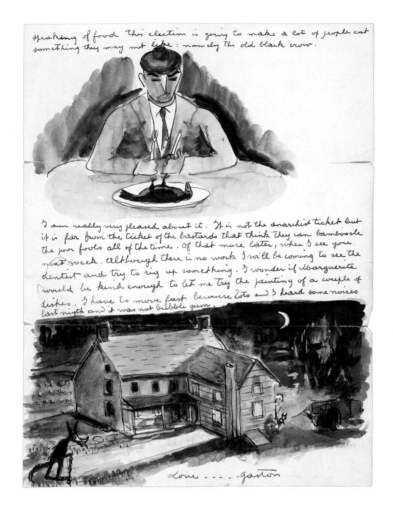

4 4	Gaston Longchamp *to* "Mr. and Mrs. Goldberg" ca. 1956	2 PP., HANDWRITTEN, ILL. *for transcription, turn to p. 214*

French-American painter and set designer Gaston Longchamp had a theatrical way of corresponding. He addresses this letter to "Mr. and Mrs. Goldberg"— presumably, for art dealer Hugh Stix and his sculptor and ceramist wife Marguerite, as the letter was among their correspondence and contains a request to paint a couple of Marguerite's "DISHES." Here, Longchamps paints a political commentary, remarking "THIS ELECTION IS GOING TO MAKE A LOT OF PEOPLE EAT SOMETHING THEY MAY NOT LIKE: NAMELY THE OLD BLACK CROW." He may have been referring to Dwight D. Eisenhower's landslide victory over Adlai Stevenson in the 1956 U.S. presidential election.

Kintnersville

Dear Mr. & Mrs. Goldberg

As you know the bottom fell out of the bull market and so I came back here with alacrity. I found Ouida very well and busily engaged garnering food in her odd Cherokee way. She sends her love to all of you. We keep the pumpkin, turkey etc because we do not want to get in dutch with a certain people or the sedmen Bros. They have a corner on the market. Beside we need our food and you may need her love.

4 5	Louis Michel Eilshemius	2 PP., HANDWRITTEN, ILL.
	to Hyman Kaitz	*for transcription, turn to p. 215*
	ca. 1933	

His personal letterhead proclaimed Louis Eilshemius
(1864–1941) to be the "MIGHTIEST MIND AND
WONDER OF THE WORLDS," the "SUPREME
PARNASSIAN AND GRAND TRANSCENDANT
EAGLE OF ART." Modesty was not one of this artist's
virtues. In response to a fan letter, he sketches a
distinctly graceless nude in his signature style and
boasts, "As a composer I rank with the German galaxy."

 While Eilshemius was a known eccentric, here his
rant suggests something beyond pure ego-mania. In
1932 his legs were crushed in a car accident. He writes,
"SINCE LAST JULY I'M LAID UP ALONE WITH
BLASTED LEGS (AUTO CRASH). CRUEL FATE."
He had given up painting and was now forced to live
as a virtual recluse, confined to his home. In this letter
he pours out his bitterness for a world unwilling to
recognize his talents.

MAHATMA

● Dr. Louis M. Eilshemius, M.A. etc.
Mightiest Mind and Wonder of the Worlds.
Supreme Parnassian and Grand Transcendant Eagle of Art.

HOURS: 10 to 11 A. M.
1 to 3 P. M.

118 EAST 57th STREET
NEW YORK CITY

A Flop!

Dear Mr. Hyman Kaitz —
Strange to say, the article
you speak of never met my eyes in
the Mirror which newspaper I read
daily, as it is more handy than the
Times, Herald etc

<table>
<tr><td>4 6</td><td>Warren Chappell
to Isabel Bishop
27 Oct. 1982</td><td>2 PP., HANDWRITTEN, ILL.

for transcription, turn to p. 215</td></tr>
</table>

Illustrator Warren Chappell (1904–1991) here writes to his long-time friend, painter Isabel Bishop (1902–1988) about his aversion to dealers, agents, and other artists' representatives. While Chappell pictures the dealer/artist relationship as a trainer leading a performing bear, his words reveal that he envied the contact that artists represented by agents maintained with their clients. Chappell was part of the impersonal business of book publishing; Bishop, in contrast, enjoyed a long relationship with Midtown Galleries in New York, outliving her first dealer, Alan D. Gruskin, and then working with his wife, Mary J. Gruskin, who became director of the gallery in 1970. In 1982, when this letter was written, Bishop's work was included in the Midtown Galleries' fiftieth anniversary exhibition.

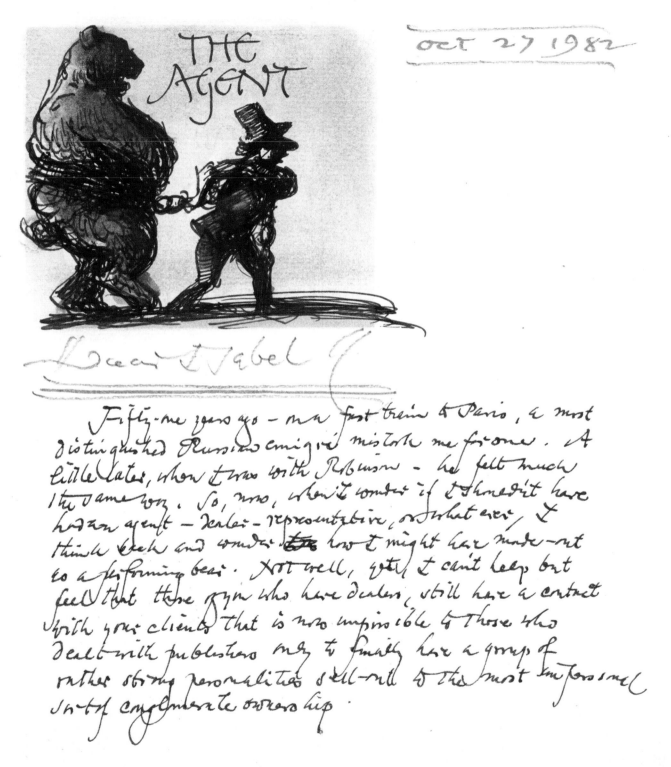

THE
AGENT

oct 27 1982

Dear Isabel

Fifty-one years ago — on a first train to Paris, a most distinguished Russian emigré mistook me for one. A little later, when I was with Robinson — he felt much the same way. So, now, when I wonder if I shoned't have had an agent — dealer — representative, or what ever, I think back and wonder how I might have made-out to a performing bear. Not well, yet I can't help but feel that those guys who have dealers, still have a contact with your clients that is now impossible to those who dealt with publishers only to finally have a group of rather strong personalities sell-out to the most impersonal sort of conglomerate ownership.

| 4 7 | Samuel Finley Breese Morse *to* Elizabeth Breese 20 and 22 Jan. 1827 | 4 PP., HANDWRITTEN, ILL. *for transcription, turn to p. 215* |

If playfulness is the mark of an inventive mind, then the illustrated letter of Samuel F. B. Morse (1791–1872) to his thirty-three-year-old cousin is further evidence of his pliant ingenuity. Morse is well known as the inventor of the telegraph, as well as the dot-dash code used to transmit words over the wire. He was also one of America's most prominent painters in the early nineteenth century and a founder of the National Academy of Design. Here, "HALF DEAD WITH FATIGUE," he attempts to "DOZE OUT" a letter before falling asleep. His words are punctuated by one small sketch of himself—snoozing in a chair, mouth open, eyes shut, limbs limp, followed by a second, of himself the next morning, lurching awake, wide-eyed and dazed. He writes,

I HAVE RELINQUISHED THE IDEA OF LECTURING AT THE ATHENAEUM THIS SEASON, AS ALL MY LEISURE TIME IS DEVOTED TO OUR ACADEMY, WHICH IS IN A FLOURISHING CONDITION.

The National Academy of Design was just two years old. Its purpose was to improve and advance art instruction. Morse, a strong advocate of academic training, was its first president.

sound — a s l e e p.

Ned Morse will understand the
marginal diagram, as it is an
attitude which he has practised
in the greatest perfection. — Good Night.

Monday morning Jany. 22. 1827.

I almost got through my letter on Saturday night,
but got asleep before I made t (not tea) so will
now go on, being wide awake, as per mark,
as the merchants say Ned Morse I
think will translate this too for you
as I am certain of having seen him
look with such a neutral stare
fifty times. — Love to all in great haste as my
dinner bell is ringing. —

Y Affectionate Cousin.
Finley 3

<table>
<tr><td>4 8</td><td>Julian Edwin Levi
to Mrs. Julian Levi
[1932]</td><td>1 P., HANDWRITTEN, ILL.

for transcription, turn to p. 216</td></tr>
</table>

In this charming get-well message to his wife, painter Julian Levi (1900–1982) takes on the persona of their dog, Victoria.

When can I welcome
you back to New York—
the old man bores the life
out of me—all I want to do is
sleep and eat —thanks for
 the jelly roll—
 I cannot tell
 a lie

 love

 Victoria

Sent to Mrs Julian Levi by her husband, during
a hospital stay. Victoria was their dog

49 Winslow Homer *to* William Macbeth 17 Mar. 1893

4 PP., HANDWRITTEN, ILL.

for transcription, turn to p. 216

A friendly yet forceful letter from painter Winslow Homer (1836–1910) to the Macbeth Gallery in 1893 reveals the delicate relations between an artist and his dealer. Homer had just completed his masterpiece *Fox Hunt* and wanted his dealer to raise its price. He observes that the work was "QUITE AN UNUSUAL AND VERY BEAUTIFUL PICTURE" and maintains that the "PRICE SHOULD BE NO OBJECT TO ANYONE WISHING IT." Homer lightens his bravado with a sketch of himself in allegorical dress, hiding his light under a bushel.

The following year, Homer sold *Fox Hunt* to the Pennsylvania Academy of the Fine Arts, accepting less for it than he had hoped. It was his first major painting to be acquired by a public institution.

Did not draw the
sketch I sent you
of this picture with
any care — so you
will be much surprised
below this line.
S.S.

Chs Thulz

Winslow Homer

x "
W.H. hiding his light under a bushel.

5 0 Yves Saint-Laurent 1 P., HANDWRITTEN (IN FRENCH), ILL.

 to Alexander Liberman *for transcription, turn to p. 217*

 7 June ca. 1970

In this letter to Alexander Liberman (1912–1999), art director at *Vogue* and later editorial director of Condé Nast Publications, French couturier Yves Saint-Laurent (b. 1936) literally uses the language of clothes as his medium. He writes affectionately to Liberman on the space of a traditional Islamic cloak worn by women in Marrakesh (where Saint-Laurent owned a home). The boldly patterned background offers a counterpoint to the elegant simplicity of his message.

le 7 Juin

Marrakech

mon Très Très cher
Alex
Je suis ici, à Marrakech
et je pense à toi
comme toujours
à Ton amitié fidèle
à Ta sincérité
J'espère te voir le plus
vite possible et t'embrasse
de tout mon coeur qui t'aime

Yves.

<table>
<tr><td>5 1</td><td>H. C. Westermann
to Clayton and Betty Bailey
17 Nov. 1963</td><td>1 P., HANDWRITTEN, ILL.
for transcription, turn to p. 217</td></tr>
</table>

In 1963 sculptor H. C. Westermann (1922–1981) and ceramist Clayton Bailey were both guest artists at the Washington University School of Architecture in St. Louis, Missouri. Bailey and his wife Betty had given a dinner party for Westermann, his wife Joanna, and the architecture students at their home. This letter constitutes Westermann's thrill-filled, high-flying thanks for the party and embodies his personal blend of fantasy, melodrama, and sophomoric self-caricature. The cryptic postscript, "AND I THINK THAT PAINT JOB YOUR WIFE DID WAS AN HERCULEAN TASK AND A DAMN GOOD GREEN JOB," refers to the painting of the Baileys's living room walls, which Betty had recently made pea-soup green (a color provided by the landlord).

5 2 George Grosz 1 P., HANDWRITTEN, ILL.

 to Erich and Eva Herrmann *for transcription, turn to p. 217*

 ca. 1940

German painter and political satirist George Grosz
(1893–1959) unleashed his expressionistic talents in this
enthusiastic welcome home note to his friend Erich and
Eva Herrmann. Grosz immigrated to the United States
in 1933 to escape Nazi Germany and taught at the Art
Students League of New York. He became an American
citizen in 1938.

202 SHORE ROAD
DOUGLASTON MANOR
LONG ISLAND, . N. Y.

Hores too you

Lieber Erich & Eva,

Welcome

HOME

hope both of you had a
nice and successful trip, and
quite some excitement the last
days about

lear Erich could you send me
a _one_ pound tin of that delicious

Love and greetings to both of you
as ever yours — George & Eva
& the boys

+ the allusion of any chance photo

+ the studio and then relieve me

the necessity of being out my

imp —

2 of canvases make me

looke very much like

Had a

great afraid he

he did not

— drawing —

fun —

you heaped too

head when you're

ugly — that everything

guys this you would no

matters like these too.

You should know, Little

how much I care for you and

CHAPTER IV

Visual Events

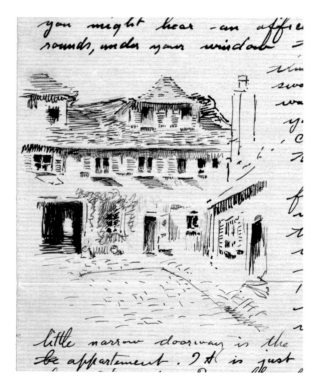

53 William Cushing Loring
to his parents
14 July 1901

6 PP., HANDWRITTEN, ILL.

for transcription, turn to p. 217

In this letter to his parents, painter William Cushing
Loring (1875–1959) describes his neighborhood in Paris
and the three-day Bastille Day celebration that was
taking place there in July 1901. He rhapsodizes,

THE STREETS ARE CROWDED WITH
PEOPLE, THE BUILDINGS A MASS
OF COLORS AND AT NIGHT PARIS IS
MAGNIFICENT, THOUSANDS OF RED
WHITE AND BLUE LIGHTS. BANDS
ARE PLAYING IN EVERY SQUARE.
ALL PARIS SEEMS TO BE DANCING.

people, some dancing
and at night Paris is magnificent
thousands of red white and blue lights.
Bands are playing in every square

All Paris seems to be dancing. I was
reminded last night of our Thanksgiving
Virginia reel. For in front of the Opera
to splendid music many had assembled

5 4	Alfred Joseph Frueh *to* Giuliette Fanciulli [21 Mar. 1913]	3 PP., HANDWRITTEN, ILL. *for transcription, turn to p. 218*

In March 1913, while the Armory Show was making sensational headlines in New York, Alfred Frueh (1880–1968) sent to his fiancée, Giuliette Fanciulli, his firsthand impressions of the Salon des Indépendants in Paris, the annual exhibition established in 1884 in response to the rigid orthodoxy of the government supported Salon. He writes, "WE'VE GOT A SHOW HERE TOO WITH PICTURES IN GEOMETRY BY ARTISTS WHO LOOK AT THINGS THROUGH A SAUSAGE GRINDER." Like many artists, Frueh was slow to embrace cubism. He includes two views of cubist canvases and compares them to what he saw when he once rode down the courthouse steps on his bicycle.

of promise cases. I can tell you better
you are when I see you anyway.
say, Juliette. We've got a show here too with
in Geometry by artists who look at things
a sausage grinder
al Salon of the
des Independents
n some 2500
us and about 100
5″ in the show.

mber when I was
back in Lima ①
to ride down the
ouse steps on a
I'm sure every time I hit one of
ne steps on my way down I saw a
of these same canvasses... That was
rs ago. and they say they are doing some
er. There's some good stuff out
though but the average — ugh.
ny out again.

5 5	John Sloan	2 PP., HANDWRITTEN, ILL.
	to Walter Pach	*for transcription, turn to p. 219*
	9 June 1920	

During his summers in Santa Fe, New York painter
John Sloan (1871–1951) found a change of pace and
fresh inspiration. In this letter to artist and art writer
Walter Pach (1883–1958), Sloan sketches his Santa Fe
studio complete with local models and large moths.
An American Indian with a long braid and cowboy hat
enters asking, "YOU WANT ME POSE?" Happily
immersed in the foreign culture of Santa Fe, Sloan felt
"FAR AWAY" from New York; he writes,
 I HAVE STARTED PAINTING—NEARLY
 A WEEK WENT BY BEFORE I FELT
 READY—A CORPUS CHRISTI PROCESSION
 THROUGH THE ROADS AND OVER THE
 BRIDGE SUNDAY—GAVE ME A THEME.

big moths
very common

"you want me pose?"

105 Johnson St
Santa Fe N. M.
June 9 – 1920

Dear Pach :—
 Well! here we are again in the old town — it looks
just the same we feel the altitude more this year
than last I suppose because we climbed more slowly
by automobile last year we took three days to get
here and were delayed a mile east of Lamy for 3 hours
very provoking, for we would have arrived on the dot of
schedule time if a freight wreck in Apache canyon
had not occurred ahead of us.
 Dr Hewett I have seen just once for a few minutes
he seemed glad to welcome me back

| 5 6 | Antoine de Saint-Exupéry *to* Hedda Sterne ca. 1943 | 1 P., HANDWRITTEN, ILL. *for transcription, turn to p. 219* |

for transcription, turn to p. 219

Antoine de Saint-Exupéry (1900–1944) sent this note to his friend painter Hedda Sterne (b. 1916) hoping to meet with her. He mentions a great event—the completion of his masterpiece *The Little Prince*, which is both a tale of adventure and a meditation on friendship.

A former fighter pilot, Saint-Exupéry fled to the United States when the Germans invaded France in 1940. He had hoped to fight for the United States but was told that he was too old to fly. To console himself he wrote *The Little Prince*, drawing on his experience flying mail to remote settlements in the Sahara.

5 7	Dale Chihuly	4 PP., FACSIMILE TRANSMISSION, ILL.
	to Italo Scanga and Su-Mei Yu	*for transcription, turn to p. 220*
	1 Aug. 1995, 1:02 p.m.	

for transcription, turn to p. 220

Artist Italo Scanga (1932–2001) was like a brother to
Dale Chihuly (b. 1941), who is known internationally
for his work in glass. Chihuly often sent him illustrated
faxes as a way of keeping in touch. In 1995 he sent
Scanga and his companion Su-Mei Yu his preliminary
plans for a project in Ireland, a fanciful series of twenty
installations on the grounds of Lismore Castle. The
overlapping lines of Chihuly's drawing mimic the
transparent layers of his glass sculptures.

Ireland Part II Lismore Castle.
CHIHULY STUDIO 509 NE NORTHLAKE WAY SEATTLE, WA 98105
TEL: 206 632 8707 FAX 206 632-8825

Crystal
out of the
Blackwater
River.

N° 039

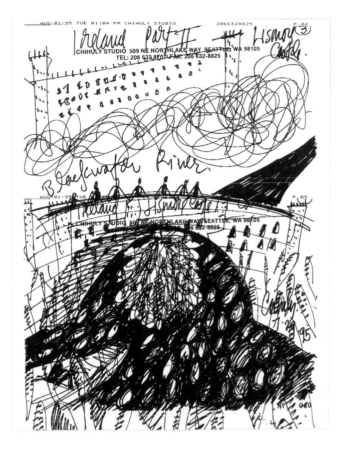

Ireland Part II Lismore Castle.
CHIHULY STUDIO 509 NE NORTHLAKE WAY SEATTLE, WA 98105
TEL: 206 632 8707 FAX: 206 632-8825

Blackwater River.

Ireland Lismore Castle
CHIHULY STUDIO 509 NE NORTHLAKE WAY SEATTLE, WA 98105
206 632-8825

N° 040

5 8	Max Bohm	6 PP., HANDWRITTEN (IN GERMAN), ILL.
	to Emilie Bohm	*for transcription, turn to p. 220*
	12 May 1889	

for transcription, turn to p. 220

In 1889 painter Max Bohm (1868–1923) writes to his mother describing his first "VERNISSAGE" at the Paris Universal Exposition of 1889:

> I WORE A SIMPLE PRINCE ALBERT, BLACK KID GLOVES, WHITE TIE AND HIGH HAT AND DID NOT LOOK BAD (PAS MAL). WE SPENT FIVE HOURS IN THE SALON AND AMUSED OURSELVES GREATLY....NEVER IN THE WHOLE WORLD HAS SUCH A WORLD EXHIBITION BEEN ARRANGED AS THIS ONE....EVERYTHING IS DONE IN ALMOST UNBELIEVABLE SPLENDOR AND ARTISTIC ELEGANCE. ONE CAN SEE EVERYTHING THE WORLD HAS TO OFFER IN ART, SCIENCE, CURIOSITIES, AND INDUSTRY. YOU CAN'T PICTURE THE GRANDEUR AND SPLENDOR TO BE SEEN NOW IN PARIS. AND ALL THAT FOR 14 CENTS.

A "vernissage" signals a private preview, or opening of an exhibition. In French it literally means "varnishing day," the day traditionally set aside for artists to put finishing touches on their paintings and to apply a final coat of varnish.

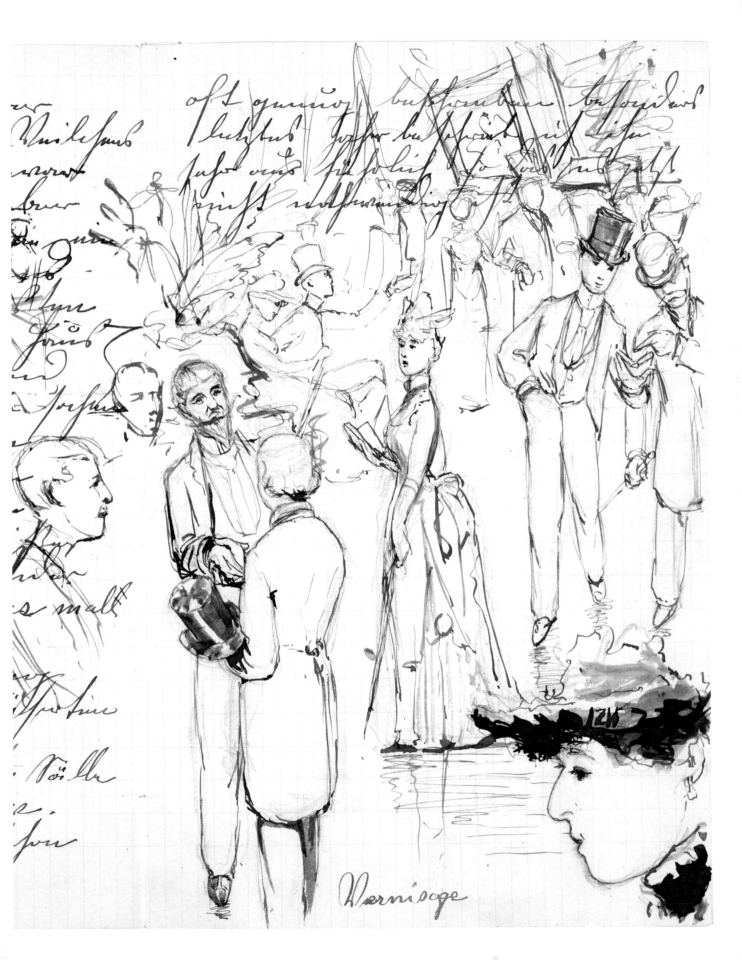

Vernisage

5 9	Winslow Homer *to* George G. Briggs [19 Feb. 1876]	7 PP., HANDWRITTEN, ILL. *for transcription, turn to p. 221*

During the Civil War, Winslow Homer (1836–1910) was contributing artist for *Harper's Weekly.* In this letter to George G. Briggs, Homer recalls his encounter with sharp shooters in a peach orchard at the battle of Yorktown in 1862. He writes,

> I WAS NOT A SOLDIER BUT A CAMP FOLLOWER & ARTIST. THE ABOVE IMPRESSION [REFERRING TO HIS SKETCH] STRUCK ME AS BEING AS NEAR MURDER AS ANYTHING I EVER COULD THINK OF IN CONNECTION WITH THE ARMY & I ALWAYS HAD A HORROR OF THAT BRANCH OF THE SERVICE.

Homer's illustration *The Sharpshooter* appeared in *Harper's* on November 15, 1862.

When they were in
a peach orchard in
front of Yorktown in
April 1862 -

this is what I saw -

I was not a soldier -
but a camp follower
& artist, the above

6 0	Edgar Spier Cameron	4 PP., HANDWRITTEN, ILL.
	to his parents	*for transcription, turn to p. 222*
	7 Aug. 1884	

On August 7, 1884, painter Edgar Spier Cameron
(1862–1944) wrote to his parents with great news. He
had passed the École des Beaux-Arts's rigorous exam.
"I FELT LIKE GETTING DRUNK OVER THE
RESULT TO-DAY," he writes, "BUT THERE WAS
NO ONE OF THE BOYS IN TOWN SO I WENT AND
PURCHASED A LONESOME 'DEMIE' OF MUNICH
BEER AND WRAPPED MYSELF AROUND IT."
Here he draws himself with a spring in his step, about
to enter the École. The portfolio under his arm identifies
him as a former student of Gustave Boulanger and Jules
Lefebvre, both of whom taught at the Académie Julian.

Paris Aug 7 84

My Dear Parents;

(autrefois)
Eleve de Monsieurs
Boulanger et . . Lefébure,

God bless Our little Home.

Peinture Architechcure Sculpt

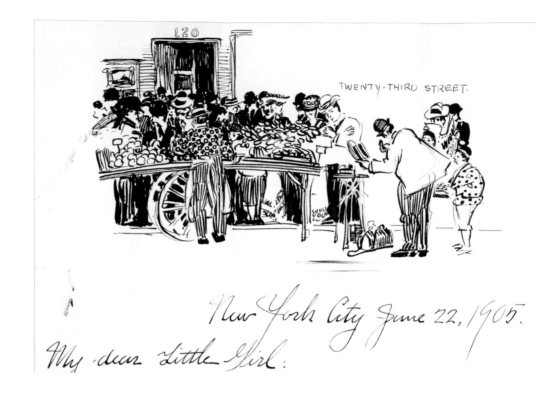

New York City June 22, 1905.

My dear Little Girl:

| 6 1 | Rutherford Boyd *to* his fiancée 22 June 1905 | 8 PP., HANDWRITTEN, ILL. *for transcription, turn to p. 222* |

for transcription, turn to p. 222

In a letter describing his New York studio to his fiancée, illustrator Rutherford Boyd (1882–1951) ends one page with an invitation. "YOU MAY COME IN," he writes, then continues on the next page, "AND LOOK OUT!" The spectacular view that unfolds is from a top floor on East 23rd Street, an area populated with artists at the time. Exacting illustrations such as this one, earned Boyd a strong reputation. His work appeared in *McClure's, Ladies Home Journal, Appleton's, Century, Success, Collier's,* and other popular magazines.

...ming to look like a stud... ...ear little girl.

You may come in

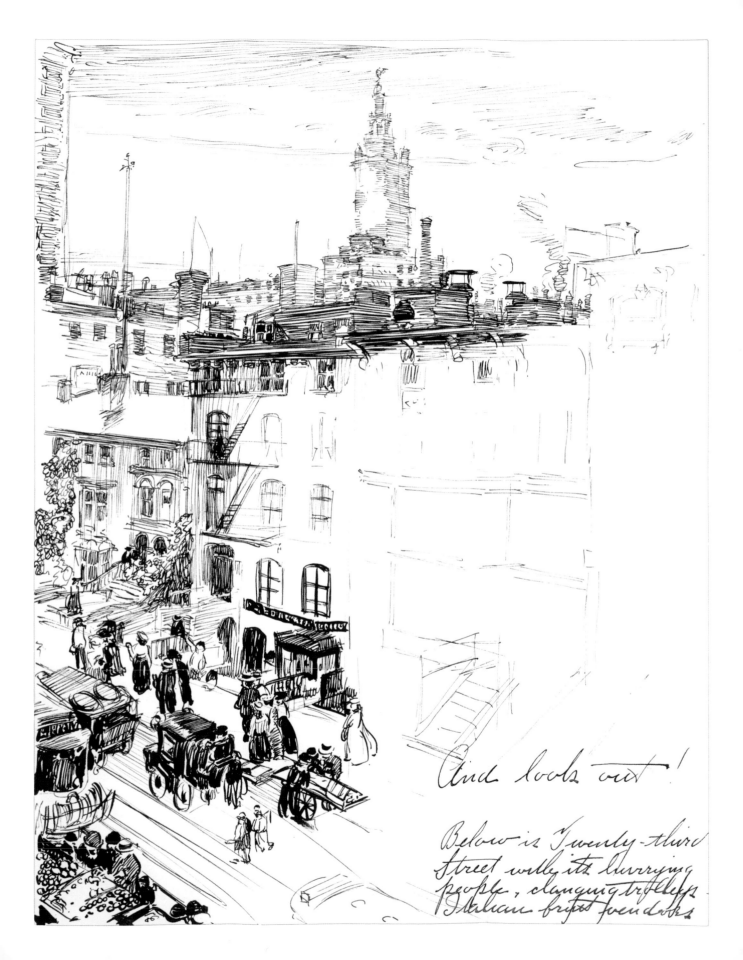

And looks out!

Below is Twenty-third
Street with its hurrying
people, clanging trolleys
Italian fruit vendors

6 2	Lyonel Feininger	8 PP., HANDWRITTEN, ILL.
	to Alfred Churchill	*for transcription, turn to p. 223*
	7 Oct. 1890	

Lyonel Feininger (1871–1956) made a practice of illustrating his letters. "I GENERALLY AVERAGE 2 PICTURES ON EACH PAGE," he writes to his friend Alfred Churchill, encouraging him to reciprocate in kind. His tiny, meticulous pen-and-ink drawings take the form of amusing self-caricatures.

and edit me a newspaper once a month or still oftener if you can! You are the best artist in your Place now, a king, a prophet in your own land! Uphold the distinction and sort of keep yourself going by just occasionally dashing off a charming little sketches in your letters! You may consider me the Belgian Correspondent to your Paper! Do not try to make a very satisfactory sketch with ordinary ink, however, but for your own satisfaction as well as mine, get a bottle of chinese ink! what useful, invaluable people these chinamen are to us artists! What should we do with out them? Chinese ink, chinese white! Yesterday and the day before, we listened, in the church belonging to the college, to 8 sermons, at the rate of 4 a day, each sermon lasting an hour. It was for the purpose of softening the sinners for confession, which takes place to-day. We caught it right hot from the bat, I tell you. But I do not confess, being a protestant. Today, I believe we only have 3 sermons. Now my dear good old man, my brother, must I close? yes! but only for want of time. Even now I am fortunate in having finished 8 Pages. You will not always get that much, I fear. I enclose a little sketch on tone paper: by the way, I use 3 shades, light, medium and dark, in keeping with the "stimmung" (A good old Berlin Academy expression that, isn't it?) I use also "Camden white ink" in bottles, costs 75 Centimes, and can be diluted as much as you like. Well! with best love to (excuse me, but this with me now and hear from you, I

your old Leo now closes, your wife and blamed pen gets away then. Hoping soon to am your old friend Leo.

"GOOD-NIGHT!!" "IN IMITATION OF MY OLD STYLE."

P. S. I never rub out lead pencil marks from the sketches! they are softer so.

6 3 Man Ray
 to Julian Edwin Levi
 26 June 1929

 3 PP., HANDWRITTEN, ILL.

 for transcription, turn to p. 226

Imagine sitting at Le Select, an American bar on the Boulevard Montparnasse in Paris in 1929, just months before the stock market crash. Gathered around a table are surrealist Man Ray (1890–1976), his American friend sculptor Homer Bevans, and a gentleman named "Cyril E." They are having a drink and a sketch and are collectively writing to painter Julian Levi (1900–1982) about their favorite pastimes—wine and women. As the sun sets on the city, Man Ray waxes poetic, "THE BLUE LIGHT IS CREEPING OVER BLVD. MONTPARNASSE AND THE SPARROWS ARE CHIRPING IN THE TREES WAITING FOR A WINDFALL."

1929

from MAN RAY

"Le Select" American Bar

99, Bd MONTPARNASSE (coin Rue Vavin)

TELEPHONE : FLEURUS 38·24
R. C. SEINE 304.673

26th of June 1929

The Blue Cigar is creeping over Bed.

Dear Julian -
Last year's 1928's wine harvest is supposed to be the very finest in the last fifty years. And Cyril is just sitting about anxiously waiting for it to age a bit and the other night after having laid in a small barrel of Clos Vougeot — turned his clock ahead a year or so to see if that might help.

I'll be over late this summer to fetch you back.

As always Man -

over

Montparnasse and the sparrows are chirping in the trees waiting for a windfall.

Dear Julian I have seven tall blondes and one with 14 digitits and one with Sapphire Garters, forces

Dear Julian, 1929 and fill a bit of wine eat but we are getting old and brave a decade and ripe

Cyril Co

<table>
<tr><td>6 4</td><td>Ione Robinson
to Julian Edwin Levi
21 Jan. 1937</td><td>2 PP., HANDWRITTEN, ILL.

for transcription, turn to p. 226</td></tr>
</table>

In January 1937 muralist and illustrator Ione Robinson (1910–1989) spent several months in Florida with her young daughter Anne. Here she entices painter Julian Levi (1900–1982) to visit, exclaiming, "THE SEA IS WONDERFUL—THE AIR SO CLEAN AND FULL OF SUNLIGHT—AND THE SEA SHELLS—I HAVE NEVER SEEN SUCH BEAUTIFUL COLORS." She also includes images of shells and of herself and her daughter in bathing suits, lounging at the beach.

Jan. 21, 1937 —

Dearest friend —

I always enjoy talking with you — and so — I am writing immediately. I have spent most of today talking of you — & most of last Wednesday — as a matter of fact I feel that you are very near me. The other evening when I saw several of your early paintings — with the familiar Julian E. Levi in the lower right hand corner — I felt a sudden nostalgia — Oh — darling — I wish you were here — !

Pearson Conrad & his wife — I love them — they love you — They really do Julian — & for me — it is always a joy to have people fond of me — so I hope that it will make you happy to hear this.

Their home is lovely — very simple — & the children such nice unspoiled — children. I was amazed to find that you had carved a rather Persian — Gauguinish panel — over their fireplace. It showed — real talent — a sensitive — one — & that is the way I always think of you. —

Pearson — stayed by me all morning in his office — while I wrote involved legal letters — we went to lunch across the street — & then I left for our all afternoon session with the lawyer. This evening at sun-down I joined him again for cocktails on their terrace. — You were there with us ———

(In spirit.)

65 William Trost Richards 4 PP., HANDWRITTEN, ILL.
 to George Whitney *for transcription, turn to p. 226*
 30 July 1876

Landscape and marine painter William Trost Richards
(1833–1905) wrote to his major patron George Whitney
(1820–1885), a Philadelphia industrialist, about the
pictures he was producing in and around Newport,
Rhode Island. Richards, who was associated with the
American Pre-Raphaelite movement, was known for
his meticulously faithful renderings of nature. In
his letters to Whitney, he would frequently enclose
miniature landscapes such as this one, which he called
"COUPONS," so that Whitney could see a subject in
advance and order a painting.

Newport July 30" 1876

My dear Mr Whitney,

The coupon was regularly
"detatched" last Sunday, but I have
had no earlier chance of writing –
The week has been very busy –
the cooler weather after our good
rain of last Sunday (ending an 8 weeks
drought) made me feel more like
working and I have successfully
laid in a 34 x 60 picture of Conanicut,
made 2 drawings – spent one day
on "Gooseberry Island" and received
numerous calls – The Conanicut
picture has interested me most of
all and I send a little sketch
like those in the Illustrated Catalogue

The view
is from
the walls
of old
fort dumpling
looking toward
the S.W.

The time afternoon rolling clouds

| 6 6 | J. Kathleen White
to Ellen Hulda Johnson
1 Sept. 1986 | 1 P., HANDWRITTEN, ILL.

for transcription, turn to p. 227 |

In this September 1986 letter to Oberlin College art historian Ellen Hulda Johnson (1910–1992), artist and writer J. Kathleen White (b. 1952) used a computer to draw her imaginary dog, cat, and bird. She writes, "THESE HOUSEHOLD PETS HERE PICTURED COME FROM COMPUTER LAND." White was using an early version of MacDraw. She notes that her other correspondent, writer Daniel Pinkwater, "COMPOSES ALL HIS PICTURE BOOKS ON COMPUTER."

Dear Ellen,

August...
NO! September! 1st!
1986

I'm sorry I haven't returned your call. I have often thought of it but if the truth be known, it would be an easier matter for me to jump on a plane + come to see you in person than to make a phone call.

How are you though. My phone machine now picks up on the fifth ring + if I'm home I always pick up before that. — by the third ring.

busy schedule this nothin planned! about third novel short essays. + composed ^a lay-out of children's picture-story book —

3 Pigs. My brother for his permanent (he's been at it of May! Length of consulate es back log) at my place which is these household pets here computer land. My composes all his picture-method is fused because retardation struggle Hope all well with you

Do you have a fall? I got I'm thinking though ... + I've just for another

a remake of the who is still waiting work visa to Australia since the last week wait typical for the

HE has set up this computer an incredible device pictured come from correspondent D. Pinkwater books on computer...the it forces a kind of spastic needed to make image

Luv, Kathleen

6 7	Gio Ponti	1 P., HANDWRITTEN, ILL.
	to Esther McCoy	*for transcription, turn to p. 228*
	28 Apr. 1968	

In April 1968, just weeks after the assassination of
Martin Luther King, Jr., Italian architect and designer
Gio Ponti (1891–1979) wrote to architectural historian
Esther McCoy (1904–1989) a heartfelt note about
America's struggles. He decorated the letter with an
arabesque of finger prints.

My dear, dear Edtties

I am not able to answer with
a letter so marvelous as you wrote
me. But I/we are sure you
will come here for the triennale,

I am thinking always about
America, your America that I love
so much, America, your America is
a big country, which will go out
from his bad situation of now, by (or that?)
the bignell and the strongnell, and
the ideality of his civilitation,

Giulia is in Milan for
the "fanghi" and I, alone, kiss
you allo for her,

Love

28/4
08

| 6 8 | Kenyon Cox
to his parents
7 Feb. 1877 | 2 PP., HANDWRITTEN, ILL.
for transcription, turn to p. 228 |

In this youthful letter to his parents, the painter and
art critic Kenyon Cox (1865–1919) complains about
the lack of inspiration, suitable models, and opportunities
for advancement at the Pennsylvania Academy of
the Fine Arts in 1877. He makes a case instead for
studying in Paris and includes this elaborately detailed
drawing—an homage to Spanish artist Mariano Fortuny
(1838–1874)—possibly to demonstrate his dedication
and skill. That fall, Cox got his wish. He left Philadelphia
for Paris, where he studied with Jean-Léon Gérôme
(1824–1904).

247 Elton Lane —
Phila — Feb — 7th 77

Father + Mother,

You urge me to work, dear
mother. To digging at the tech-
nique when without an in-
spiration + c — The very
vexation of it is that I
can't work. I want
to work. I know that
work is everything, and
I am tied down so that
work to any profitable
end is impossible. I
spend forty dollars for
canvass and materials
at the first of this month
I had several good ideas
and now Brennan can't
spare the time to stand,
the fisher model has gone off on a cruise, and I haven't enough
left to spare to hire a model if I knew a good one. What can I
I must either sit and do nothing, or go back to the exasperating
work of evolving pictures from my inner consciousness, and after
wrought up by sketching from life and seeing a good model for
week or two this last is almost impossible. It is not that

1877.

~ Sleep ~ ming
uctly!

That's a sample of the stuff my A B.
through my head all night god thing & would
me crazy. I know as parallel with C.D.
work in the mor & Beethovens Sonatas
and day for near running parallel with G H &
He will soon start up again
else &c &c.

man was very foolish to waste so much
his trill. He ought to have started on the
important thing & kept only to those curves
and parts of curves that are taking him up the
test to A B. The important thing advances him
will the little things without his knowing it or it
got some trouble & besides as he gets right close
six yards much better is he able to judge of
this I am going clearer does he see all the
corner of (pardon last to A B where slow.
instead of a seven dozback & takes
umbrella with a spike you almost straig
except where the ground is soft.

CHAPTER V

Graphic Instructions

6 9 Alexander Calder
 to Ben Shahn
 24 Feb. 1949

2 PP., HANDWRITTEN, ILL.

for transcription, turn to p. 228

With his invitation to artist Ben Shahn (1899–1969), Alexander Calder (1898–1976) enclosed a map to his home. Everything that Calder created—from his wire portraits, paintings, mobiles, and stabiles to his toys, jewelry, and even this utilitarian set of driving instructions—is infused with his fascination with abstract elements poised in balance and harmony.

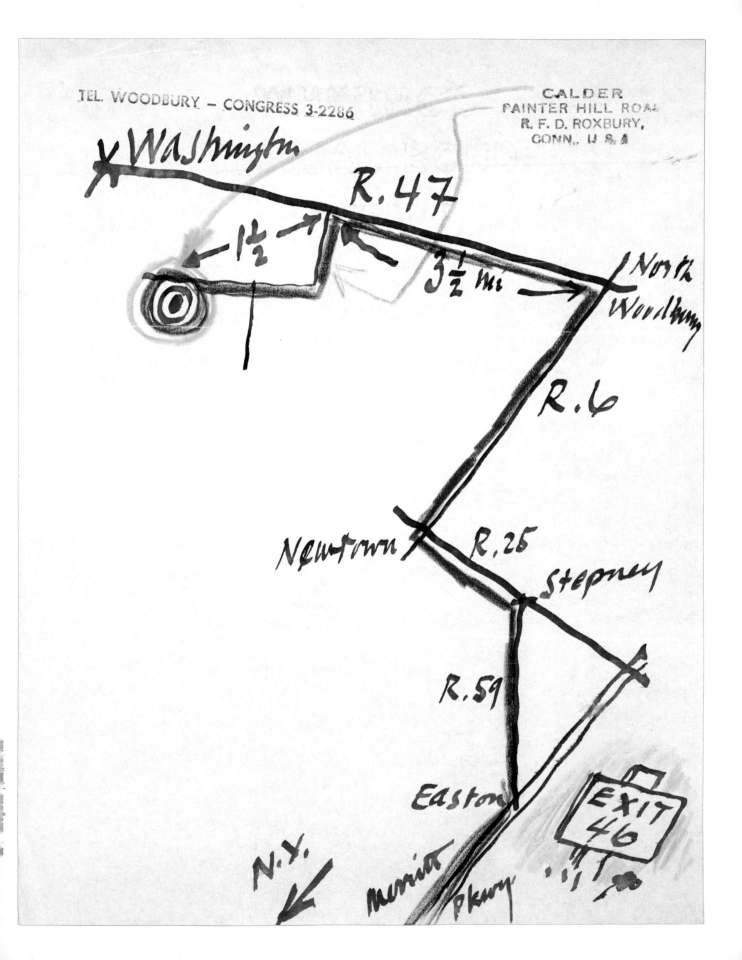

TEL. WOODBURY — CONGRESS 3-2286

CALDER
PAINTER HILL ROAD
R. F. D. ROXBURY,
CONN., U S A

Washington

R.47

1½

3½ mi

North
Woodbury

R.6

Newtown R.25

Stepney

R.59

Easton

N.Y.

Merritt

Pkwy

EXIT
46

| 7 0 | Andrew Wyeth
to Robert Macbeth
23 Dec. 1937 | 2 PP., HANDWRITTEN, ILL.

for transcription, turn to p. 229 |

Andrew Wyeth (b. 1917), today one of America's most
widely appreciated painters, had his first exhibition
at the Macbeth Gallery in New York in October 1937,
when he was only twenty. In this letter to his dealer,
Robert Macbeth, Wyeth makes a sketch of his water
color *The Bay* to show exactly which painting he took
home "WITH THE REST OF THE DISCARDED
WATER COLORS."

Mr. Robert W. Macbeth

New York City

My Dear Mr. Macbeth :

The large water color
called "The Bay" (No. 8) I brought
home with the rest of
the discarded water colors.

The composition of the water color called "The Bay"

<table>
<tr><td>? 1</td><td>Walt Kuhn
to Vera Kuhn
[14 Dec. 1912]</td><td>4 PP., HANDWRITTEN, ILL.

for transcription, turn to p. 229</td></tr>
</table>

In this letter of December 1912, Walt Kuhn (1877–1949) describes the pine tree logo developed for the upcoming Armory Show of 1913, the first exhibition of modern European art in the United States. Kuhn conceived the logo as a symbolic declaration of independence from the staid art of the American establishment. He writes:

WE HAVE ADOPTED AN EMBLEM—
TAKEN FROM THE OLD PINE TREE FLAG
OF THE REVOLUTION. I GOT THE IDEA
ONE MORNING IN BED. [ARTHUR B.]
DAVIES MADE THE DRAWING AND
WE'LL HAVE IT ON STATIONARY [SIC],
CATALOGUES, POSTERS AND EVERY-
WHERE. WE ARE ALSO GOING TO HAVE
CAMPAIGN BUTTONS—HERE IS THE
DESIGN=[SKETCH] IT WILL BE ABOUT
THIS SIZE AND VERY NEAT WE ARE
GOING TO GET THEM BY THE THOUSANDS.
GIVE THEM TO EVERYBODY—FROM
BUMS TO PREACHERS—ART STUDENTS—
BARTENDERS—CONDUCTORS ETC.

it will be about this
and very neat

you are going to get
by the thousands - give them t[o]
every body - from bums to pre[s]
art students - bartenders - condu[c]
etc - ought to make an im[mense]
hit - and get every body askin[g]
questions - This button busi[ness]
is a secret, and will have to b[e]
pulled off on the quiet, as som[e]
of the fellows might kick - a[nd]
they are out its no use to kic[k]
going to send buttons & poste[rs]
Prendergast - Boston.

7 2	Bolton Coit Brown	3 PP. EXCERPT [20 PP.], HAND-
	to his parents	WRITTEN, DRAFT, ILL.
	25 [–27] June 1888	*for transcription, turn to p. 230*

In 1888, Bolton Coit Brown (1864–1936) wrote a lengthy letter to his parents illustrating his scheme for keeping cool outdoors while sketching *en plein air* in Scotland. He writes,

> GET THE IDEA? JUST TIE YOUR FOUR STRINGS TO ANYTHING HANDY OR PUT IN PEGS FOR THEM, THEN CUT A SEVEN FOOT STAFF AND HOIST IT UP UNDER THE MIDDLE AND THERE YOU ARE AND IT WILL BE RAIN PROOF TOO IN MILD WEATHER.

This inventive painter, who taught at Stanford University and excelled at lithography as well as mountain climbing, also designed an adjustable easel for painting in mid-stream.

spike. Bah! I would n't take it if they'd give it to me. Here is a picture of my scheme as I see it realized in my mind's eye

Get the idea? — Just tie your four strings to anything handy or put in pegs for them then cut a seven foot staff and hoist it up under the middle and there you are and it will be rain proof too in mild weather. This institution will cost about 19 d. string and all and may be carried in the pocket.

About noon I went again to the Exhibition and again gave everything the dead cut in favor of the pictures.

I know now why I did n't see many pretty girls on the Street Monday. They were all at the Ex... that's where they keep themselves

7 3 Thomas Eakins
to Fanny Eakins
13 Nov. 1867

4 PP., HANDWRITTEN, ILL.

for transcription, turn to p. 230

In this letter, painter Thomas Eakins (1844–1916), who at age twenty-three was studying at the École des Beaux-Arts in Paris, gives advice and encouragement to his nineteen-year-old sister Frances, who was struggling with her piano instruction. Eakins writes, "AS YOU APPROACH PERFECTION IN YOUR PLAYING YOUR PROGRESS MUST NECESSARILY BE VERY SLOW." He uses a mathematical problem to make his point: line XY (the aspiring musician) progresses in a steady arc toward AB (perfection), but as XY nears AB, it levels out. The lines never converge. They go on forever, nearly parallel, never touching. Eakins urges his sister to find a new curve—a new way of practicing as a quicker means of achieving her goal. Like Eakins's later portraits, his formal and precise letter expresses the underlying tensions of an unattainable perfection.

Piano playing is made up of hundreds of things but the whole is motion & can of course be represented mathematically. We will take some of them. Let going along this big line **AB** be piano playing perfect which no man ever did ever could or should ever want to. He had better cry for the moon. It would be of more use to him.

A ——————————————————————————— B

C ——————————————————————————— H

E ——————————————————————————— F

c ——————————————————————————— D

O

Keith:— 20 May /47
You sound like a couple of
beach-combers (with car +
ship, of course. Thrown in)
 Edna:— would you like
 something like this
 ⅛" square gold wire.
 It might be pretty
 heavy (twice as.
 much as silver)
 about
 Louisa has similar
 bracelets in silver, +
 slides her thumb
 through the opening
←Edna→
If you don't like this idea, I
suggest something else.
 They can go the other way, but it
 isn't as elegant. Though easier

7 4	Alexander Calder	2 PP., HANDWRITTEN, ILL.
	to Keith Warner	*for transcription, turn to p. 231*
	20 May 1947	

Alexander Calder (1898–1976) is best known for his
mobiles, but he also made toys, utensils, and jewelry. In
this letter of May 1947 to collector Keith Warner, Calder
shows his ideas for a bracelet of gold wire for Mrs.
Warner.

to get into.

Anyway send me the circumference of your wrist, and approx. shape of section

I think I'll make something in silver + send it to you to verify, + you return it with remarks.

But send your dimensions!

Love to you both

Sandy

I, am in "Cahiers d'Art"

June 6 / 36
CALDER
PAINTER HILL ROAD
R. F. D. ROXBURY,
CONN., U.S.A.

TEL. & TEL. WOODBURY 122-2

Dear Agnes
From your list of colours you must be a parcheesi hound. But its purple, not blue

I too, am very fond of the parcheesi

& colour scheme i.e. the size (area) + intensity of each colour (I guess you get it!)

Please do send the things back to New York &

You can have the one from Hartford for 100—

But if you make me work in pastel shades its 125—

(I hope this wont create a dilemma) And your credit can be quite long drawn out and gentle

75 Alexander Calder 4 PP., HANDWRITTEN, ILL.
to Agnes Rindge Claflin *for transcription, turn to p. 232*
6 June 1936

In this 1936 letter Alexander Calder (1898–1976) writes to Agnes Rindge Claflin (1900–1977), educator, collector, and director of the Vassar Art Gallery, showing her the "PARCHEESI" colors of one of his pieces.

3/ I'm too much of
a truck driver already
to come over
— you must excuse
me! — But there
seems to be so much
time spent concentrating
on keeping out of
the gutter that at
times I hate the car.

I fy you go to
Middletown via Hartford
you certainly circum-
navigate us with
a vengeance !
Next time
go thru New Milford
and follow my map

4

New Milford

Bridgewater

stone dirt road

Roxbury

4 mi

hills

Bring miss Lowell

Yours

Sandy

CALDER
PAINTER HILL ROAD
R. F. D. ROXBURY,
CONN., U.S.A.

TEL. & TEL. WOODBURY 122-2

7 6 Thomas Hart Benton 1 P., HANDWRITTEN, ILL.

to James Brooks *for transcription, turn to p. 232*

5 Aug. 1933

With a stick figure as his stand-in, regionalist painter and muralist Thomas Hart Benton (1889–1975) gives painter James Brooks (1906–1992) some practical tips on copying from large to small format.

Childmark Mass. Aug 5th/33

Dear James Brooks ———

 To get a big thing to appear like a little thing — place the small sketch at such a distance from the large canvass or panel that the objects or spaces on the two appear to be the same. Even though more detail is added to the large the general effect should be ~~the same~~ alike for each.

 Give my best to Bert. I wish you two the greatest success with your undertakings. Let me know about them.

 Yrs

 Thomas H. Benton

7 7 Thomas Eakins
 to Alexander Francis Harmer
 9 Nov. 1882

2 PP., HANDWRITTEN, ILL.

for transcription, turn to p. 232

Thomas Eakins (1844–1916) was one of the first artists to embrace photography as a means of studying form and movement in the service of painting. In this 1884 letter to his former student Alexander Francis Harmer (1856–1925), Eakins explains how to make a camera. He also shows his tenderness toward Harmer, admonishing him to eat well: "KEEP YOUR BELLY FULL OF GOOD WHOLESOME FOOD & CONSIDER MY SHARE OF THE CAMERA A PRESENT." Eakins gained a reputation for freely advising and aiding his most promising and professional students.

Nov. 9. 84.

My dear Harmer.

I am very glad you got all your things at last. They went off in a great hurry. You must buy yourself a little wheel for 25 cents to cut glass with and make all your experiments of toning etc on small pieces of plates. I cut 20 square inches out of my 4x5 plate. I have made for a

piece of wood the, cigar box wood is easily worked, & cut it the exact size of a plate & then make a hole in the middle of it the size for the size I want

of my experimental pieces & on the back I fasten 4 little strips on corner to keep the piece from dropping through. CC are little springs brass to slide over the corner to hold plate but piece of plate. springs not necessary pins wood or tacks would do. This is a great saving of time chemicals & plates. If you have a single plate cut into 20 pieces you are not afraid to experiment.

The piece of wood you understand takes the place of the plate in the plate holder & presents instead of a whole plate only a piece of a plate & just flush of as in its middle its face flush with the best wood.

Anything well do to make the thing of wood hard rubber sheet brass or most anything.

You should make yourself a drop shutter like Tommy Anshutzs'. a simple drop

A piece of wood EE with a hole in it & fitting on tube. A piece of hard rubber, wood or pasteboard with an opening in it to slide past the opening in wood

7 8 John Sloan 1 P., HANDWRITTEN, ILL.

to Antoinette M. Kraushaar *for transcription, turn to p. 233*

29 July 1945

In 1916 John Sloan (1871–1951) began a long relationship with Kraushaar Galleries and its founder, John F. Kraushaar (1871–1946). In this 1945 letter to Kraushaar's daughter Antoinette, who had taken over the gallery from her father, Sloan invites her to pick up a painting from his Chelsea studio. He provides detailed instructions, sketching the storage racks so that Antoinette can easily locate the piece— *Nude in the Bedroom*, from 1929. The painting was to be exhibited in the Philadelphia Press Exhibition at the Philadelphia Museum of Art in October 1945.

A painting by Sloan of 1947–48, titled *Exploring the Unsold*, features a nude woman standing in front of the same painting rack in the artist's studio—a reminder that sales could be slow despite years of perceived success.

Santa Fe July 29/45
PoBox, 1067.

Kraushaar Gallery :—

Dear Antoinette :

If it is not too much trouble I would
be glad to have you go to the Chelsea
and have them open my studio and get
the framed painting "Nude in Bedroom"
for Philadelphia

West Wall

← Curtains

↑ Nude in Bedroom framed
(Shelf 3 C-D)

Here is a sketch which will (according to Helms
Catalog) enable you to find it easily

You can show this letter to the Chelsea
Manager Mr Bard whom I authorize
hereby to let you enter and obtain the
painting

Sincerely yours

John Sloan

g *megilp* — to Maroger —

UNIVERSITY OF WISCONSIN
EGE OF AGRICULTURE
MADISON, WISCONSIN

June 17, 1942

Black oil
5% litharge

mastic
(1- mastic) by weight
(2- turps)

y much for your information. The new
and transparent as a piece of coal.

ation of black oil mastic to be used
w varnish and gum arabic? No —

harge black oil I have been using
w varnish and gum arabic considered

I called said page, regarding *megilp* — to Maroger —
he said, that it was not the same —
The oil being different

UNIVERSITY OF WISCONSIN
COLLEGE OF AGRICULTURE
MADISON, WISCONSIN

JOHN STEUART CURRY
ARTIST IN RESIDENCE

June 17, 1942

black oil
5% litharge

mastic
(1- mastic) by weight
(2- turps)

Mr. Reggie Marsh
1 Union Square
New York, New York

Dear Reggie:

Thank you very much for your information. The new
medium is as clear and transparent as a piece of coal.

(1) Is this combination of black oil mastic to be used
with the yellow varnish and gum arabic? No —

(2) Is the 10% litharge black oil I have been using
with the yellow varnish and gum arabic considered
dangerous?

(3) If you have given up using gum arabic and yellow
varnish, what is the reason? — This is easier to handle
& more luminous

(4) What does Rubens think now? — He liked it better

(5) Is the mastic liquid or crystal in the mastic varnish? crystal
naturally
Thank you very much. Wish we could see you and get
all this straightened out. Our best to Felicia and yourself.

Sincerely yours,

P.S. Your postcard with your maroger medium received. Again
is the mastic made from liquid of crystal in the mastic
varnish? I am referring to your A medium. I suppose
you make it from the crystal. Also, why has Maroger given up
gum arabic? I thought that was the secret of Rubens.
What does Rubens think now?

7 9 John Steuart Curry *to* Reginald Marsh 17 June 1942 2 PP., TYPESCRIPT, ILL.

for transcription, turn to p. 233

Painter Reginald Marsh (1898–1954) was a devotee of Jacques Maroger (1884–1962), a French painter and restorer who rediscovered a paint medium that would help artists attain the jewel-like depth of the Old Masters. In this exchange between Marsh and John Steuart Curry (1897–1946), Marsh responds to Curry's questions about the Maroger medium.

grind your colors in linseed oil, or walnut

before painting

make the jelly with palette knife on
 your palette –

mastic

black oil butter around in a minute or two
 together a jelly forms –

put
jelly
over
surface

1

paint directly into jelly with
 your oil colors –
2 use plenty of paint

pat, parts around
3 together with
 dry brush

4 blend parts
 together with
 jelly again etc etc

maroger
has worked
all day long
3 weeks in
this new
medium
doing a portrait
of the
archbishop of
Baltimore –

dries overnight
no cracks

<table>
<tr><td>8 0</td><td>Robert Lortac
to Edward Willis Redfield
18 Aug. ca. 1919</td><td>1 P., HANDWRITTEN, ILL.

for transcription, turn to p.234</td></tr>
</table>

French filmmaker Robert Collard (1884–1973, also known as R. Lortac) was one of the pioneers of cartoon animation. In around 1919, he served as a real-estate consultant of sorts when he sent his friend Edward Willis Redfield (1869–1965) pictures of houses for rent in Brittany. Redfield, a landscape painter, was planning a trip. Lortac writes: "I SEND TO YOU ENCLOSED SOME POSTCARDS OF THIS COUNTRY IN ORDER THAT YOU SEE THE CHARACTER OF THE LANDSCAPE."

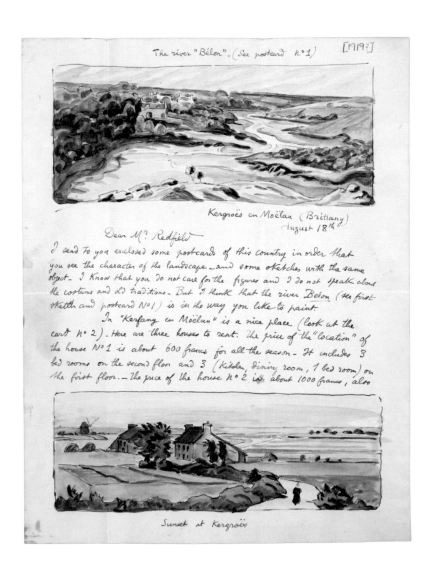

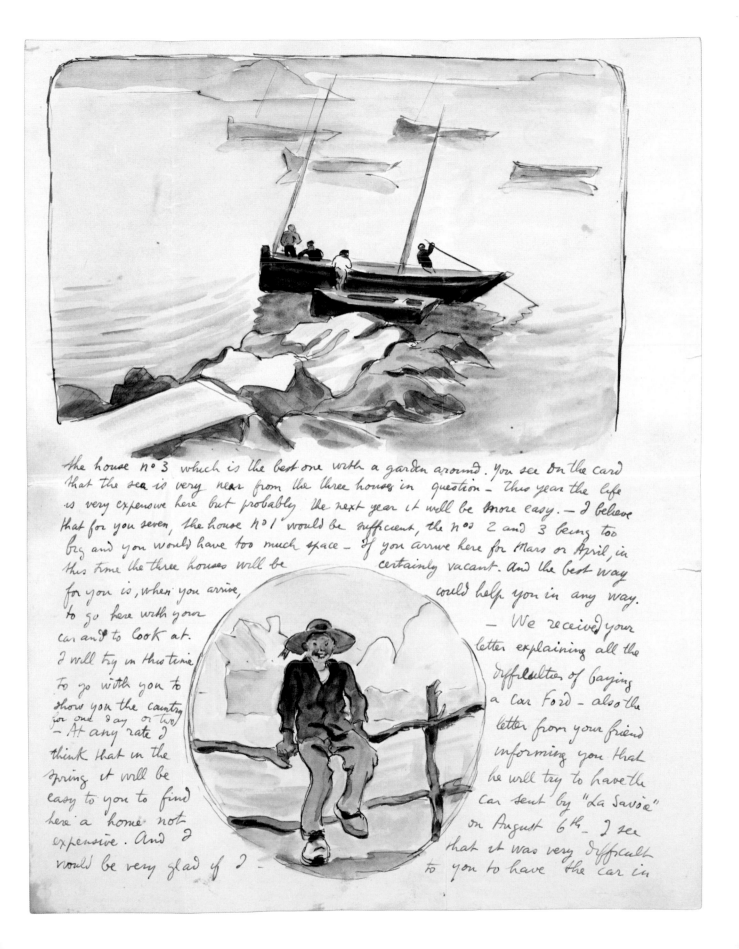

the house n° 3 which is the best one with a garden around. You see on the card
that the sea is very near from the three houses in question — This year the life
is very expensive here but probably the next year it will be more easy. — I believe
that for you seven, the house n° 1 would be sufficient, the n°s 2 and 3 being too
big and you would have too much space — If you arrive here for Mars or April, in
this time the three houses will be certainly vacant. And the best way
for you is, when you arrive, could help you in any way.
to go here with your — We received your
car and to look at. letter explaining all the
I will try in this time difficulties of buying
to go with you to a car Ford — also the
show you the country letter from your friend
for one day or two informing you that
— At any rate I he will try to have the
think that in the car sent by "La Savoie"
spring it will be on August 6th — I see
easy to you to find that it was very difficult
here a home not to you to have the car in
expensive. And I
would be very glad if I —

8 1	Joseph Lindon Smith	1 P., HANDWRITTEN, ILL.
	to Albert Smith	*for transcription, turn to p. 235*
	[undated]	

for transcription, turn to p. 235

Joseph Lindon Smith (1863–1950) clears a debt with this imaginative self-portrait that he sent to his little brother, instructing him to take the two dollars from under the arm and give it to their father.

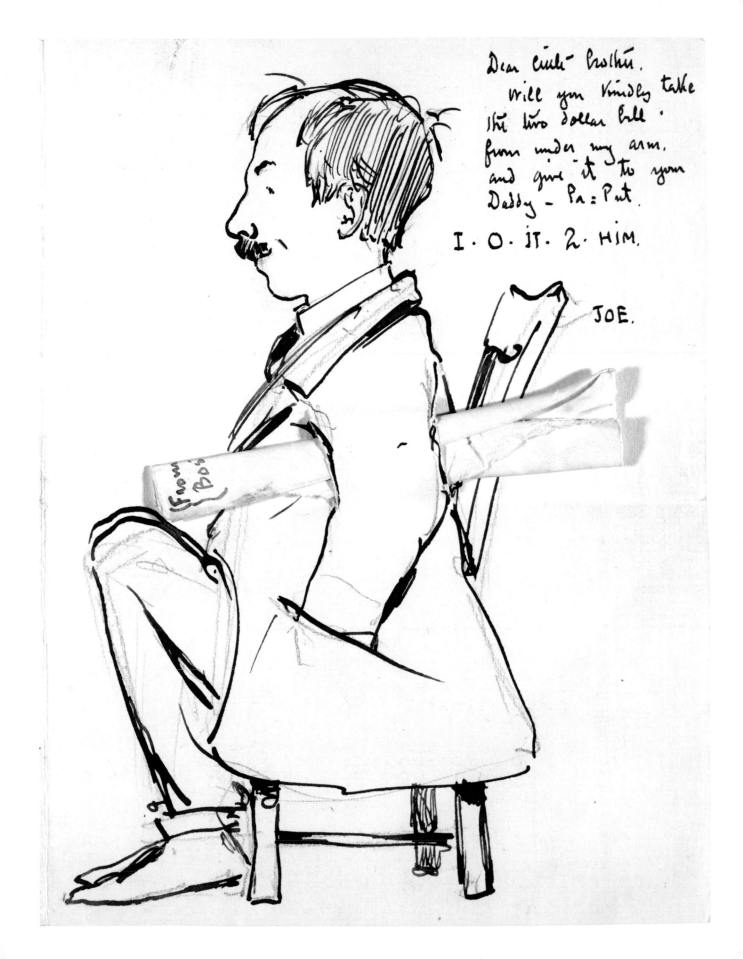

| 8 2 | Ray Johnson
to "Dr. Frye"
3 July 1970 | 1 P., TYPESCRIPT, ILL.

for transcription, turn to p. 235 |

In 1962 Ray Johnson (1927–1995) established the New York Correspondance School, an international network of poets and artists who exchanged artwork through the postal system. Here Johnson "INVITES" Dr. Frye to send work to the first New York Correspondance School exhibition at the Whitney Museum of American Art. The exhibition was held between September 2 and October 6, 1970, and included 106 works sent by Johnson's correspondents to the museum.

Mail art is distinctly different from illustrated letters; it is an art that uses the postal service for circulation. Mail artists also mimic the postal system by creating artist-made postage and employing rubber stamps.

July 3, 1970

Dear Dr. Frye,

Lucy Lippard has lovely legs and is a very good dancer.
My little correspondance school concept of dance has to
do with Quakers and Shakers and a book I once saw about
the Shaker dances our first Meeting was held in a Quaker
church I once attended a Quaker Meeting and a fly buzzed
around deliver an Emily Dickinson sermon I saw a photo
somewhere of her dress it really wasn't any different
than Judy Garland's dress both had missing heads and Johanna
Vanderbeek wrote from Hawaii saying there were lots of
rainbows.

Is Judy Garland there Over the Rainbow?

Please send something to Marcia Ducker.

MARCIA
DUCKER

Sincerely yours,

SEND LETTERS, POST CARDS,
DRAWINGS AND OBJECTS TO
MARCIA TUCKER, NEW YORK
CORRESPONDANCE SCHOOL
EXHIBITION, WHITNEY
MUSEUM, MADISON AVE.
AND 75 ST., N.Y.C. 10021

EVAPORATIONS BY RAY JOHNSON

Ray
Johnson

this exhibition opens
Sept. 17th.

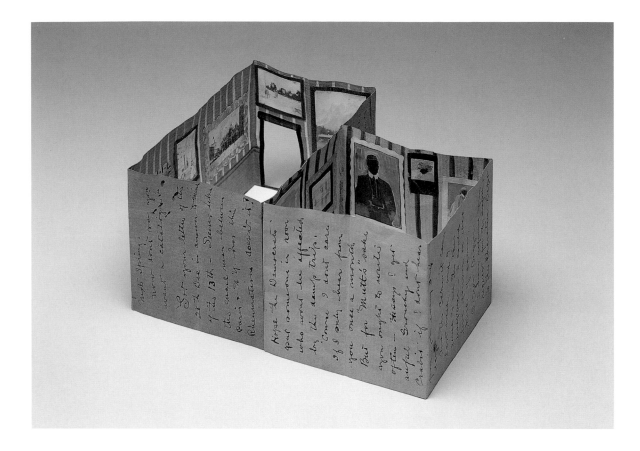

8 3	Alfred Joseph Frueh	3 PP., HANDWRITTEN, ILL.
	to Giuliette Fanciulli	*for transcription, turn to p. 235*
	10 [Jan.] 1913	

On January 10, 1913, caricaturist Alfred Frueh (1880–1968) sent his fiancée Giuliette her own art gallery, so that she could train for the "GALLERY MARATHON" she would experience when she arrived in Paris. It came complete with original works of art and a coat check.

To ready her for the transatlantic voyage, he advised her to sleep with sea shells in her pillow case. This way she would grow accustomed to the sound of the ocean in her ear.

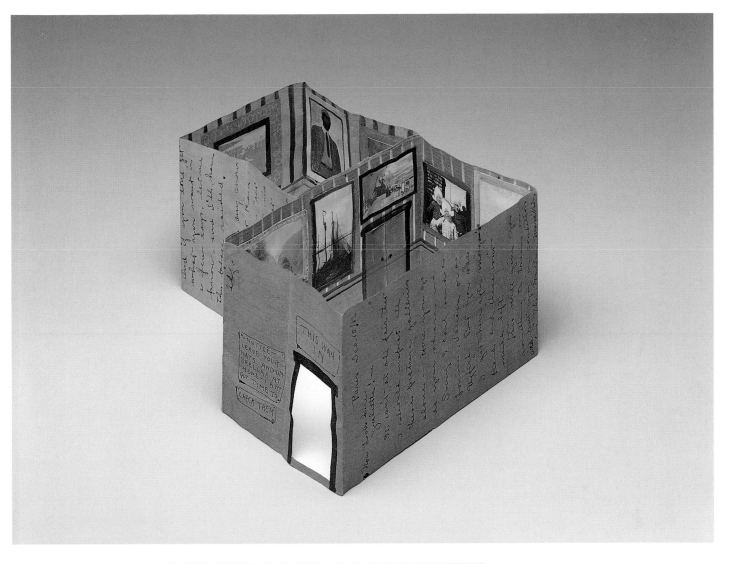

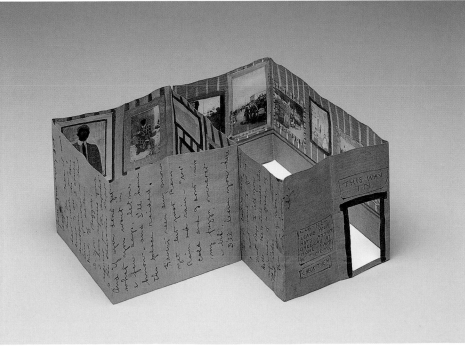

8 4	Paul Manship *to* Leon Kroll ca. 1935	1 P., HANDWRITTEN, ILL. *for transcription, turn to p. 236*

Artists often share models. In this note from Paul Manship (1886–1966) to painter Leon Kroll (1884–1974), the sculptor recommends a model, Miss Miriam McCreedy, and sketches her figure.

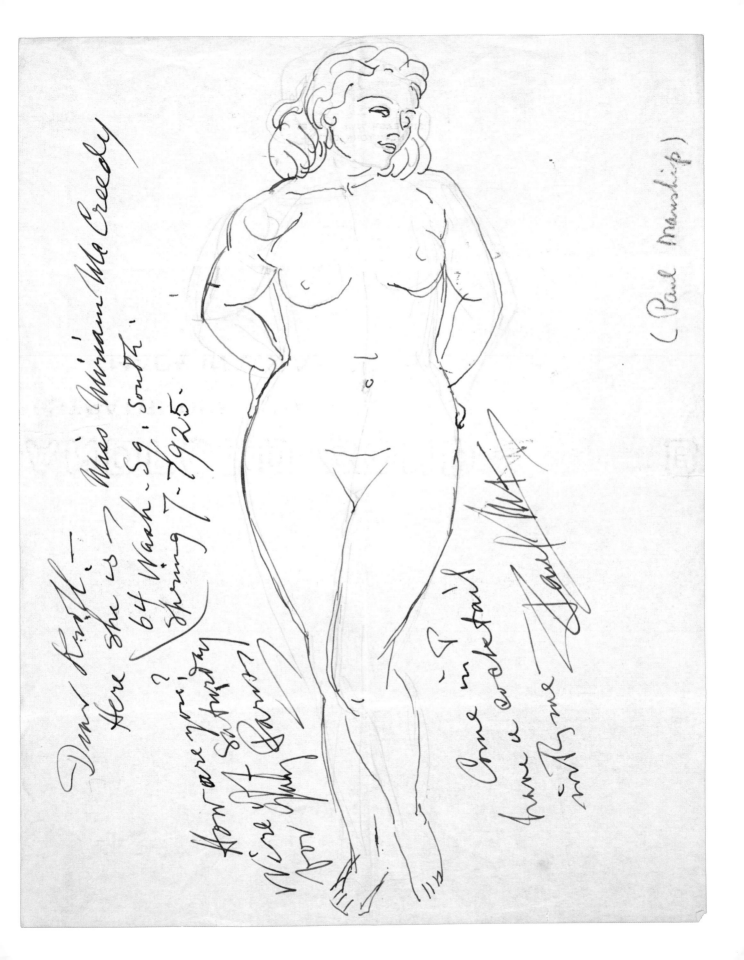

Dear Knight —
Here she is —

Miss Miriam McCready
64 Wash. Sq. South.
Spring 7-7925.

How are you;
We're just home
New York —

Come in + I'll
have a cocktail
with you —

Frank Art

(Paul Manship)

| 8 5 | Timothy Cole
to William Lewis Fraser
21 Apr. 1884 | 2 PP., HANDWRITTEN, ILL.

for transcription, turn to p. 236 |

for transcription, turn to p. 236

In April 1884 Timothy Cole (1883–1931) was in Paris making wood engravings of the Old Masters for *Century Magazine*. Writing to the editor, W. Lewis Fraser, the artist reports on his progress on a number of Rembrandts, including his *Head of Christ*. Cole sketches the master-piece on the back of his letter to give Fraser an idea of the composition.

Do you accept belated thanks? I am thoroughly
shamed of myself for having been so negligen
out thanking you for accepting the drawing
ch Max accompanied with his short story
the check which I was delighted to re
ay after I rendered the illustration
reported for work with the Air F,
auroux; and life has been a me
irm believer in punctuality,
t I owe you my most sincer

d from Barcelona, Spai
holiday; and ran in
reported that he
his story. I'm
1 as the illus
o Max, to yo

Here I am yet.
after my arrival in this city, wrote
stating that I should start this m
But, on enquiry, I found th
time by going to-day, b
would be increase
to keep one hund

Now, bless
own, — wh
you a bi
from
r
too coo
till too
d through,
thus, finding
Deck promenade
and all, down into th
by a warm stove and

Heard of nothing, nor
in going down the Bay, — no
down the Sound. — Reached An
where the Boat stop'd a minute an
a few passengers, — Push'd on to Soun

CHAPTER VI

"Thank-You"

<table>
<tr><td>8 6</td><td>Michael Lucero
to Patti Warashina
[Nov. 1979]</td><td>2 PP., HANDWRITTEN, ILL.

for transcription, turn to p. 236</td></tr>
</table>

After sculptor Michael Lucero (b. 1953) received his
M.F.A. from the University of Washington in Seattle,
in 1978 he moved to New York City. In this thank-you
letter to one of his former professors, Patti Warashina
(b. 1940), he brings her up-to-date on his activities in
New York—teaching, making art, socializing, and
becoming fashion conscious amid the "CHIC-PUNK"
downtown scene. Lucero sketches himself with one of
his hanging figures made of wood and wire.

I still wear my red hat - I guess that's my biggest thing - even when you can buy them "in the chic shops in a variety of rainbow colors - mine gets thrown in the wash! - poor thing - - - -

What you should do is let your hair grow longer - I liked your 60's look - oh Pfannebecker loves it when I use the word 60ish - he says its part of the Pfannebecker folklore - he'll tell you the story! -

Love,
Michael
in New York

8 7	Andy Warhol	1 P., HANDWRITTEN, ILL.
	to Russell Lynes	*for transcription, turn to p. 236*
	[1949]	

"MY LIFE COULDN'T FILL A PENNY POST CARD,"
writes Andy Warhol (1928–1987) to Russell Lynes
(1910–1991), an editor at *Harper's*. It was 1949 and
Warhol had just graduated from college and moved
to New York City, where, in quick succession, he
shared two roach-infested apartments with his friend
and former schoolmate Philip Pearlstein (b. 1924).
One of Warhol's earliest jobs in New York was to
illustrate John Cheever's story "Vega," which appeared
in *Harper's* in December 1949. This letter to Lynes
is Warhol's response to a request for biographical
information.

Hello mr lynes
thank you very
much

biographical information
 my life couldnt fill a penny post card
i was born in pittsburgh in 1928 (like
 everybody else in a steel mill)
i graduated from carnegie tech
now im in NY city moving from one
roach infested apartment to another.

 Andy Warhol

8 8	Gio Ponti	1 P., HANDWRITTEN, (IN ENGLISH
	to Esther McCoy	AND FRENCH), ILL.
	ca. Oct. 1966	*for transcription, turn to p. 237*

In this thank-you note from Italian architect and designer Gio Ponti (1891–1979) to architectural historian Esther McCoy (1910–1989), Ponti writes in the form of a delicate bouquet that begins in English then moves to the more familiar French. He mentions his upcoming trip to Los Angeles, arriving November 13, 1966, for the opening of the exhibition The Expression of Gio Ponti, organized by the University of California Los Angeles Art Galleries (now the Wight Gallery). Ponti's concept of total design extended to his personal letters, which evoke a magical sense of fantasy, love, and lightness.

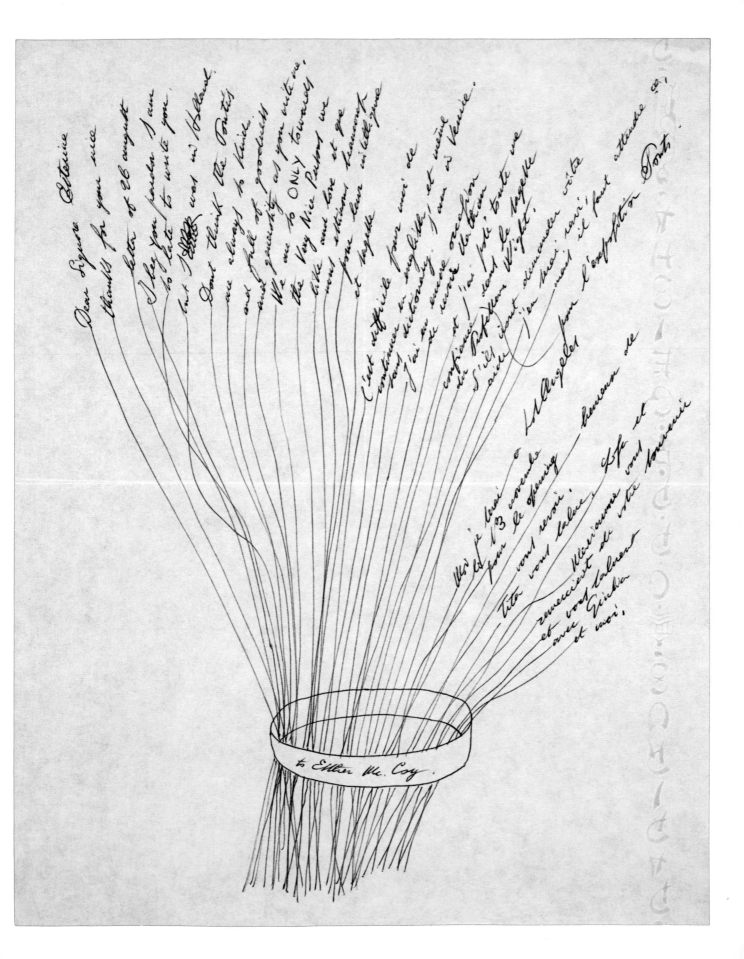

8 9 John Steuart Curry 1 P., HANDWRITTEN, ILL.
 to Margaret D. Engle
 11 Mar. 1942 *for transcription, turn to p. 237*

Regionalist painter John Steuart Curry (1897–1946) penned this dynamic cartoon of himself as "A LITERARY GENIUS" for Mrs. Tomah, who had ghost-written an article for him for her magazine the *Demcourier* in 1942. The black, squawking bird perched above his bathroom door is perhaps an oblique reference to Edgar Allen Poe's poem "The Raven," there to mock his literary skills.

JOHN STEUART CURRY
ARTIST IN RESIDENCE

March 11 42.

Dear Mrs. Tomah;

My writing is unknowing — Made some changes in which I thank I shall let stand —

The Pate was Pious Ch XI —

If you don't like any thing about my work say so —

JSC —

"A Literary Genius"

88.

~~Sixty-five~~ Central Park West
New York City

Oct. 24 1940.

Emmy Lou my darling,
Please forgive for, writing you
in pencil – cant find any
fountain pen or ink in this
house.
I am terribly worried about
Diego's eyes. Please tell me
the exact truth about it. If
he is not feeling better I
will scram from here at
once. Some doctor here told
me that the sulphamilamid
some times is dangerous.
Please darling ask Dr Eloesser
about it. Tell him all the
simptoms Diego has after taking
those pills. He will know because
he knows about Diego's condition

9 0	Frida Kahlo	6 PP., HANDWRITTEN, ILL.
	to Emmy Lou Packard	*for transcription, turn to p. 238*
	24 Oct. 1940	

In late October 1940, Frida Kahlo (1907–1954) wrote to Emmy Lou Packard (1914–1998) thanking her for taking such good care of her former husband Diego Rivera (1886–1957), who was in San Francisco painting his fresco *Pan-American Unity* (intended for the new library of San Francisco Junior College, now City College of San Francisco). Rivera was suffering from an eye ailment; Packard was one of his assistants. Kahlo was in New York, arranging for an exhibition of her work at the Julien Levy Gallery. She mentions her failed attempt to interest Levy in Packard's drawings and uses this opportunity to vent about Guadalupe Marín, Diego's second wife. She adds, "KISS DIEGO FOR ME AND TELL HIM I LOVE HIM MORE THAN MY OWN LIFE," and signs her letter with red lipstick kisses: one for Emmy Lou, one for Diego, and one for Emmy Lou's son Donald. On December 8, 1940, Rivera's forty-fourth birthday, he and Kahlo remarried.

arrange some thing here for
you next year. I still
like the first one you
made of me better than
the others.
give my love to Donald
and to your mother and
father. Kiss Diego for
me and tell him I love
him more than my own
life.
Here is a kiss to you and
one for Diego and one for
Donald. Please write to
me when ever you have time
about Diego's eyes.

Diego. Donald

Mariana Frida.

9 1	David Carlson. Jr. *to* Miss Jackson 6 Jan. 1952	1 P., TYPESCRIPT, ILL. *for transcription, turn to p. 238*

In this note David Carlson, Jr., thanks Miss Jackson and *Harper's* for purchasing his illustrations for the short story "Captain of the White Yacht," by Max Steele, which appeared in the March 1952 issue. Steele and Carlson were classmates at the Académie Julian in Paris. When he wrote this letter, the illustrator was working as a civilian with the U. S. Air Force in Châteauroux, France. The self-portrait he enclosed, with its penetrating gaze, may have been intended as a subtle appeal for more illustration work.

Chateauroux, France
January 6, 1952

Dear Miss Jackson:

Do you accept belated thanks? I am thoroughly
ashamed of myself for having been so negligent
about thanking you for accepting the drawings,
which Max accompanied with his short story, and
for the check which I was delighted to receive.
The day after I rendered the illustrations for
Max, I reported for work with the Air Force here
at Chateauroux; and life has been a melee since.
Being a firm believer in punctuality, however,
I feel that I owe you my most sincere apologies...

Just returned from Barcelona, Spain, where I
spent a brief holiday; and ran into Max my last
day there. He reported that he had received
the proofs for his story. I'm anxious to see it
in print, as well as the illustrations, and feel
deeply grateful to Max, to you, and to your
magazine...

David Carlson, Jr.

| 9 2 | Edith Schloss *to* Philip Pearlstein 25 Mar. 1981 | 2 PP., HANDWRITTEN, ILL. *for transcription, turn to p. 239* |

In 1981 painter and writer Edith Schloss (b. 1919) wrote to Philip Pearlstein (b. 1924) and others thanking them for their help and encouragement on her extended stay in the United States. On the back of the letter, she writes: "I WISH WE HAD A NATIONAL ARCHIVES HERE TO GIVE ALL MY JUNK & DIARIES TO— I'M NOT GOOD AT THROWING AWAY THINGS." During Schloss's stay in New York, Pearlstein may have mentioned the Archives of American Art as an appropriate repository for her "junk." He donated his papers to the archives, and she subsequently followed suit.

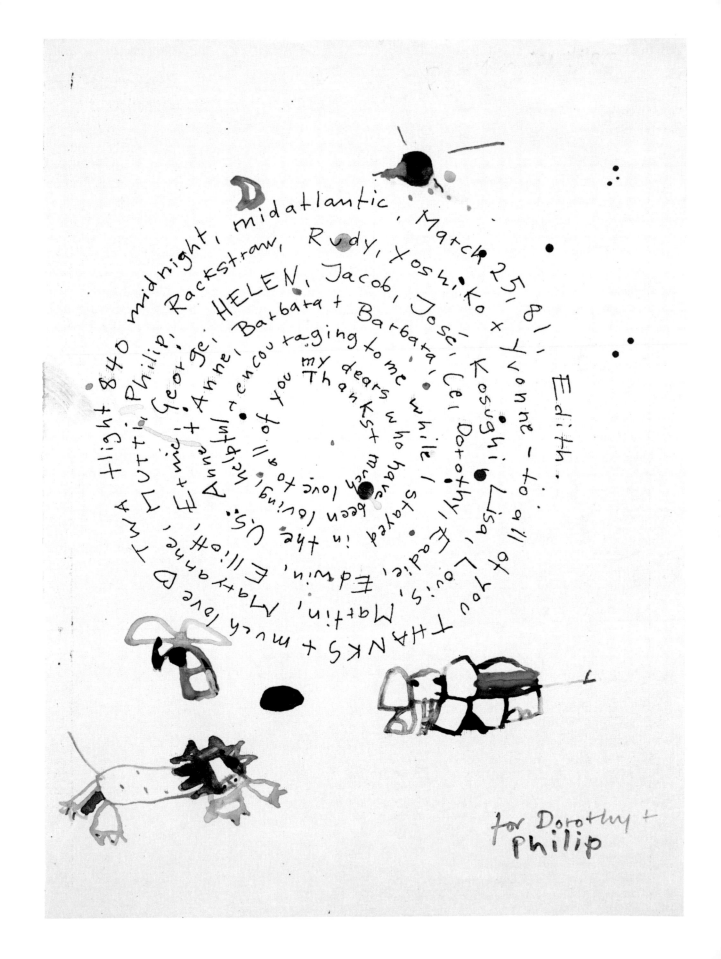

TWA flight 840 midnight, midatlantic, March 25, 81, Edith, Philip, Rackstraw, Rudy, Yoshiko + Yvonne – to all of you George, HELEN, Jacob, José, Kosughi, Lisa, Louis, Martin, Ethnic + Anne, Barbara + Barbara, Cei, Dorothy, Edie, Edwin, Mayanne, Elliot, Mutti, Anne, + encouraging to me while I stayed in the U.S. all of you my dears who have been loving, helpful, Thanks+ much love to all of you THANKS + much love Dorothy

for Dorothy + Philip

<table>
<tr><td>9 3</td><td>Philip Guston
<i>to</i> James and Charlotte Brooks
[1949]</td><td>2 PP., HANDWRITTEN, ILL.
<i>for transcription, turn to p. 239</i></td></tr>
</table>

In the summer of 1949, abstract expressionist painter James Brooks (1906–1992) kept a studio in Montauk, on Long Island. Perhaps this is where fellow painter Philip Guston (1913–1980) spent a long weekend with Brooks and his wife Charlotte, who was also a painter. In his thank-you note to the couple, Guston includes a sketch of a hairy, pipe-smoking local from his Woodstock, New York, neighborhood, whom he compares (unfavorably) to the well-heeled South Fork type.

Guston's parting comment that there is "TOO MUCH OF THE PAST AROUND ME" may refer to what biographer Dore Ashton called a "period of unease" in the painter's life, when he had received most of the major honors available to an American artist but still doubted his abilities.

Jim — this is
a local type ..
much less fashionable
than at East Hampton.
Phil.

| 9 4 | William Wegman *to* Athena Tacha [1974] | 1 P., HANDWRITTEN, ILL. *for transcription, turn to p. 239* |

Sculptor Athena Tacha (b. 1936) taught at Oberlin College and organized a series of visiting artists' lectures there. In spring of 1974 she invited William Wegman (b. 1944) to speak about his collaborative videotaped "skits" with his Weimaraner Man Ray. Wegman illustrates his reply to her invitation with a sketch of Athena as an art booster, sheltered under the portico of a Greek temple. He would lecture at Oberlin on April 17 of that year.

ATHENA
AT OBERLIN

Thanks for the invitation — I can't figure out the date yet — probably May — anything around thanksgiving in Nov. I might be driving to Chi and could stop off.

Bill Wegman 49 Crosby St

| 9 5 | Red Grooms
to Elisse and Paul Suttman and
Edward C. Flood [1968] | 1 P., HANDWRITTEN, ILL.

for transcription, turn to p. 239 |

In this thank-you note to his friends Elisse and Paul
Suttman and Edward C. Flood, Red Grooms (b. 1937)
shows himself at a low point—sick and spotted and
turning green and pink. His wife at the time, Mimi
Gross (b. 1940), reads his health insurance policy
aloud. They had just returned to New York from an
extended stay in Europe following the great success
of their sculpto-pictorama *City of Chicago* at the 1968
Venice Biennale. The cow on the wall is an Andy
Warhol print that Grooms had found discarded on
Canal Street. Grooms's drawing inadvertently juxtaposes
his humorous, earthy brand of Pop art against the
cooler, decorative Warhol.

WELL, HERE WE ARE BACK IN BUSINESS.... GOING OVER
THE SUMMER MAIL.....
 GEE, THANXS FOR THE GREAT STAY AT YOUR
PLACE.
 LOOKING FORWARD TO YOU BEIN HERE IN FEB.

YOUR MAP AND TIPS WERE VELLY HELPFULL
IN BARCELONA.
WE STAYED IN THE PENCONIE IN THE GAUDI
HOUSE. THRILLING. AN ATE AT SNIAL PLACE.
ELISSE THANXS FOR BEAUTIFUL THOMPSON.
 LOVE... RED & MIRIAM

| 9 6 | Gladys Nilsson *to* Mimi Gross and Red Grooms [postmarked 4 April 1969] | 1 P., HANDWRITTEN, ILL. *for transcription, turn to p. 239* |

Painter Gladys Nilsson (b. 1940) uses United Airlines stationery to send a thank-you note from the friendly skies to Mimi Gross (b. 1940) and Red Grooms (b. 1937). Nilsson connects her collage of smiling faces with telepathic dots to a message cloud where her words, in silver ink, express her thanks for letting the Nutt family—Gladys, Jim, and their six-year-old son Claude—stay at their place in New York. The words "HEAT COMB" and playful doodles in the upper right add whimsical flourishes.

flying the friendly skies of United

"Heat Comb"

dear red and mimi,

as you can see, all
the friendly people on
this page are helping to
convey messages of thanx
from the Nuthouse to the
gromhole, from the bottom
of nuttharts, for letting
us stay at your place.

no plain crashes, all
arrived safe without mishap
except for Claude who got an
earcold, and it is as ever
very hard to "get back to
vork" after tripsville. (we
deplaned in Denver and Reno,
the latter imediatly offering
now upon now of ele't upon
steping of a playn. IT IS FUN
TO FLY.

good to see u soon.

Love GLADYNESS

grooms is
Nice people

Coast·to·coast...and to Hawaii

Transcriptions

THESE VERBATIM TRANSCRIPTIONS
PRESERVE THE EXACT SPELLING AND
PUNCTUATION OF THE ORIGINAL
LETTERS. THE FORMAT OF THE LETTERS,
HOWEVER, HAS BEEN STANDARDIZED
ACCORDING TO THE MODIFIED BLOCK
STYLE FOR GREATER CLARITY.

1. Robert Frederick Blum
to Minnie Gerson
6 Dec. [1884]

4 PP., HANDWRITTEN, ILL.
18 X 12 CM.
ROBERT BLUM ILLUSTRATED LETTERS

48 Jansstraat
December 6.

Dear Miss Minnie—

I come too late I know but just show the above to your father as my idea of the Christmas card—my own idea!—my idea of "Peace on Earth" in fact. Too late! Too late!! And I could have made splendid use of the $5000⁰⁰ too! Well, just my luck I suppose! Its fatal to be afflicted with Inspiration that wont be controlled; its sure to lead to bankrupcy some of these fine days!

Well, let that pass.

I rec'd your letter last week and see that you are again in the old nest, that charming little roost away up out of harm and out of breath by the time you get there I could add.—But I won't. Never mind I always found it worth while to get out of breath when I got there. Please excuse this miserable scrawling I'm nervous today. Weather! Had a straight streak of rain now for two weeks always made me feel miserable at home doubly so here. You ask what I'm doing well I hardly like to tell but I can hint and let your imagination "work its passage". In the morning I usually awake with a smile because Im sure the weather is fine, then I look to see if had the desired effect and turn over again. I dont smile this time. I just say something. Its not much but its to the point. I've gotten so used to this performance that I've lost the relish and the novelty all worn off. I do it now to fill in time. Im not doing a thing. oh if you could just see such weather I'm writing now at half past two oclock near the

window and I can hardly see it is so gloomy. I feel like an outcast. Yet the natives dont seem to mind it. The hand organ with its cheerful walzes toots and groans its hacking and rheumatic notes through it all. I hear it now.

Yesterday was St Nicholas (They can't wait till the 24th like we do) I got this!

Good bye
Yours as ever
Bob Blum

Blum's mention of "my idea of the Christmas card" is a reference to Louis Prang and Company's 1884 Christmas card design competition. Between 1880 and 1884, Prang held four contests for Christmas card designs. The competitions were so popular (575 entries in 1881) that in 1884, Prang commissioned a group of prominent American artists to paint Christmas themes, then invited them to enter these same designs in a competition for cash prizes. There is no evidence that Blum was among this group. When he wrote this letter on December 6, 1884, Prang's "prize exhibition of designs for Christmas cards by eminent artists" was on view at Reichard's Gallery at 226 5th Avenue in New York. The winners for 1884 were C. E. Weldon, Will H. Low, Thomas Moran, and Frederick Dielman.

. .

2. Lyonel Feininger
to Alfred Churchill
20 May 1890

4 PP., HANDWRITTEN, ILL.
21.9 X 13.9 CM.
LYONEL FEININGER PAPERS, 1887–1939
© 2004 ARTISTS RIGHTS SOCIETY, NEW YORK/VG BILD-KUNST, BONN

Unter d. Linden 16ᴵᴵ·
Berlin May 20th
1890

My dear old Al!

Dear old man! I knew you wouldn't "disremember" me! I was only

delighted to get your letter, which I did just now while at the dinner table; not astonished. The rough manner in which this drawing is sketch, may bear witness to my haste in answering your letter. I had no idea of your adress and did not have the heart to visit Kronprinzen Ufer, for you were gone, so I remained steeped in ignorance as to your address.

If this is an unsatisfactory letter, both as to sketches and Literachewer, please attribute it to my anxiety to hear more of you and to my excitement. But after all this babble and preamble let me commence to answer your letter:—I have received repeatedly, orders of 5 or 6 drawings at a time, from the Humoristische Blätter, and have made some drawings in my best style, most highly finished for that weekly. Oh! wont some of them do your heart good when you received the printed copies! I had a story to illustrate, an episode of a wintry night, supposed to take place in a cellar! so, if the idiots only half decently print the things! you will have second hand examples of the very best work I have done yet. I will have to order backnumbers for you, of the 3 drawings I have had printed since you left. There are a great many yet to come which have as yet not appeared, which you shall received as soon as they appear. As for money—riches as you call it!—hmm! I have earned 217 marks up to date! I will enclose a little example of tusch work, which I made recently, but as a rule I do only penwork. I make very few fantasies. That will come again though, for I am getting to be a regular storehouse of the most vivid, horrible drastic chiarooscuro effects man every saw or dreamed of—Of course unpeopled, for my imagination generally fails to conjure up figures drastic enough for thier surroundings. I am increasing daily in power of conception, but not until I have drawn from the nude for several years, will I be able to do myself justice in anything resembling the human form divine. Dear old Alf! I am so glad you and

Marie are happy! I am sure you must be quite a different fellow from what you were last time you were in Paris alone. Then you were undecided and alone—Now you are on a steady course, with every thing gradually clearing up, gaining such knowledge of art and overcoming old doubts as must give you every day more confidence in your own latent powers and more happiness. In spite of the lot of work I am now doing, I should be only too glad to drop all penwork for a few years and be with you, getting right at the foundation of art knowledge. As it is, to use a metaphor, I have commenced somewhere on the 3rd story and am trying to draw up, from the basement, my material and knowledge which I should have first sent on and then climbed up after on the ladder of pen technique. That is the ladder I am now on but I have no mortar, and but few bricks! How old Al is agoing to laugh at poor old Feininger! But still, if Feininger has expressed himself crudely he still speaks what he believes. (another Haw-haw from Al, and applause from rear of Auditorium, with repeated cries of "Bravo! Bravo!" "put him out" etc) Well, to drop off the platform and exit by the fire-escape is but the work of a moment for Feininger, and now I will try to close this letter as a rational being should. Am I rational? Dear old Al, do please send me the original drawing you speak of in your letter, for at the head of this letter is my present address, so you may depend on its safe arrival. But I will also make one more demand upon your friendship, also it is you promise to me before we parted. viz: to illustrate your letters! If it is only a little landscape of or a simple figure, or any little sketch or sketches illustrating the text of your letters, it will be just as welcome and will do you very considerable good in helping you on in penwork or ready interpretation of any little conception you may wish to put on paper. I am honestly sorry that I myself have so little time to illus-

trate this letter more fully, (I generally average 2 pictures on each page) so as to give you an example of how simply one can illustrate a letter, but next week when I write again, will fill the letter up. Down below however you have an example, or rather a specimine of the usual way in which I illustrate the letters. It represents me, sitting by the Spree, thinking of Alfred, and watching a bee! That verse is worthy of Werner, but do not think me vain or boastful in saying so! Can you manage the parly-voo yet or does it elude your tongue as in the goodold Berlin days? Goodbye old fellow. I am too upset and distracted to write a common sense letter this time, but you write soon and you will see. If possible use this sort of Paper for your illustrated letters. Best love to yourself and Wife, Marie, from your faithful friend Leo. NB. Werner is payed up! that debt!! Hurra!

. .

3. Alfred Joseph Frueh
to Giuliette Fanciulli
17 Sept. 1912

6 PP., HANDWRITTEN, ILL.
17 X 26 CM.
ALFRED J. FRUEH PAPERS, 1909–CA. 1961

Besancon France—
about the 17th Sept 1912

Dear Julliett:—

Blew into this place today from Switzerland and found your letter waiting here for me and O Gosh! How readin' "your trash" by now makes me tired. but you jes' keep on a "trashin'" I aint a kickin'. At that. I bet I can trash" you. Say. What a bully good excuse I've got now since you have moved.—Gee. I must have wrote you a 1000000 postal cards and ten million letters. between

the time you complain of not getting but one. And Ill just bet they got lost, cause you moved 'Course they might of stopped up the mails. I do'no—but I'm a havin a nawful bum time. It taint a rainin' neither. I dont care if the $tourists do claim it rained and rained. I havent seen so awful much of it It didnt rain a single drop all the time we were in Italy—In switzerland while it rained a little and snowed a little more It didnt interfere cause it rained mostly by night while we were enveloped in hay.

And it aint bugs nor fleas neither. I aint had a flea bite since The Pope pointed the Cannons of the Church at me and threatened to shoot if I didnt remove myself from Italy

But its this. This stuff, a sample which I have inclosed. I aint done went and gone put any arsenic in it for you either. But just you chew this. Chewing Gum? (bought it in a sporting goods store here—You gotta ask for Gum des Atheletes) and tell me if I aint got a right to kick and fuss a little ere I perish from gum such as this.

I'm here for about 5 days. Have relatives here to whome I had my trunk sent—Im getting cleaned up and into my winter clothes. before I make a dash for any further north. Cleaned up Switzerland. I like it best in Winter when there's Skying and tobogganing. Got my degree from the Conservatory of Yoedeling and if you ever hear a steam calliope under your window, That's me. Gosh durn you, Julliett here's some Eidelveis for you. I gotta go now—this is trash enough for one envelope and dont you disremember that if you dont rite some more "trash" quick I'll get sick.

Now run along and be a good little bambino—You know what happened to those bad bambinos up in Berne

—Same like ever
Jerrimiah

. .

4. Oscar Fabrès
to Russell Lynes
25 June 1959

1 P., HANDWRITTEN, ILL.
28 X 21.6 CM.
HARPER'S MAGAZINE RECORDS KEPT BY
MANAGING EDITOR RUSSELL LYNES,
1946–62.

June 25th, 59

Dear Mr. Lynes,

I just mailed to Mr. Acheson the sketches, in watercolor as you suggested so well.
I added to my letter the little cartoon (l'illustrateur à New York) of which I am sending you a copy above.
It was very nice to see you yesterday.

Cordially
Oscar Fabrès.

. .

5. Thomas Eakins
to William Trost Richards
19 June 1877

3 PP., HANDWRITTEN, ILL.
21 X 14 CM.
WILLIAM TROST RICHARDS PAPERS, CA.
1850–1914.

1729 Mount Vernon St. June 19 1877

My dear friend,

You will be pleased to learn that I have just got a commission to go to Washington to paint the President. The portrait is for the Union League, It is and I am to make it according to my own notions as to size & composition. It

pleases me very much for I knew nothing of their intentions till they came & gave me the order while other painters tried to get it ~~through~~ to do.
I make you the projections of a little brick shaped box tilted up on its corner, in case you might wish to draw a yacht sailing.
First I have drawn it parallel with the three planes of projection.
Second I tilted it back on the egde gh. which motion taking place in the plane of the end elevation, it is in that plane that you first draw it ~~now~~ this time; & then you can draw its side elevation & ground plan anew ~~from~~ with the change introduced.
Then you can tilt it up on its corner g. This motion takes place in the plane of the elevation. Therefore you make the change in that plane & then deduce its ground plan anew with that change introduced.
Now you have it tilted up on its corner & by going round it you may see it in any position. You can put your parallel square feet at any angle with your brick You see with my red lines I have indicated the brick in the ground plan as 10 ft off & 1 foot to the right of the picture & ~~on~~ at an ~~slope~~ angle with the picture.
Having the ground plan of each point & its exact height it is nothing to put the same brick into perspective. I drew in the third time the end elevation in lead pencil to show it complete but this was unnecessary for the perspective. If you will letter the corners of a little real box you will understand it right away.
I hope you are having a good time at Newport, that you have a cool breeze, & that you may bring home more of your good work to shame weakness and dishonesty & silly affectation.

Yours truly,
Thomas Eakins.

. .

6. Walt Kuhn
to Vera Kuhn
[20 July 1913]

4 PP., HANDWRITTEN, ILL.
25.3 X 20.1 CM.
WALT KUHN, KUHN FAMILY PAPERS, AND
ARMORY SHOW RECORDS, 1882–1966.

Saturday 7pm
Oqt.

Dear Chick,

Strikes me that I spend most of my time writing to you—
Had a stack of forwarded mail this a.m. Your letters arrived O.K. apparently Brenda is making real progress. Sketching the crowd today was out of the question. Only a handful of people and they were spread over half a mile. It's a good thing. I had no serious ideas of work. My stay here has been boresome of course, but it surely clarified my mind. You are perfectly right when you said that you were the only pal— now don't get cocky about it—but how did you guess it?
I saw the local baseball game today, they were so punk that they were funny. I shall probably go to the movies tonight—they have them 3 times a week.
Walking round the old painting places today I suddenly realized how much I have progressed—
Saw Field today and the young frenchman wood carver who is with him, tried to get some pointers but was not able to glean much—this fellow is practically nothing but a mechanic.
As I have already hinted to you I think I have hit upon a new and entirely fresh vein of working It's just a matter of stick to it—and ought to be a big success—Can't describe it in writing, as it will take some time to work out. I have only the crude germ at present more later

Love to you and all
W

Why is it that painter ladies always look like this
or this
this
or this
latest prune figure
This one has rare beauty
As regards this one—one should never forget that the power of words is limited
See if you can find out if there is any oil burning lamp which will cast its light directly below without casting it's shadow—like this
You might be able to discover some thing in some store or catalogue
Must be a strong clear light and not bad for the eyes—

Kuhn writes from Ogonquit, Maine; Brenda is their daughter; Field is Hamilton Easter Field (1873–1922), a supporter of modern art, who in 1911 established a summer school in Ogunquit, Maine; the young Frenchman woodcarver is Robert Laurent (1890–1970).

. .

7. George Benjamin Luks
to Everett Shinn
18 May 1900

1 P., HANDWRITTEN, ILL.
22.2 X 15.1 CM.
EVERETT SHINN COLLECTION, 1894–1953

May 18th 1900

I suppose that you will have to wade out in the river to board the boat

My dear Shinns—

Bon Voyage!
What a pity—you must put up at Hoboken for the night—by "put up" I dont mean pawn things—simply try and sleep bugless

Au revoir
success—Geo B luks

. .

8. Betty Parsons
to Henry Ernest Schnakenberg
ca. 1939

2 PP., HANDWRITTEN, ILL.
27.3 X 20.7 CM.
HENRY ERNEST SCHNAKENBERG PAPERS, 1905–69

Colorado Knight Ranch view from my room

Dear Henry—

Very happy to hear from you—We certainly had a fast, and beautiful Mexican trip—We were given a little house for two weeks in Taxco, I painted madly all the time and managed to get a few good ones—Went to the college at San Miguel where Jéla Archipenko and Tamayo teaches, it is really a wonderful place will tell you all about it when we meet—Will stay on this ranch a week or so then go to Santa Fe for a day or two and expect to be in New York the 15th to take a trip with [*illegible*], who is not well—Also have desided to give up my studio at 14 East 58th and share Rosalind Constables appartment as her friend Natasha is moving out. It will be cheaper for me, an elevator and a kitchen, and Rosalind whom I jolly well like—So my dear you won't have to climb so many stairs when you see me—So glad many thanks for clipping—interesting and sad—The old order certainly has passed away—you will keep the Vermont house in the family would like to see it again some day—Hope to see you soon

Love,
Bett

Jéla is artist Gela (Angelica) Archipenko (1892–1957), the wife of sculptor Alexander Archipenko (1887–1964). Tamayo is Rufino Tamayo.

. .

9. John Frazee
to Lydia Frazee
18 May 1834

4 PP., HANDWRITTEN, ILL.
22.5 X 18 CM.
JOHN FRAZEE PAPERS, 1810–1964

Philadelphia May 18, 1834,
Commercial Hotel, 31 Chesnut St.

My dear Lydia,

Here I am yet. I yesterday, after my arrival in this city, wrote you a line stating that I should start this morning for Baltimore. But, on enquiry, I found that I should gain no time by going to=day, but my expenses also would be increased by so doing. So I concluded to keep one Sunday in Philadelphia—
Now, bless your dear life—dear to me as my own,—what shall I tell you? Suppose I give you a brief sketch of my 8 ½-hours ride, yesterday, from N. York to this city?—Well then, we loosed our fastenings from the Wharf at the Battery just at 6 Oclk and away we came, in the steamer Swan, down the Bay in fine style.—Weather too cool for comfort, so I put on my wrapper,—still too cold for comfort, for I was "chilled through and through," as my Granny used to say, I fairly ached, thus, finding no pleasure in pain, I quit the Deck promanade and carried myself, wrapper and all, down into the Cabin, where I sat down by a warm stove and read the news=paper.
Heard of nothing, nor saw nothing remarkable in going down the Bay,—nor up the Kills, nor down the Sound.—Reached Amboy about 8

where the Boat stop'd a minute and landed a few passengers.—Push'd on to South Amboy where we were unboated and stowed away in the Rail Road Cars,—and I, you know, for the first time. [*image of a train*]

I give you a view of what is called a Train of cars, all chained together

The Deck Cars carry those who wish to go cheap. They are more open and more corsely made than those in the middle, and those forward are subject to more noise and smoke and to greater danger in case the Boiler bursts.—The 6 small cars are very neatly and comfortably made, and each one carries 24 passengers without the least crowding!—The other 3 cars will carry nearly double that number.—So when this Train is full they will take about 150 persons;—and if there are more they can hitch on more cars.—A few minutes and we were off like a shot, at the rate of 15 miles an hour.—The sensation to me, in this new conveyance, was, at first, quite disagreeable and for several miles I was chuck full of fears, fits, and starts!—But a person will get used to anything; and, as I could not help myself, I was compelled to get used to this, and am now pretty well reconciled to the Rail Car; except the eternal and deafening roar which the whole Train makes upon the ear.—This I dont like, it made my head ache some all the way.—Past 9 Ocl^k here we go over the Bridge at Old South River,—and no bones broken yet.—On we go—roar—roar—roar, like a continual thunder!—Here we are, at Spotswood, Stop'd to water.—Dont laugh!—for I can tell you that Madam Engine is an evaporating Animal, as is a ~~well~~ horse;—Out we all jump'd to stretch & straighten our legs & limbs.—In 3 minutes the Bell rang and such a scampering you never saw as there was among our troops to get their seats before she was off, and several who had step'd into the Tavern, had to run and climb in, after she was under way.

On we go again, roar, roar, roar, over deep vallies, and through deep hills; now we skim along on the level plain,—now we dart under Bridges, and now under Aquaducts;—now over Bridges;—now in a dense wilderness; now in open day again.

Halloa! Whats this! O! we are just passing other Train from Philadelphia;—we dart by eac other as swift as two streaks of lightning.—Now 'tis 10 Ocl^k here we are at Heights Town, stopd to give the Creature more water.—And out we jump again,—and I get some Brandy & water to cure my head=ache. I now feel better.—Away we go—roar, roar, roar, forever.

Here we are at Borden Town ½ past 11—Jump into the Steamer Trenton.—Quiet. Steam on land & take Steam on water again.—Off she goes, with an old fashion'd roar—a splash & a surge. Stop here & there to take in passengers, along the Delaware.—Now we heave in sight of Philad²—now we areopposite the city,—now we are at Chesnut St Wharf, at ½ past 2 Oclock, and I has-tenened to drop you a line before the mail closed.

Tomorrow, Monday morning I start for Richmond I do not stop at Baltimore in going.—Write to me on next Wednesday, at Richmond; and I will write to you as soon as I get there.—Tell me how Adeline is, and all things else. Remember me, my Dear One, all the time till I return.—I pray God may bless us, and preserve us in love & affection while we breathe.—

My dear Lydia

Adieu. Yours
J. Frazee

Let Mr. Launity see this if you please—and tell him I shall write him as soon as I arrive in Richmond—

. .

10. Howard Finster
to Barbara Shissler
1981

1 P., HANDWRITTEN, ILL.
25.4 X 20.2 CM.
HOWARD FINSTER PAPERS, 1932–87

DEAR BARBARA

I AM EXCITED TO BE COMING TO WASHINGTON WHERE THESE GREAT MEN ONCE HAD OUR FUTURE RESPONSIBILITY UPON THEM I FEEL SO UNWORTHY TO LIVE IN A WORLD OF LUXERY AND THESE GREAT MEN PAVED OUR WAY I AM COMING WITH ART ROSENBAUM AND ANDY NASSIAS OF THE UNIVERSITY OF GA THEY ARE GOING TO BRING ME UP TO BE WITH YOU ALL THEY SAID THEY MIGHT HAVE A MOVY FILM OF ME AND PARODISE GARDEN INSTEAD OF A SLIDE LECTURE I HAVE A ROUND PROJECTOR SLIDE HOLDER FULL OF SLIDES I CAN BRING IT IN CASE I MIGHT HAF TO USE YOUR PROJECTOR IF WE USE SLIDES ANDY AND ART ROSENBAUM HAVE MOVYS AND SLIDES SO THEY WILL WORK THAT OUT I AM SORRY I HAVE BEEN SO BUISY I HAVENT WROTE YOU SO I AM VERY HONORED TO HAVE THE CHANCE TO BE WITH YOU ALL IT IS LIKE A DREAM THEY SAID I WOULD BE STAYING IN THE BOON HOUSE UP THERE I UNDER STAND IT WOULD BE OCT. 31 SO PLEASE CHECK WITH ART ROSENBAUM AND ANDY NASSIAS THEY NOTIFY ME WHEN TO COME TO ATLANTA AND I MEET THEM THERE TO FLY UP TO WASHINGTON ART WAS BY THE OTHER DAY AND RECORDED ME SINGING AND PLAYING MY BANJO AND GETTAIR. HE IS PLANNING ON TAKING ME UP WHEN HE GOES SO IF NOTHING

HAPPENS WE WILL BE RIGHT IN ON YOU PEOPLE IN WASHINGTON WE WILL HAVE A GREAT TIME IT WILL BE EXCITING BELIEVE ME I HAVE BEEN IN 2 UNIVERSITYS IN CALIFORNIA ONE IN DENVER COLORADO I WAS IN UNIVERSITY IN PHILADELPHIA MIAMIA UNVERSITY AND LA GRANGE AND UNVERSITY AT ATLANTA AND UNIVERSITY OF GA AND 2 UNIVERSITYS IN NORTH CAROLINA AND ALL OF THEM WAS A GREAT HIT AND WE REALY HAD FUN AND FELLOWSHIP I WILL SOON BE GOING TO NASHVILL TENNESEE FOR ABOUT A WEEK IN A BIG ART SHOW SO IT WILL BE THE SAME THERE WITH YOU ALL IT WILL BE GREAT I AM NOW WORKING ON THE GARDEN ON A WALK ABOUT 3 HUNDRED FEET LONG FOR A WALK TO MY NEW GALLERY

HOWARD FINSTER
1981

Finster's traveling companions were painter Art Rosenbaum (b. 1938) and ceramist Andy Nasisse (b. 1946), both in the art department of the University of Georgia, Athens.

. .

11. Maynard Dixon

to William Macbeth

26 June 1923

2 PP., HANDWRITTEN, ILL.
27.8 X 21.6 CM.
MACBETH GALLERY RECORDS, CA.
1838–1968

728 Montgomery St
San Francisco
June 26–1923

Dear Macbeth—

Here comes a letter from Harshe, inviting the Desert Shepherdess for the fall exhibition of Chicago, opening Nov. 1st If you have not <u>sold</u> it by then, will you please send it, with the enclosed tag?

Herewith also is an article on my work by one of our local critics,—the best talent available. She is a pretty fair observer & has published some stuff in Studio—Translations of Gauguin's letters, etc. I had a passing word with Boswell about an article on some "California man" & he seemed favorably inclined. If you could plant this MS. on him for next fall it might favorably influence our joint attempt to bust the Eastern market. If you do not care to do this I will try to place it, but think that you have a better chance of success than I. Guard this MS—I have <u>no duplicate</u>.

One of the pictures I am now finishing would make a fine color-page with this, & photos of other works will be forthcoming soon.

Just now I am working on a <u>long</u> decoration for the Water Co's new building. Plenty Travelling.

Any developments concerning Dallas?

Yours
Maynard Dixon

Come to Arizona & cool <u>off</u>

Harshe is Robert Harshe (1879–1938), painter and director of the Art Institute of Chicago; Boswell is Peyton Boswell, founder of Art Digest *and art critic for the* New York Times; *and the woman writer is Ruth Pielkovo, author of the article "Dixon, Painter of the West," that appeared in* International Studio *in March 1924.*

. .

12. John Sloan

to Walter Pach

[postmarked 4 Aug. 1922]

2 PP., HANDWRITTEN, ILL.
25.6 X 20.3 CM.
WALTER PACH PAPERS, 1883–1980

Climbing La Bahada (no exaggeration!)

Dear Pach—

This is some of the kind of thing Im doing this Summer I have my own tin Lisbeth Ford and I can tell you it opens things up! Ive been driving a month now and its great fun I do it much better than I had ever thought I would. We had your postal with the "Big Model" reclining on her back a la Maya Do you know Chas Rumseys sculpture? Its very like it. Well! The Ford has made this a great great summer I had thought I was suited before but this makes it pluperfect—the spicy, sporty New Mexico roads, tricky and dangerous, are inspiring to the driver, and how we do get around to the Pueblo dances! Etc

We are enjoying our house & studio this year too! No "building" to bother us everything is in perfect order the orchard is having a hard time on account of the great dryness (this summer is the first typical dry desert summer we have experienced only 3 rains since June 1st!) Water is getting low in the mountain reservoirs we are not allowed to use any for irrigation. Ere long they may put us on bathing rations. Henris are here—he too has his car Randall Davey has a "Stutz" not in our class.

I have painted some and feel that I will get a few before the summer passes

I was glad to hear that you were painting in Mexico I know it will add all thats necessary to make your trip a thorough success to you.

I wrote and asked "Bayley" to come out a few weeks but he says he cant make it financially Im sorry I know hed get a "kick" from this land and would probably paint some good stuff

Well then isn't much news so Ill just fill up with our best very best regards to you Mrs Pach and Raymond (hope he's riding horseback) Bill

Davey is a little older and hes a great cowboy

Well till later
 Yours sincerely
 John Sloan

The Henris are painter Robert Henri (1865–1929) and his wife Marjorie; Stutz is a Stutz Bearcat automobile; Bayley is possibly A. S. Baylinson (1882–1950), a friend and painter; and Raymond is Pach's son, born 1914.

. .

13. Alfred Joseph Frueh

to Giuliette Fanciulli

Oct. 1912

4 PP., HANDWRITTEN, ILL.
17.7 X 11.4 CM.
ALFRED J. FRUEH PAPERS, 1909–CA. 1961

STRATHEDEN
TEMPERANCE HOTEL,
CUPAR.

Hoot. Bonny Birn:—

Brrrrrrr— My knees they be noo warum.

But what be that when yea hae a bonny pink envelope full of trash from a bonny little lassie from over the sea. Dinna yea ken, that trash from yea is noo trash to mae? An' if your letters be trash, what be mine, pray?

Your letter hae been a long time a reachin me (15 days) but that be noo fault of yearn, lassie, and I will noo be contented over here if you be all the time telling me to come with yea and hae a walk on the palisades or be a askin to hae me at year tea pairties but I'm fortellin' yea that I be noo beauty at a tea table.

I wood that yea be along wee us this week. If the weather be noo too baid, we be a going to walk across the Troasschs (I dinnoo ken if this is spelled aright.).

Eye, Did nae I tell yea that the Gum be noo much gid? Why do yea noo mind? Eye.

I betcha the Giants do noo win

We hae been here among the skootch since a Monday morning but the weather be noo too gid. It be coald. The way you love it, but they be noo sun.

Gimme Italy.

We hae noo been oot to Scotland yard as yet and we hae noo seen Andy Carnagie but we hae hae a high ball or 2—Eye I ken a gid dram shoop over behind the kerk where I kin ga some gid Skootch whisky. Eye—(A Saloon keeper over here is a Publican)

Eye. An I hae a mind to gay to Dancin' school and learn how to Highland Fling but I hae me doots whither I kin Larn it.

I hae noo mare to write you this necht but I will write you some mare soom other necht.

Do yea ken we hae now the penny post and I can write you two times as oft

Be a gid Birn or ye ken what will happen to yea.

Same ole goodlookin' me

P.S—INSIDE.
Yea must noo laugh at mae.
Memory from Belgium.
Translated from the French— heard it on the stage.—
A man ~~goes~~ went into a butcher shop and asked for a pound of steak as tender as a woman's heart and the butcher wrapped him up a pound of sausage—
How 'bout it?
P.S.
Write me soom mare trash. I wood NOT ➜ noo be happy withoot it

Aye. You just be a leavin' the country whin I get back. I'll be a follerin' yea and make your trip mizerable

I will noo come back broke.

. .

14. Joseph Lindon Smith

to his parents

8 Sept. 1894

3 PP., HANDWRITTEN, ILL.
21 X 13.5 CM.
JOSEPH LINDON SMITH AND SMITH FAMILY
PAPERS, 1647–1965

Venice 8th September 1894.

Dear Mother and Father;

Behold Jojo eating fruit!
Delicious fruits are here in Venice now—and I consume vast quantities of it. Melons pears peaches plums apples figs grapes and other things unknown to my interior.

To-day is a grand "festa" and I am taking a half holiday—The festa has come to a head in the church opposite the traghetto and the smell of frying things comes across the canal from the little campo where the booths are with the big shiny brass plates and the steaming things in the iron kettles.

There is to be music in the piazza to-night and on the Grand Canal and the 22nd of March Street and the campo are to be illuminated.

I eat fruit so much of the time and so much at a time that I go to bed at night expecting

To wake up this way, but I hav'nt yet

I have been back in Venice now 15 days—and have taken but two dinners alone—at the "three stars" 2 out of 15 which gives you an idea of the "push" I am in and the kind of social diner-out I have been.

The Bostonians begin to arrive and I shall take unto myself a second class ticket to Firenze—in 8 days more. I go up to the station to-night to meet and welcome to Venice the Greenes—Mr. and Mrs. Brimmer—Mrs. Whitman—Mr. and Mrs. Gardner—Mr. Clayton Johns—Mrs. Copley-Greene makes quite a "Personal and Social gossip" looking list does it not.

Mrs. Gardner wishes so much to have the extreme pleasure of having me make her a visit there that I have promised to go over on Wednesday and end my visit in Venice there.

I lunched there yesterday and showed my pictures and dined with the Brimmers and again passed them all out and told the same little anecdotes with the same inflexion of voice—and they seemed pleased and Colleroni and I are pretty well set up and conceited—for when they wer'nt admiring him—they were the workmanship—and I simply floated home in air I was that puffed up my waistcoat hasn't a button to its name—and the upper part of my trousers looks like two funnels.

And you will ask—you miserable money ideaed things you sordid American parents you will ask if I sold any pictures to Mrs. Gardner—so I will just say yes—"it was bit off"—and with love to you all

I remain your little sonnie JoJo.

Traghetto is Italian for "ferry." The Greenes are Mary Copley Greene, an artist and great-granddaughter of painter John Singleton Copley (1738–1815), and her husband James Sullivan Amory, who like Smith, are from Dublin, New Hampshire; The Brimmers are Mr. and Mrs. Martin Brimmer; Mrs. Whitman is Boston artist Sarah Wyman Whitman; Mr. and Mrs. Gardner are John Lowell Gardner, Jr., and his wife Isabella Stewart Gardner; Mr. Clayton Johns is a composer who taught at the New England Conservatory. "Colleroni," refers to a painting that Smith is working on, a view of the bronze sculpture of Bartolomeo Colleoni. The letter includes this anonymous annotation in the margin: The one armed man who being tormented by questions as to its loss said he would tell how it happened on condition that he would ask one question. The question was "how did it happen? The answer was". It was bit off.

. .

15. Rockwell Kent
to Frances Kent
16 July 1931

3 PP., HANDWRITTEN, ILL.
28.9 X 17.2 CM.
ROCKWELL KENT PAPERS, CA. 1840–1993

Igdlorssuit.
July 16th 1931.

My darling:—

It is some time since I've written—but there has been no prospect of getting a letter off and little leisure to write, living as I do in this crowded house of Jörgensens.

Fortunately when I left Umanak I brought along two barrels of cement. I've been able to start the foundation of my house. The rest of the materials, as well as practically all my goods & chattels are at Umanak; and there's no knowing when they'll be brought over. The motor boat has been brought north as far as Egedesminde and has been there, or somewhere, almost a week. We suspect that she has been commandeered by the [*illegible*] for governmental errands. So I'm stranded here: no tools, no paints, no building materials. I could get lumber, boards, here for my concrete forms—but these had to be bought. Nails there were none. I've had to use old ones out of boxes & crates.

But! This is a most lovely place. (Here I was going to draw a map—but there's not enough room. It will be on another page.

The view across the bay at the wilderness of mountains that is there is unbelievably lovely. The ice bergs that dot the water are always changing. Only the weather is constant.—warm and fair. There has been no rain since I've been here. It rarely ever rains.

My house is just behind the other houses so that I look down on the whole pageant of village life. It is perfectly situated. I'm part of the village but removed enough so that I can't be disturbed by it.

Jörgensen is grand! An intelligent and entertaining man, good natured, jolly; a fine companion. And his little Greenland wife is sweet. They hope to go to Denmark for a visit next year—with us. And she's training herself in Danish manners. It would be grand if youd bring her a pretty dress and hat next summer; she's small, quite slender, dark—of course. You'll maybe have something that would fit her. Bring some nice things for the Jörgensens. I'll be much in their debt by then. They have two sisters of hers here now as servants, but one is going south where the family belongs.

Always, darling, always I wish to God that you were here. Oh, I do love you so. And when I find your little "I DO's" in everything, I almost cry.

R.

. .

16. Allen Tupper True
to Jane True
[1927]

1 P., HANDWRITTEN, ILL.
21.6 X 14 CM.
ALLEN TUPPER TRUE AND TRUE FAMILY
PAPERS, 1841–1987

Dear Jane.

Many thanks for your letter and a lot of kisses for you.

Dad.

This is a lot more what New York looks like. This is me.

. .

17. William Zorach
to John Weichsel,
18 Oct. 1917

4 PP., HANDWRITTEN, ILL.
28 X 21.5 CM.
JOHN WEICHSEL PAPERS, 1905–22

Plainfield, N.H.
Oct 18th 17

My dear Dr. Weichsel—

At last I am going to get a chance to write you. Marguerite is away at Windsor Vermont about 10 miles from here boarding at a Doctors house waiting for the arrival of our little daughter!?? The doctors wife is a trained nurse so I feel she is in good care. I am alone out here in the back woods with Tessim. Everything is still & there isn't even the sound of a cricket the birds are all gone & the insects are all frozen I guess. This morning I saw the tracks of a deer in our garden but I havent a gun just now & if I did have I probably wouldnt have the patience to lay for one—I really have been trying to write you for a long time I hope you do not think that we have neglected our duty but there is so much to do on a farm its either feed the pig dig in the garden the horse or milk the cow & chop wood. It seems as though all that I have done this summer is farm. I have even worked out by the day haying cutting corn etc. Doing my bit. I suppose. Still I feel this has been a very profitable summer to us. We have gained a great deal of practical farming experience & some day we are really going to own a farm & really work it Marguerite loves to garden & I like animals. It gives me great pleasure to feed the pig & drive a horse & milk the cow I really like it & I like the chores around a farm. Perhaps I could or should have been a farmer. But there is something in the cities street one misses here & I'd like to be in the city for a little while in the winter. In other words I suppose I'd like I would really like to be a gentleman farmer with a winter home in the city well we will see perhaps some day we will quite gypsying around & settle down & try to collect a little cash & buy a farm.

I sold my horse the other day & got five dollars more than I paid for it so I've had the use of the rig all summer & received five dollars to boot I suppose if

I'd been a clever business man I'd would have made 25 on the deal. Still I feel that I did pretty well—When we leave we expect to sell our pig & make about 20 dollars on him. With our cow we have done pretty well too we rented a cow for 20 paid 5 for having her tested for tub. & got all the milk butter cream everything but eggs until we go. In fact we have never lived so luxuriously before in our lives. All the animals in the meanwhile have lived off the landscape. It costing us nothing to keep them Also we are going home with enough potatoes apples & nuts to live on for the winter—I hope I am not boring you with all this detail but such is life on a farm.

I hope you have all had a fine summer & I really hope next winter that I will be able to do more for the guild I hope you do not feel that I have neglected my share but it was really impossible for me to do any more. Marguerite could not come with me & I could not leave her alone. In fact whatever we do we have to do together. I appreciate how hard you have worked to make the guild a success. & I hope the guild will grow & prosper.

Marguerite asked me to remember her & she send greeting to Mrs. Weichsel & yourself

Also best wishes & luck from myself believe me as ever
yours

Zorach

Marguerite is artist Marguerite Zorach (1887–1968), William's wife; Tessim is their two-year-old son; the guild is The People's Art Guild in New York, founded by John Weichsel (1870–1946). Marguerite gave birth to their daughter Dahlov on November 12, 1917, in Windsor, Vermont.

. .

18. Frederic Edwin Church *to* Martin Johnson Heade 7 Mar. 1870

4 PP., HANDWRITTEN, ILL.
21.4 X 13.6 CM.
MARTIN JOHNSON HEADE PAPERS,
1853–1900

New York Mar 7th 1870

My dear Mr Heade

Why haven't I written?—Because I have had a string of influenzas thus -cold-cold-cold-cold-cold-cold- The one at the right is the last and I am not through with that—

We have had a mild summery winter—every body has had, is having, or is going to have had colds Old Father winter himself has finally taken cold and is chilled through—Mother Winters is well and often asks after you.

Interval for a Sneeze—The Artists say "the winter" has been dull—It looks a little brighter now say they—I saw Darley for a moment at the Century, Saturday night. He looked well—

I am ashamed of you for making such a fiascre trying to find Santa Marta—you were in this position

Why didnt you stick to it?—I saw the Mountain distinctly from the sea about 6 or 8 miles off Santa Marta town and also very grandly from Barranquilla—Bother your Tigers and varmints generally—Why all the Mountains in S.A. are full of them.

I tell you—you have missed a big thing—I have half a mind to go to Aspinwall collar you and trundle you off to the Mountain and make you sit for ten hours on the snow, lately an American Engineer studied the mountain and measured it—and here's one of our Artists—couldn't find it when he was actually sweltering at its foot. Perhaps the mosquitoes were in the way thus—

Its an awfully good joke. And I won't tell Mr. Bierstadt—only your good friends

However you have good sketching on the Isthmus and must feel repaid for your journey—I have had two letters

from you this is three so you owe me one—I am in the midst of "Jerusalem" but owing to my string of influenzas have really accomplished little this winter—

I have carefully stored your traps in the dark room by them selves and have had one corner and part of one end of the studio cleaned I shall try to get at ~~the~~ another corner soon—

There is a great effort making to get up a great Art Museum here—I am on four committees relating to it and thus keep my time pretty well filled—

Hays has commenced a huge flower piece—The Artists generally are pegging away as usual

There have been several inquiries for you at the door from strangers to whom I have done my politest. Your brandy bottle shows signs of evaporating and there has been one fly in the Studio who has eaten up all your sugar plums.

Gold is down to 112 ½ to-day—It looks as though par was coming. When are you coming? People will soon begin to enquire—

I shall be ready to vacate in your favor by May 1st if not a week sooner—

We are hungry for the Country—Bring me a lot of Alligator Pears—Chirimoyas—Granadillos Mamei apples—Mangoes—Bananas—Soursops—jackfruits—oranges Pineapples—Patalipas—Zipanes Akes—Zapotes—Plantains. Malafustimenscïteneoceotes—etc. etc. etc. etc. etc. etc. etc. etc

Will apologize for this letter in my next.

Yours sincerely,
Frederic E. Church

Church and Heade shared a space in the Tenth Street Studio Building in New York. Darley is illustrator Felix Octavius Carr Darley (1822–1888), who was a member of the Century Club in New York from 1850 to 1884. Mr. Bierstadt is Albert Bierstadt (1830–1902), who was Church's chief rival in monumental landscape painting; Hays is Dr. Isaac Israel Hayes (Church was giving him drawing lessons). The effort to "get up a great Art Museum" refers to the founding of the Metropolitan Museum of Art.

. .

19. Robert Frederick Blum

to Otto Henry Bacher

18–23 July 1887

4 PP., HANDWRITTEN, ILL.
20 X 12.4 CM.
OTTO BACHER PAPERS, 1873–1938

Mid Ocean
"The Rhynland"
Monday
July 18. 87.

Dear Otto

<u>This</u>!! is what sits opposite me—me—poor unoffending me!! (If you can't make out the girl—its the one that hasn't parted its hair!) But this isn't "enuf" on my right sits a thing that looks something like this and must be a Duchess at least from the air of superiority—with which it surveys this little world. It is French, and a capital likeness. Then on my left I have another joy something of this order. She is hardly my style being a trifle over the middle age and diseased with a frivolous desire to forget it. I think the pictures will be "enuf"—to go into details of characteristics is "too much" for your humble. So you see that I hardly have a chance to lose my heart on this trip—not just yet I guess, even if it weren't against my usual custom. Well the male portion is hardly better, & so between the two parties I am about the only one left to associate with and this takes up all my time—pretty nearly, excepting when I have other things to think about. I shall be glad to get over on the other side you see. The weather so far has been pretty good only too chilly after leaving that hot box New York, to be an agreeable change.

23rd Saturday

Well—we expect to get in on Mond some time if all goes well. I'm not at all sorry for it, strange to say even with that cheering prospect—of a dusty dirty railway journey ahead of me. I hope dear Otto that you have been a good boy all this time and have attended properly to the things intrusted you. By the way I wish you would take especial care of my jewelry (ha!!) No! but I left a pin (the one Chase gave me) in an old cravat—wont you kindly put it with those trinkets in the little box in the trunk? I hope all is well with you and "I want you should" write me often if not sooner.

Yours
Bob.

address for the present
℅ Café Florian
Venezia

In looking over the things today (Sunday) I found the pin

Chase is painter William Merritt Chase (1849–1916). Blum, J. Carroll Beckwith, and Chase were founding members of the Society of Painters in Pastel.

. .

20. John Von Wicht

to Will and Elena Barnet

14 Aug. 1956

1 P., HANDWRITTEN, ILL.
27.9 X 21 CM.
WILL BARNET PAPERS, 1938–2000

Aug. 14. 56.
Pownal—Vermont

Dearest Helene and Will,

I am very much ashamed to have waited so long with my letter, but we both, Will, know more now than we did 2 months ago. I hope that you and Helene had a joyful summer, good

swims and good rest, that your work came off fine and you sold many pictures there. This would help your finances anyway. I hope the summer was so successful that you will do the same during the following years, you have a loss by not teaching but you will have gained as an artist. One has to have time to work. How long will you stay there?

In any case we always are separated but this time Kuni will not be to lonely. She now has joined her sister in Belgium and will stay there for a week or two. Before she saw Paris, went to the Dordogne to see the cave paintings at Montignac-sur-Vézère. She really enjoys her trip, she returns about Oct 1st, when I'll be back. Yaddo June–July was a great help for me, now resting one month on this farm, then Sept. again at Yaddo, Saratoga Springs—N.Y.—Your canvas was a great help and very good, thanks so much Will, hope I did some good paintings.—Please remember me to Mr. Bing and to all friends there, Mr. Knaths, Botkin and so on. How does exhibition go, I probably never sold, I should have been there, but without a car it is hard to do.

All my best wishes and
love to both of you.
John.

Helene is Will Barnet's wife Elena; Kuni is Kunigunde, John Von Wicht's wife; Knaths is painter Karl Knaths (1891–1971); Botkin is painter Henry Botkin (1896–1983).

. .

21. Walt Kuhn

to Vera Kuhn

25 Sept. 1912

9 PP., HANDWRITTEN, ILL.
18.3 X 14.2 CM.
WALT KUHN, KUHN FAMILY PAPERS, AND
ARMORY SHOW RECORDS, 1882–1966

Amerika
Sept 25 1912
Wednesday,
Mid Ocean.

Dear Chick,

I repeat, I do not see what fun people get out of prolonged ocean travel. You will be surprised to hear that I have not been actually sick, although very close to it. The first two days out it was fine, and then we had very heavy weather. Almost every body sick, but I managed to stay up on deck most of the time, I missed one dinner in the dining room. No doubt being sick down from Boston, last week fixed me up. Don't think however that I feel fit, at present I am in a semi comatose condition, the boat is rolling hard but all danger of being sick in my bunk seems to be excluded.

Expect to reach Plymouth early friday morning, and not arrive at Hamburg until Sunday, which will make me hustle to get to Cologne.

The crowd is pretty punk on board, The usual quoto of jews, only 61 passengers in the 2d class. Opposite me at the table is a regular East side Jew with his whole family. I have been running about more or less with a Californian ranch man, a real "rough-neck," and a Kaufmann from Hamburg. We play poker for ¼ cent a chip. I've won about 40 cents.—My head is so weary that I hardly know what I'm writing but I want this to get off at Plymouth

Send the news to Pieschel (201 25 St. Guttenburg)

I forgot to attend to it.—Will send you some money in a day or so after I land. Have been trying hard to do some thinking about what I'm to do abroad, but the eternal swinging of the boat leaves me in a dazed condition. Nothing doing, I guess, until I land. Davies was fine, stayed with me on the boat until she left the pier.

I am getting more confidence as the time goes on, as to my doings to come,—

It's up to me to get a bunch of fine things and if it can be done within the money on tap, I am going to do it.

I only hope that I'm not too woozy next monday—that Cologne show is important. I imagine that ~~the~~ my dodging of sea-sickness is due to the fact that I have been taking a good stiff drink of Hunyadi every day, before breakfast—

Have been using the ship's library, although it contains nothing wonderful.

A huge wave has just broken over the lower deck, drenching a lot of resting stokers, etc This old ocean is surely a big "hunk of water".

The table is fairly good, although the deserts don't Touch Miss Amy's by a long shot—

Will write you again as soon as I reach Hamburg.

Love to you and all the folks
as ever
W.

Old lady from Berlin with a great appetite and a the autocrat of my table.

Chauffeur to a rich man in 1st cabin funniest man of the lot and a good fellow

Munich cape and hood

Two Harvard students, who have the world lashed to the mast and standardized to their ideas. (lots of fun!)

Swedish American girl traveling to Stockholm with her aunt to spend the winter there has, a trunk full of candy and lays around with the jew boy.

The Californian rancher tough and weatherbeaten but no fool.

Some of the frightened passengers at dinner. (They always look this way,

14 year old jew boy patronized by the swedish girl

Two Danes who never speak to anyone—

Strange figures in steamer chairs, are always there and never change

The deck steward.

Mr and Mrs Fink. Horse radish magnates going to spend the winter in der "Riviera".

(Excuse the awful draughtsmanship the old boat is a rolling to beat the band.)

A Hamburg saloon keeper returning from a 3 week trip to America, and who sings at every opportunity

Davies is Arthur B. Davies (1862–1928), president of the Association of American Painters and Sculptors, the group that sponsored the 1913 Armory Show. Kuhn was the secretary. Hunyadi, also known as Hunyadi Janos Water, is a Hungarian mineral water said to cure all ills.

. .

22. Joseph Lindon Smith

to his parents

ca. May 1891

1 P., HANDWRITTEN, ILL.
20.3 X 12.7 CM.
JOSEPH LINDON SMITH AND SMITH FAMILY PAPERS, 1647–1965

My dearest Parients;

Your son longs for Dublin—he will arrive Wednesday night or Thursday evening he cant <u>now</u> tell which—if he brings all the things you have asked him to, he will appear like this ↓

. .

23. Richard Kozlow

to Lester and Kittie Arwin

19 Jan. 1961

1 P., TYPESCRIPT, ILL.
26.5 X 20.3 CM.
ARWIN GALLERIES RECORDS, 1948–81

january 19
1961

dear lester & kittie,

received your note this a.m thank you for the enclosure also the news of the scarab blue ribbon was good for the ego as to my show i shall attempt to get some photos and all the necessary data for use in an article i am really sorry i sent those ~~color~~ slides . . . because the change set in just after my sending them just imagine in my last six paintings there is not one kozlow sun . . . melanie may want to divorce me i think they are the best group i have ever done . . all big and bold and all of the mountains . . . they simply knock me out . . . the mountains that is. just curious to know if you lovely people have been thinking of any plans for what to do with kozlow when he returns a show next fall in detroit seems too soon to me . . . what say you? how about out of town?

when are you coming to pay us a visit? we'd love to have you give the idea a long hard thought . . . our rates are very reasonable and the foods good and look how much you will save in phone bills.

oh yes . . . i thought one of those black & white landscapes would make a nice present for guy & nora by the by did we ever sell any of those or am i the only one who liked them?

what and who is new and exciting at the gallery? oh yes . . . please extend my congratulations to caryl hayeson on her show i'm sorry i am so late in sending my wishes . . she's a doll.

must go now . . . keep well and happy . . . we miss you much oh yes i'm forming a "morley for mayor" committee down here. give her our love

lil richard

. .

24. Robert Frederick Blum

to Otto Henry Bacher

20 Nov. 1890

3 PP., HANDWRITTEN, ILL.
27.4 X 19.7 CM.
OTTO BACHER PAPERS, 1873–1938

Tokio Nov. 20. 90

Dear Otto

I rec'd your last enclosing Mary's delightful little note and was pleased to learn that the little gown proved acceptable. I had no idea it would cause much bother—but I guess it didn't worry you too much since it was for Holland. You see I say Holland because that is what he will come to be called eventually—well I will try not to feel too jealous. If you were over here now you could really enjoy having a baby boy for you could take him around with you wherever you went—down to the Century or Scribner's—anywhere. He wouldn't be in your way as he ~~is~~ would be strapped securely to your back and you could have your hands free for shopping in case Mary told you to be sure not to forget to bring along so & so on your way home. But fancy you walking down Broadway like this—

As for news—I am hard at it finishing the third & last paper of Sir E's and expect to get the things off by the last of the month—must in fact. But this was the hardest of all three and with all my planning out I fail to get more than about 5 drawings and those anything else but what I would care to send. The drawings are of the dances and I had to squander a good deal of gelt to get some of the girls to pose. I wouldn't mind if I had got some stunning drawings—well I did the best I could so don't hit a man when he is down. I can see Brennan's smile when he will see the drawings and

his snort of contempt but—it won't be nearly as vigorous as my own so it don't disturb me much on his account. However being of a spiteful nature I wish some damned adverse fate would cast him on these shores so I could enjoy some of those productions evolved from his own individual consciousness—and get square with him. Excuse this ragtag letter but I'm very tired and only wanted to send word that I still loved you all

Bob.

P.S. please Otto send Charlie Fairbanks the money for a year's subscription for Sunday Sun. He is sending them but now that I expect to stay for some time I can't of course expect him to furnish me with a paper every week. Willy will pay you back.

Bob.

Mary is Mary Holland Bacher, wife of Otto Bacher; Holland is Robert Holland Bacher, Otto and Mary Bacher's first child, born in June 1890; Sir E. is Sir Edwin Arnold, author of a series of articles on Japanese life and customs that Blum was illustrating for Scribner's; and Brennan is illustrator Alfred Laurens Brennan (1853–1921).

. .

25. Paul Bransom

to Kicki Hays

17 Oct. 1947

10 PP., HANDWRITTEN, ILL.
27.8 X 21.5 CM.
HELEN IRELAND HAYS PAPERS
CONCERNING PAUL BRANSOM, 1903–79

That good old
Canada Lake, N.Y.
Oct. 17ᵗʰ 1947

Dearest Kicki:

At Last! I have a chance to really get down to write to you and to thank you for your fine letter which gave us so much pleasure—It is so nice to hear of all your activities and to know that you are well and happy and that you think of us—as we certainly often do of you—We miss you very much indeed and each day as we go "Post Officing" and for "Watra" we wish that you were here to enjoy the beauty of the woods with us.

At one time about three weeks ago it seemed as though we should not have our usual fall color sensation. There were several nights of below freezing temperature and many of the leaves on the trees in open places were just plain frozen—all curled up and black—as though they had been burned! These leaves promptly fell off but those that were left eventually took on their usual autumn as glory—

The old trail along the short-cut and the road down to Barbours camp have been unbelievably beautiful—a lane of golden delight—and ~~each day~~ for the past two weeks a succession of warm, clear, languorous days.—As Aunt Grace and I walk through the soft colored stillness broken only by the rustle of falling leaves and the swish of our own feet through the dry carpet, we muse on past days and those to come—now almost all the trees have dropped their gay dress and wait for the harsh advances of the north-Wind and his rough caresses.

I cannot help reflecting how beautifully and gracefully the season ages—and accepts it's fate with simple resignation—so different from your recalcitrant Uncle who is always young with you in spirit—as you play ball, climb trees, swim and dive! and ski: This reminds me to tell you that Mr & Mrs Gore came in to see us a few nights ago and showed us a very remarkable enlargement of a snap-shot of Midge at the peak of one of her big moments in her sail-boat. It was taken by Doctor Bataglio (?) as he sped past in a motor boat and it looked something like this you can see the whole keel and boats' bottom out of water—it's really quite a picture—

Another thing—you ought to see the lake water level now! It is like it was several years ago when we had the broad beach all around and when the lake suddenly came up three feet after the heavy rain—remember? Well, we have the same thing now except for the rain which has been non-existent for almost a month—every thing is very dry and the Governor had ordered the woods closed and no hunting season—(Im glad for the latter!) But, to get back to the water—at the end of your boat-house, just under your diving-board there is now just about six inches of water— you'd have to make a very flat dive now! As Aunt Grace told you we easily walked all the way around the bay and out around "Fort" Breeze point—

I wonder if your mother told you about all the black-birds we saw during a short walk on Sunday—We first heard their noisy chatter when we reach the Trobridge camp and discovered them bathing all along that little sandy cove between Eberly's bridge and his house. There must have been a flock of two or three hundred and it was lovely to watch them splashing all along the length of the shore in the warm afternoon sunlight—They would take alarm and all fly up en-masse into the pines lining the shore and in a minute the whole crowd would drop down to the beach to resume the bathing—this performance—up and down—went on for a long while to our great delight—speaking of birds and animals, reminds me to tell you that Miss Trymason said that two small otters spent a morning playing and frisking around her back yard last week! So, those little fellows you all saw in your boat house were evidently that same otter family—I do hope that nothing happens to them during the winter and that we may have the fun of seeing them occasionally next summer—Next summer—what a long way off that is—So many things to be done in the mean time—

Jean Wells, who was here recently to do some sewing for Aunt Grace told us that her garden and in fact all around Johnstown were many praying Mantis—she says the place abounds with them now—and if you were here you could have lots of them—(all eating each other, I guess) I immediately thought of you and your pet mantis when you first stayed with us—remember?

I must tell about a lovely trip we had with the Trobridges last monday. We drove over through Benson to Northville and down the entire shore of the Sacandaga Lake to the dam. It was the first time we had ever been down that other shore—the day was perfect—heavenly color and the low lake level gave the water's edge a striking border of sand and gravel edging—a yellow fringe to the blue water with brown and red-gold hills all around—At Conklinville the site of the dam—the road rises steeply along the shoulder of one of the mountains holding the dam and there is a turn out where one can park cars and get out and look! And what a grand "look" it is—the top of the broad dam holding back all that water stretching away into the hazy mountains as far as one can see—and below the dam a thin rocky river wending its noisy way down the narrow valley to keep its tryst with the lordly Hudson a few miles further on at Hadley—After enjoying the view—We also drove down to Hadley and just there at the confluence of the two streams there is an old iron bridge across the Sacandago—a fine place to stop and see the eager waters meet and join and flow onward together rejoicing in thier marriage—

From there we drove along the Hudson to Corinth and thence to Saratoga Springs for dinner and back through Gloversville to home—Quite a trip—One that we hope you will do someday—if you haven't already done so—Maybe we can do that together next summer—also I do want to show you that water fall and rapids over at

Griffin—Perhaps you will remember that I wrote to you about that place?

Last Sunday Mrs Scott drove up from Cooperstown to spend the weekend with us—She is teaching art and handicraft there at the Knox School—Anyway—she was anxious to leave early in the afternoon so she could get back before dark—she has an old old Ford—which she calls Louie—We planned to have dinner about three P.M and I was to do the chops outside—at 2.30 I laid the fire and lit it—Then people began to arrive—I wish you could have seen me—running back and forth—between trying to entertain company and keep that fire going—I burned up wood and the fire almost go out—I'd run frantically to the wood-shed for more wood—get another fire blazing—come back in the house and visit—Excuse myself—run out to the fireplace and find the fire all burned out—!! Run to the wood shed—more wood—another fire! etc—etc— Honestly, I burned enough wood to eventually cook those six little chops to have cooked several whole oxen!! Mrs Scott finally got her dinner—jumped in her car—just before dark and rushed out our back road—She afterwards wrote us that she brushed off one of her headlights in her hurry!

I'm still working on your book-plate whenever I have a chance—I'm sorry it isn't finished yet—Please be patient with me—If you could see it now—it looks as though a dozen mice had been chiseling at it with tiny teeth—Wouldn't it be nice if some of our mice could chew out a few letters on it some nights as I sleep. Like those who worked for the Tailor of Glouster—remember "NO MORE TWIST"

I must close now and to bed—before the length of this letter will tire you and send you to bed too—Good night—Pleasant dreams—

With much love—as always,
Your devoted—
Uncle Paul

We leave next Wed. for 15 West 67 St. N.Y. City—All afternoon I've been tying up packages. It is so hard to say goodbye to the Lake—as hard as to say goodbye to you—

. .

26. Charles Nicholas Sarka

to Paul Bransom

18 Apr. 1917

7 PP., HANDWRITTEN, ILL.
26 X 21 CM.
PAUL BRANSOM PAPERS, 1862–1983

692 Madison Ave
April 18/17

Dear Paul

While bent on my morning daily journey of going to the store for provender for our breakfast. Peggy and I e'spied a missive in the mail box down stairs, whereupon, after extracting said missive from said box with no small difficulty and plus much finger pain and anxiety mingled with aprehension & wrath (as I allways leave the key up stairs 5 flights) We managed to get a half-Nelson on the postal card and draged it shrieking from its' hiding place—when low and behold it proved to be, (on close inspection) from One Grace to another Grace, having nothing otherwise important ~~about~~ with which to occupy our walk for 4 or 5 blocks where the Delicatessen store begins to mark the way to the busy marts and markets of ~~uper~~ upper Madison Avenue & the sky a clear morning blue above with fleecy puffs floating on its' assure vault—as reminders of ~~last weeks~~ yesterdays and festivities long past,—We noted allso that the card was dated the 1st April.—Now we don't wish to criticize Uncle Sam's mail system but only call attention to the fact that this day being the 18th and if my memory serves

us right Green Lake is not quite a 17 days' journey, be it by boat, train or stage if its' the fault of the "Green Lake postal authorities high state of affenciency" Uncle Sam is not to blame for Green Lake allways enjoyed a special charter in that line for so long it would hardly be cause for trying to disrupt its' time old industry in starting a new precedent, or frankly speaking; throwing a monkey-wrench into its' high-power-gear. Rural Postmasters letter carriers and neighbors bringing your mail have, from time immemorial—allways had the previlige of reading unsealed postcards, not officialy but technicaly we were a "Letter Carrier" and did not deem it amiss to appropriate the previlige allso—by that time Park & Tilford's store was within hailing distance—and Mr. Tifford was just in the act of dusting off the fruit on the front walk in front of his store accordingly, hailing him a cherry good morning to which he responded right smartly we proceeded to get down to the business at hand, wiping off a last year's apple on the inside lining of his coat he informed me (as a preliminary to our conversation) that Gold label flour was now $14 a barrel. yep. fourteen iron men, allmost a weeks wages and "butter" of the best brand the same as what Mrs. Tilford had just churned that morning—was now 54 cents a lb. I said that was rather a high price to charge an old neighbor but he stuck to that price and wouldn't come down a cent neither on the flour—said he would probably pay the freight on the flour if I bough some other articles to go along with it. Old Mr. Park was'nt around anywhere or I'd a bargained with him on the prices But Ole Til Lowed his partner hadn't any more to say about it then he. so Peggy and I left him polishing up his apples.

Now what do you know about that? fourteen a barrel. Why I don't pay as much—as that for my cigars.—

Now Paul—if you carried that postcard around with you in your boat and got it mixed up with the bait and

discovered it after a lapse of time just leave out that part of the letter if you read it aloud I have done the same thing even when I didn't go fishing—You remember "Oh!—Hall" he was in to see us last week has been married again is now the partner in a large picture factory—with a large art-Dept of about 15 chained to the Oars. ~~in~~ Cleveland Ohio, hails him as one of her most respected citizens, which means he has a tin-wagon a motor boat that doesn't run a lawn mower in good working order & so far four kids tearing up the house to complete the happy state of man. The Independents Artist Assn'. is no exposing it's Art at the Grand Central Palace some 3000 oil paintings in all, was there the other day two or three other people were wandering around making loud echoes with their feet—the advanced Arts have an atomsphere of staleness mingled with a feeling of "where have I seen that before" & lonliness—it is becoming a bore as Old J. G's B's news-boys. Another year and it will be sadly laid away to "rest."

Saw Kuhn some time ago befor the War resolution was passed he had a scheme for making posters to stimulate recruiting asked if I'd do some I said "Sure" and am waiting to hear from him now.

Schow is married and quiet. Everything going along as usual The Coons and Brown Bears eat just as many peanuts as usual. Should peanuts advance in price that would be certainly cruelty to animals, wild animals would no longer be tame. And as for when we get up to the Lake it is possible to say yet but I 'ope 2 soon.

I shall have to rent our suite first any way and get probably a million-dollars next in order to lay in a stock of grub—let's hear from you oftener, all about the Lake how does our place look. give it the once over—and-the-dock. where are you living and how's the weather up there is the ice gone out is the water high??????????? Etc.—here's a little article I cut out of

the paper think you'l enjoy it—with best wishes to Grace Harry & yourself—write anon

Sincerely Yours
Chas. Sarka

Old J. G's B's is John George Brown (1831–1913) known for his paintings of newsboys and bootblacks; Kuhn is painter Walt Kuhn (1877–1949).

. .

27. Marcel Duchamp *to* Jean Crotti
8 July 1918

7 PP., HANDWRITTEN, ILL., IN FRENCH
24.6 X 20.1 CM.
JEAN CROTTI PAPERS, 1910–73
© 2004 ARTISTS RIGHTS SOCIETY (ARS), NEW YORK/ADAGP, PARIS/SUCCESSION MARCEL DUCHAMP

N.Y. 8 Juillet. 33 W. 67

Mon cher Jean, Yvonne t'a écrit et tu as reçu le cable que j'allais et probablement Yvonne aussi partir pour Buenos Aires—Plusieurs raisons que tu connais: Rien de grave; seulement une sorte de fatigue de la part des A.—Des gens malintentionnés ont probablement arrangé les choses ainsi—J'ai vu dernièrement Lou qui a été très gentille—Walter vient de perdre sa mère. Il est à Pittsburgh et je ne l'ai pas vu depuis un mois. J'ai fini le grand panneau pour Miss Dreier et j'ai recommencé une autre chose plus intéressante pour elle aussi. Tu te rappelles les ~~les capes de~~ coiffures de bain en caoutchouc de toutes couleurs = J'en ai acheté, les ai decoupées en petites bandes irrégulières, les ai collées ensemble, pas à plat, au milieu (en l'air) de mon atelier, et attaché par des ficelles aux différents murs et clous de mon atelier Ça fait une sorte de toile d'araignée de toutes les couleurs.

J'ai presque fini ça—Si tout se passe comme je l'espère, il y a un bateau partant le 3 aout-ou bien un autre vers le 14 aout-Si le bateau du 4 aout n'est pas réquisitionné par les Etats Unis, nous devrons le prendre; il est beaucoup moins cher : $200 jusqu'à Buenos Aires direct—L'autre, le 14 va par Panama, le Pacifique et Valparaiso, Chili où nous prendrions un train que traverse jusqu'à Buenos Aires en 2 jours. Ce second est plus cher; le voyage coûte prés de $400—

Le premiere met 27 jours.

Le seconde met 21 jours—train compris.

De Sur le bateau je t'énverrai un petit mot t'annonçant que nous avons quitté la N.Y. et comment!

Nous avons eu le cable de Suzanne et Yvonne je crois est contente de partir—car comme tu l'avais déjà constaté ici est bien changé, atmosphère et tout. Contraintes règne—Je n'ai pas travaillé à mon verre depuis que tu es venu ici et n'ai pas grande envie.

Probablement une autre ~~at~~ terre me permettra d'avoir un peu plus d'entrain—

Ne parle pas à ma famille de ce départ, que je veux annoncer que du bateau—En même temps qu'á toi j'écrirai à Rouen et à Puteaux. Mon intention très vague est de rester longtemps là bas, plusieurs années vraisemblablement-c-à-d. au fond couper entièrement avec ~~cet~~ cette partie ci du monde—

Tu pourrais avoir envie de venir à Buenos Aires. Peut être t'y verrai je plus tôt que nous ne le croyons tous les deux.

—Ce soir je viens de poser une petite scène de blessé soigné par une superbe nurse dans un film de Perret qui s'appelle: <u>Lafayette, we come</u>. Si par hasard ce film est donné à Paris va le voir uniquement pour ma petite scène de 2 minute.

Yvonne espère pouvoir arranger ses affaires avec ta maison qui a un correspondant à Buenos Aires, de sorte qu'elle est je crois contente de voir un soleil un peu moins humide que celui de N.Y.—

Je vais chercher des leçons français là-bas, car je n'espère pas trouver d'amateurs d'art moderne et n'ai pas l'intention d'exhibiter quoique probablement le pays doive être amusant à cultivar dans ce sens—

J'emporte tous mes papiers pour travailler à mon verre pour finis sur le papier tous les dessins-de sorte que si un jour je repasse par N.Y. je pourrai finir assez rapidement cette grand saloperie.—

Au revoir, vieux. embrasse Suzanne pour moi dis lui mes excuses de ne lui avoir pas écrit, prends en ta part—

Quand tu me reverras, j'aurai beaucoup changé beaucoup!

très affectueusement à vous deux.
Marcel

En principe tu peux écrire Poste Restante Buenos Aires-J'irai de temps en temps à la poste dans les premiers temps jusqu'à ce que j'aie une adresse fixe que je puisse t'envoyer—

English translation:

N.Y. July 8. 33 W. 67

My dear Jean, Yvonne wrote to you and you got the cable announcing that I, and probably Yvonne too, are going to leave for Buenos Aires—Many reasons that you already know: Nothing serious; only a sort of fatigue on the part of the A.—Some ill-disposed people probably arranged things this way.—I recently saw Lou who was very kind—Walter has just lost his mother. He is in Pittsburgh and I haven't seen him for a month. I finished the big panel for Miss Dreier and I started another more interesting thing for her as well. You remember those rubber bathing caps of many colors—I bought some, cut them up into small irregular strips, glued them together, not flat, up in the middle (in the air) of my studio, and, attached by strings to different walls and nails of my studio, it makes a sort of multicolored cobweb.

I have almost finished this—If all goes the way I hope it will, there's a boat leaving on August 3rd—or another around August 14th. If the boat of August 4th is not requisitioned by the United States, we should take it; it's much less expensive: $200 direct through to Buenos Aires—the other, of the 14th will go by Panama, the Pacific, and Valparaiso, Chile, where we would take a train that crosses over to Buenos Aires in 2 days. The second one is more expensive; the trip costs almost $400—

The first takes 27 days.

The second takes 21 days—including the train. I will write you a note from the boat to let you know that we left N.Y. and how!

We got the cable from Suzanne. And Yvonne, I think, is happy to leave—for, as you've already noticed, everything here has changed, atmosphere and all. Constraints rule—I haven't worked on my glass since you came here and I have no desire to.

A different country will probably allow me to have more energy.

Don't speak to my family about this departure, which I want to announce only from the boat. At the same time that I write to you I will write to Rouen and Puteaux. I have a very vague intention of staying down there a long time; several years very likely—which is to say basically cutting completely with this part of the world.

You might have the desire to come to Buenos Aires. Maybe I'll see you there sooner than we both think.

—Tonight I just appeared in a little scene as a wounded soldier attended by a gorgeous nurse, in a film by Perret called <u>Lafayette , we come</u>. If by chance they show this film in Paris, go see it just for my little 2 minute scene.

Yvonne hopes she can work out her business with your company through their correspondent in Buenos Aires, in such a way that, she will I think, be happy to see a sun which is less humid than that of N.Y.—

I am going to look for French lessons down there, since I don't expect to find devotees of modern art and I have no intention of exhibiting, even though the country would probably be amusing to educate in that respect.

I am taking all of my papers in order to work on my glass and finish all the drawings on paper—so that if one day I ever stop by N.Y. again, I would rather rapidly be able to finish this big piece of trash.

So long dears, kiss Suzanne for me, and tell her I am sorry not to have written her, or you for that matter.

When you see me again, I will have changed a great deal!

very affectionately to you both,

Marcel

As a rule, you can write to me in care of general delivery in Buenos Aires—I will go to the post office from time to time in the beginning, until I have a definite address that I can send you—

Translation by Francis M. Naumann in "Affectueusement, Marcel: Ten Letters from Marcel Duchamp to Suzanne Duchamp and Jean Crotti," Archives of American Art Journal 22, no. 4 (1982): 10. Yvonne is Yvonne Chastel (1884–1968), Jean Crotti's ex-wife (they divorced in 1917); A. is collector Walter Arensberg and his wife Louise (Lou); Dreier is Katherine S. Dreier (1877–1952), an artist, writer, collector, and booster of modern art; the big panel for Dreier is Tu m' (1918), Duchamp's last work on canvas; the sketch is of Sculpture for Traveling (1918), one of Duchamp's readymades (the original has disintegrated); Duchamp's family lived in Rouen and Puteaux; Perret is film director Léonce Perret (1880–1935), who shot the movie La Fayette! We Come! in New York in the summer of 1918 (Duchamp was an extra in one scene); "my glass" is The Bride Stripped Bare by Her Bachelors, Even (The Large Glass; 1915–23); Suzanne is Duchamp's sister, whom Jean Crotti married in Paris in 1919.

. .

28. Paul Suttman

to Red Grooms

18 May 1963

1 P., HANDWRITTEN, ILL.
31 X 22 CM.
RED GROOMS PAPERS, 1960–66

18 Maggio, 1963

Dear Friends,

We are all still here in Tavarnuzze, KK fell off the [*sketch of scooter*] & broke her collar bone!! We are moving to a BEAUTIFUL house near Impruneta (June 1st) & we go to Sardegna next week. KK has a parrot on her cast on her arm. We like to get letters from friends ← yes love KK

PAUL SUTTMAN

KK is Katharine Kean. In 1963, Paul Suttman and his second wife, Evelyn Gwinner (known as Gwin) and Katharine Kean shared a large farmhouse, a casa colonica, *near Impruneta, at Bagnolo, Italy. The Suttmans met Kean through Mimi Gross.*

. .

29. Mimi Gross

to Reneé and Chaim Gross

6, 10 Aug. and 5 Sept. 1968

3 PP., HANDWRITTEN, ILL.
PAGE 1, 34 X 49 CM.; PAGES 2 AND 3,
21 X 14 CM.
CHAIM GROSS PAPERS, 1920–83

—Dear Renee & Chaim—
AUGUST 6. '68

EVERYWHERE is bustling. It is MARKET DAY here in NOVI PAZAR (bottom of Serbia). Thousands of farmers are here, with horses & wooden saddles and sheep, chickens, goats, carts, bags, baskets, rugs, woolen suits, skull caps, cloths around heads, Muslim scarfs, moustaches, watermelons, green pears and green peppers, plums, potatoes, grapes, tomatoes, peaches, raggedy scrawny kids, patched-up old men, toothless, braided, hump-backed, 8 meter wide pantaloons, embroidery threads, cow & sheep cheese, 3 meter high ice-cream cones (in a row), HOT HOT sun and skies.

Red & I sit peacefully under an umbrella drinking Turkish coffee and lemonade. This morning we drew from our hotel window looking at the main square as the people went to the market. At one point a thousand people passed by in a funeral procession. The noise of carts was like New York. [an incredible moustache just came to the cafe].

Now we have been a week in Serbia: looking at the Midieval Monasteries. We have been to: ARILJE; ZIČA; RAVANIČA; MONASIJA; KALENIČ; STUDENIČA; SOPAČANI—and today we are going to an 8th century church here in town & another monastery (Serbian) MILEŠOVO. Then, south to Montenegro & Macedonia → Pristina, Skopje, Ohrid (on a lake) & up along the Albanian boarder to Dubrovnik where we'll take the boat to Bari. We're very glad we decided to see the Monasteries. They are as beautiful as expected. All in isolated hilly locations—some striped brick & stone others limestone. They have all been defaced by time, weather & the Turks—but whether fragments or whole walls the mixed Byzantine & attempts at individuality are so sensitive, it is impossible to feel it just from photos. Sometimes we picnic on a mountain top, or wash the clothes in a brook & draw while they dry. Sometimes the peasant children come around & we draw them.

Two days ago we went to visit a naive painter (most famous in Yugoslavia) who lives in a tiny town & is a farmer. We saw all of his work. & had a great cheese & peppers & eggs &

bread & shlivovitz together. & all of us drew together. All of his family gathered. He said he was glad to know he had friends from NUJORK.
UROŠAVAC—FRI. AUG. 10th

Well, we've been on a marathon trip since last writing & I hope today to post letter in Skopje where w'll be later this morning. It is the city where ~~on~~ a few years ago there was an earthquake. Now we're in a tiny town—still in KOSMET—not yet MACEDONIA. The Muslims ~~here~~ wear very very bright costumes—the ladies in print blouses & trousers & deep deep red aprons & red socks. The men in pointed white felt skull hats. There are many Albanians & they're very beautiful—& very poor. The kids swarm the car till it's black outside the windows. They don't ask for money or anything—just, where we're from & what language do we speak. Yesterday we went to a jewel of a Monastery: GRAČANICA—all decorated in the construction with brick, stone & mortar designs—endless brick handiwork & crescendo of domes.

Thursday—
5/September.
Monte ~~Sa~~ Gargano [Italy].
I thought we would be heading towards a city, so I didn't mail letter #1. We just spent 3 nights & 2 days at a fantastically beautiful isolated beach, with huge limestone cliffs & grottoes. (we slept inside the grottoes) There is a huge super delux hotel being built there—fortunately not finished yet—so we were all alone. Also, with the german couple with whom we've hooked up for a couple of days. Now we are heading down to Foggia where I can mail the letter.

Now I'm worried maybe you left P'town for New York?!! Maybe there will be a letter in Taranto from you—? Please write us to Palermo (see envelope)

We really just had our 1st vacation—doing absolutely 0 but sitting in sun and swimming. But we went to

town once to buy some food & found an extraordinary DRUGSTORE—with all the drug things on one side & on the other an enormous artifact & archeological collection—Roman, Pre Roman, Pugliese ceramics from 17th century, silver, coins—oh, everything. all in great disorderly order. He told us alot of things about the area; & showed us everything piece by piece—& we were very impressed. Especially—the Pugliese pots have now completely disappeared & he had so many to see.

Now we are in Foggia & have eaten well, & about to see the cathedral & then on to a fortress, lucera, nearby—where we will probably be sleeping.

Please, please forgive me for not writing more—I mean to, & then the days go by.

We think of both of you all the time—& hope all is really well.

I will write again from Taranto, where we will be in a few days & for a few days. lots of love & kisses xxxx

Mimi & RED

Red is Mimi's husband Red Grooms (b. 1937). P'town is Provincetown, Massachussets, on Cape Cod.

. .

30. Paul Bransom

to Grace Bond

ca. 1905

3 PP., HANDWRITTEN, ILL.
28 X 21.5 CM.
PAUL BRANSOM PAPERS, 1862–1983

Monday—

My Sweetheart—

No doubt you are now rehearsing in Boston—& thinking of your boy between songs. & I—am simply full of you—all my thoughts—

Oh: It was a dear letter I got from you this morning & so thoughtful & considerate of you to write me from New York—I certainly do appreciate it dear heart. Am going to take my first lesson again from Kimball on Wed. (that's when the ghost walks) We had some company up last night & were singing & carrying on—but I was awfully blue & thought about you all the time—I expect I was thoroughly a bore to those present. I hope you won't get used to being with out me. I'm sure I can't get along with out you. I hope you have nice comfortable lodgings & are eating regular—I want to take real good care of your self—I want my girl to be strong & healthy—Give my regards to Mr "Mac" if you see him & tell him how I regret not having been able to meet him—Mother & Sister send love—also Mammy—In my minds eye I can see Hollis street theater & the stage door so plainly. Oh! I wish I were there with you—I agree with you that our home is going to be perfect—It could not be otherwise while we love each other so.

I will never cease to love you with all my heart—dear—nothing but great love for you until tomorrow—

always yours
Paul

. .

31. Rockwell Kent

to Frances Kent

13 Sept. [1926]

2 PP., HANDWRITTEN, ILL.
27.3 X 21.3 CM.
ROCKWELL KENT PAPERS, CA. 1840–1993

Glenlough.
September 13th
Weather
Mood?
But!

In reply, dear madam, to your recent
inquiry I beg to state

I
DO!
in spite of everything. do you?

Health—as usual.
Behavior? EXCELLENT.
Ticket rec'd O.K.

Panels? No.
Wool? yes—all of it.
And the McGinleys are at work on it.

One side covered already! What
long letters I do write! Oh Darling: I am
so terribly lonely for you. Even the
friendliness of this little house becomes
a thing that hurts with you away. It's too
long until October 9th And then 8 days!

The weather is too bad to paint.
Incessant rain. So I've been working in
the house writing. I've made an outline
of the drama of Tristan and Iseud. And
to-day I wrote the first chapter of the
book we talked about. How is NOTH-
ING ON for a title? I think it's a grand
one. A good title requires to be—provok-
ing, inviting, and suggestive. I think
we'll make a grand book of it. Let's try.
Hurry and learn stenography.

While I think of it:—A lot of my
canvasses and frames are stored with
W.S. Budworth & Son—424 West 54th St.
I believe. Look it up. When you get a stu-
dio have them deliver the things there.
I'll enclose a note you can send them.

Yesterday I carried the dublin wool
to the McGinleys—the other Mrs. McG.
took over a day or two before. I found
that she had made one sample sock of
the blue and gray. It was grand. They'll
work hard on them to get them finished
for me. Old McGinley started the mash
for another lot of poteen. They want me
at the making. God help me!

Sweetheart—my thoughts are
always with you. Oh it is lonely. But
that's because you have been so sweet
and crawled all through me with your
loveliness, that now I'm just always
hungry without you. My darling.

Now, my sweet one, I shall go to
bed, where your pillows beside me have
still a little of you about them.
Goodnight, my sweet.

Thine forever—
Rockwell.

I've mailed the 14 more tail pieces to
Adler—Saturday.

*The "outline of the drama of Tristan and Iseud" is Kent's
screen adaptation of the romance of Tristan and Iseult. While
he produced an outline, which he sent to George G. Putman for
consideration in 1927, Kent never published his treatment of
Tristan and Iseult. Adler is Elmer Adler (1884–1962), a book
designer and proprietor of Pynson Printers, Inc., in New York.*

. .

32. Eero Saarinen

to Aline Bernstein

[1953]

1 P., HANDWRITTEN, ILL.
27.9 X 21.4 CM.
ALINE AND EERO SAARINEN PAPERS,
1857–1972

DARLING

ACTUALLY I HAVE GOTTEN
QUITE A LOT DONE IN THE OFFICE—
I HAVE WORKED QUITE A BIT ON
MICHIGAN—WHICH I WOULD LIKE
TO SHOW YOU—BESIDES THAT I HAVE
WORED I BIT ON A NEW SCHEEME
FOR FINNISH LEGATON WHICH I
WOULD LIKE TO CONTINUE
EVENINGS AT HOME ON—BESIDES
THAT I HAVE KEPT TRACK OF THE
LUTHERANS AND SOME ON
MILWAKEE AND SOME ON THE
BANK.—THE BIG PUSH NOW IS
MICHIGAN BECAUSE WE DO WANT TO
COME UP WITH A GOOD SCHEEME
ON THAT. DARLING I LOVE YOU.

MICH. SCHOOL OF MUSIC AS OF TO
NITE

. .

33. Waldo Peirce

to Sally Jane Davis

25 Apr. 1943

1 P., HANDWRITTEN, ILL.
27 X 21.5 CM.
WALDO PEIRCE LETTERS, 1943

For Sally
Easter Sunday
25 april 43

Oh my heart's in Louisiana—
Wherever my rump may be—
For there on this Easter Sunday
Are my Waccodils all 3—

There's a portion for Jenie Belle
And another for Addie Lou
And last but not least, Sally Flashbulb,
A good thick cut for you—

Would you like it well done or tender
Hardboiled or fricasie—?
O my heart's in the land of the
bayous—
Pleasantly Delightfully—cleft in
three.—

. .

34. Moses Soyer

to David Soyer

[1940]

1 P., HANDWRITTEN, ILL.
22.7 X 15 CM.
MOSES SOYER PAPERS, 1920–74 AND
UNDATED.

Dear David—

It's terribly hot here you're lucky
to be in the country we enjoyed fat par-
ents day very much. The children did
well. So did the grown-ups. Ida is com-

ing up to camp this Friday or Saturday. She is going to bring with her a little Viennese boy. He is a refugee. Be kind and friendly to him. ~~This is~~ make things easy for him.

MOSES—Love & Kisses

Whittey Brownie

. .

35. Alfred Joseph Frueh

to Giuliette Fanciulli

29 Jan. 1913

7 PP., HANDWRITTEN, ILL.
18.2 X 13.8 CM.
ALFRED J. FRUEH PAPERS, 1909–CA. 1961

Paris 29 Jan 1913

Dear little "Black Bird"

"The "Pinkies" for hapiness"

Good night
Alf

PS—I had to tear up a "P" to do this— But you'll send me another, wontcha?

. .

36. Gio Ponti

to Esther McCoy

ca. 1978

1 P., HANDWRITTEN, ILL.
29.9 X 20.9 CM.
ESTHER MCCOY PAPERS, 1896–1989

think
look
hear
smell
eat
speak

smile
drink
kiss
sing

love Esther
 Gio

. .

37. Moses Soyer

to David Soyer

[1940]

1 P., HANDWRITTEN, ILL.
29.7 X 21.5 CM.
MOSES SOYER PAPERS, 1920–74 AND UNDATED

Monday

Dear David

That was a swell letter you wrote us. The illustrations were swell too. I guess that by the time you receive this letter you will have gone ~~b~~ swimming. It's getting very warm in the city There's not much that's new ~~The War~~ Except the war. I see by the papers that Dizzy Dean will try a pitching come back in the minors. The Cincinatti Reds are in the lead so far Tinkerbelle is still growing and so is Jester. Are you getting your injections

Puzzle picture—Where is Jester

LOVE From IDA and ME.

Regards from NAT and EMMA.

MOSES

P.S. Am sending you the glove today

Tinkerbelle and Jester are the Soyers's dog and cat; David is taking injections for his allergies; Nat and Emma are family friends in New York.

. .

38. Jim Nutt

to Don Baum

ca. 1969

2 PP., HANDWRITTEN, ILL.
19.8 X 12 CM.
DON BAUM PAPERS, 1966–1990

Dear DON,.

The enclosed slides were picked as they came up—there probably some duplicates etc—pick & choose. I searched for more A. Green—particularly the leg I cream cone—check with Whitny if you don't already have it.

got back just in time for faculty evaluation puke
I never realize how exausting trips are till I get home & try to get back in [*drawing of swing*] of things. I've felt like a zig-zag (ie [*drawing of zig-zag*]) line since geting back. Was nice to sea you all—Regretted not getting Rap a port (in some rome consorting with [*drawing of a woman's lower torso and legs*] 'a, but Gladys filled me in on train: Some how Rapport familiar to me. [*nonsensical writing*]

Write—Best
Jim.

Nutt refers to Art Green's work Leg Ice Cream Cone; *Gladys is artist Gladys Nilsson (b. 1940), Nutt's wife; Whitny is Whitney Halstead (1926–1979), an art historian at the School of the Art Institute of Chicago. As the stationery suggests, Nutt and Nilsson are traveling by train on the Vista-Dome North Coast Limited.*

. .

39. Joseph Lindon Smith

to his parents

15 June 1894

1 P., HANDWRITTEN, ILL.
20.5 X 13 CM.
JOSEPH LINDON SMITH AND SMITH
FAMILY PAPERS, 1647–1965

Palazzo Dario. Venezio.

15th June. 1894.

Dear Mother and Father.

"It never rains but it pours."
Behold your son painting under a shower of gold. I am selling pictures on every side and every day.—And we are feeling very much set up and bloated at Palazzo Dario these days.

Yesterday we had another informal exhibition of pictures—at 5 P.M. for Mr Harry Hidder. and he bought two watercolors—one of a well curb—which I have just finished the one up in Piazza Giovanni e Paolo, back of Colleoni—and the other the fountain I did at Viterbo

Mr. Hidder told me he owned a water color of mine which surprised me very much as I never sold him one—he said he bought it at Doll's and it turns out that it is the San Giusto doorway at Lucca which I thought I had lost sight of. I am glad a Bostonian owns it.

I send with this a checque for one hundred and ninety dollars, which Daddy can do what he wants to with, it is from Mrs. Morse for the pictures she bought of me.

Venice is just as beautiful as ever—the nights have been devine with a full moon—and the days not too warm, as they might be now, were it not that the season is so very backward here. There are many friends still in town, and I am obliged to show my things on an average of four times a week—but I have the exhibitions at six oclock—so they do not interfere with any other work

I am painting the Dario (for Ned—an order) and as I wrote you in my last letter, the interior of San Giorgio dei Schiavoni—I am going to make this last picture the best thing I have ever done.

Doll's is the Doll & Richards Gallery in Boston; Mrs. Morse is Bostonian Francis Morse, who had recently purchased three pictures from Smith for $190.00; Ned is Edward Robinson (1858–1931), then curator of classical antiquities at the Museum of Fine Arts, Boston.

. .

40. Arthur Garfield Dove

to Suzanne Mullett Smith

15 Mar. 1944

4 PP., HANDWRITTEN, ILL.
26.5 X 18.4 CM.
SUZANNE MULLET SMITH PAPERS, 1923–89

Dear Suzanne,

Thank you so much for your letter. It was lots of fun, and we both enjoyed it.

Yes I think it is a good idea to have the large and small reproductions. We must be sure to pick ones that will reproduce well.

Just be sure that my Miss Boswell does not get drafted for work else where for being so efficient.

Glad Mr. Goodrich appreciates the opportunity. He wrote me also. Have you seen their booklet?

Do you suppose that there can be already more spurious Doves than real ones and that the other fellow who did them is better than I am? That would be quite a situation.

Fred is raising hell out side. Mr. Mueller who runs the inn across the way, asked me, if I had noticed a particularly noisy sea gull, might be the one from Halesite. Used to follow me up the street toward Huntington because I brought him scraps from the butcher. They must live for ever, I've never seen a dead one.

"Condition of Light" must have been what I referred to, as I always tried to establish that before beginning to paint. A certain Red, a certain blue, a certain yellow [*dots of color*] for instance

that is the motif for the sketch you have. and [*dots of color*] almost spells Mallard drake here under the window. Or Raw Sienna, black and a willow green, the willow tree in front of me. Anyway— Who is writing this? I am just the painter.

Snowing hard yesterday and spring again to day. We are anxious to see you. Reds said there were some pussy willows out, but all I see are cat tracks in the snow.

Ought to be all right tomorrow Spring every other day until it comes for good. So please bring it along.

Soon,
Our best as ever,
Helen and Arthur

If Reds is not able to get to Storage, her sister or our psychiatric girl friend, Dr. Loyals will be glad to go.

Reds is artist Helen Torr Dove (1886–1967), wife of Arthur Dove. Mr. Goodrich is Lloyd Goodrich (1897–1987), then a curator at the Whitney Museum of American Art.

. .

41. Walt Kuhn

to Eloise Spaeth

ca. 1940

7 PP., HANDWRITTEN, ILL.
15.5 X 7.5 CM.
ELOISE SPAETH PAPERS, 1937–83

When some one's been laid up for a long time, pretty sick at that, it's not going to be easy to put up with the long pull to full recuperation, that's why I feel something should be done—Maybe a little still life like this ↑

I'm not sure but a sylvan sunset would be more cheering. In the woods with a babbling brook?

Something more robust would really be more appropriate. A burly athlete of the sub-social type might be more the thing, or—

A bit of the rugged coast of

Maine with all the works—Ship, waves, lighthouse, gulls, et al.

First I was going to say flowers in a pot, but I think it would be more fun to supply a bulgy floosie with a red plume—but, I'm still unsettled.

Here it is = The Bull, the Matador, the Maid and the Rose—The bull doesn't seem to have his mind on his job—but we can't worry much about that—

No—after all why pester people with my pictures. I'll make no picture at all, but just tell you how glad I am that you made the grade so well, and that you know that you must be careful from now on and not over do things—For you will be needed here abouts, to stand ready to receive such silly balder-dash as this—

Good Luck
W. K.

. .

42. Miné Okubo

to Roy Leeper

18 May [1971]

1 P., HANDWRITTEN, ILL.
28 X 21.6 CM.
ROY LEEPER AND GAYLORD HALL COL-
LECTION OF MINÉ OKUBO PAPERS, CA.
1950–98

May 18th

Dear Roy & Hall:

Your failure to see what I did in painting stymied me but now all in the bag. a matter of painting integration and not design

Wow! No doubts! Doing large. Wow!___Wow. now—all proven & can do

Of course I thought of also B Burns saying "They got eyes big as grapefruit but no brains.

Miné—

Smile, Be patient Be around wont be long—It is suddenly spring & warm.

. .

43. Dorothea Tanning

to Joseph Cornell

29 Apr. [1948]

2 PP., HANDWRITTEN, ILL.
28.2 X 21.6 CM.
JOSEPH CORNELL PAPERS, 1722–1973

Apr. 29.

Dear Joseph:

You are quite right in wondering about the fate of your lovely book and I want to say at the very outset that I responded deeply to the story of Lucie Le Merle and her anguished papá. I am sure she will inspire me to some effort to convey her drifting poetry, her innocently magical destiny.

I am sorry to have to tell you that shortly after hearing from you I became ill and was obliged to go to the hospital and undergo a most grimly disagreeable operation. On the other hand, I am happily out of danger, on the mend, and expect to be functioning with all cylinders in a few weeks. Tomorrow will be 3 weeks since operation and I am still awfully good-for-nothing. But what a wonderful difference from a week ago! Such an experience makes one appreciate the simplest things: one's good home cuisine, the flowers bursting out in the garden, waking up in the morning with the fresh new sun that becomes strong and hot and urgent by noon. I hope you can visit us here some day. Some nice lads from Hollywood came here last week (just at the moment of my return home). They are opening a surrealist gallery and were full of enthusiasm for your work. We all spoke of you, of your own special genius, of their plans for

showing it to the west-coast public. Well, I hope for their success. Please expect a better letter, Joseph, from me when I am better.

Love from us both,
Dorothea

The story of Lucie Le Merle appeared in Ik. Marvel [pseud.] Fresh Gleanings; or, A new sheaf from the old fields of Continental Europe, (New York: C. Scribner, 1851); the "lads" are William N. Copley and his brother-in-law John Ployardt, who opened the Copley Gallery in Beverly Hills. Cornell showed there in September 1948.

. .

44. Gaston Longchamp

to "Mr. and Mrs. Goldberg"

ca. 1956

2 PP., HANDWRITTEN, ILL.
27.8 X 21.8 CM.
HUGH STIX PAPERS, 1947–63

Kintnersville [PA]

Dear Mr & Mrs Goldberg

As you know the bottom fell out of the bull market and so I came back here with alacrity. I found Ouida very well and busily engaged garnering food in her odd Cherokee way. She sends her love to all of you. We keep the pumpkin, turkey, etc because we do not want to get in dutch with certain people or the Seamen Bros. They have a corner on the market. Beside we need our food and you may need her love.

Speaking of food this election is going to make a lot of people eat something they may not like: namely the old black crow.

I am really very pleased about it. It is not the anarchist ticket but it is far from the ticket of the bastards that think they can bamboosle the poor fools all of the time. Of that more later, when I see you next week. Although there is

no work I will be coming to see the dentist and try to rig up something. I wonder if Marguerite would be kind enough to let me try the painting of a couple of dishes. I have to move fast because Zoto and I heard some noises last night and it was not bubble gum.

Love.....gaston

The Goldbergs are probably art dealer Hugh Stix and his wife Marguerite Stix, a sculptor and ceramic artist. Zoto is Longchamp's dog.

. .

45. Louis Michel Eilshemius

to Hyman Kaitz

ca. 1933

2 PP., HANDWRITTEN, ILL.
27.9 X 21.7 CM.
HYMAN KAITZ PAPERS RELATING TO LOUIS
EILSHEMIUS, 1933—78

Dear Mr. Hyman Kaitz—

Strange to say, the article you speak of never met my eyes in the Mirror, which newspaper I read daily, as it is more handy than the Times, Herald etc.

I knew a young lady friend wrote a short biography some months ago. She did not see it in paper. This is a mystery. Should you have kept the Mirror (Sunday/would you kindly state date— or could you mail the article to me to read. Will return it after having read it. Thanks.

Well, yes I am a versatile artist. Enclosed slip will tell you all. Was my photo in Mirror article? She said she gave one to Editor. Humans are strange—they kept me in dark all these years!

As a composer I rank with the German galaxy, but not one publisher would bring out any of my 50 compositions. ~~out~~

And now that fame in Painting is mine, no important man comes to see Me!

As literary man I am a. Like Milton, Shakespeare, Shelley etc. Read! Then you will know.

Since last July I'm laid up alone with blasted legs (auto crash). Cruel fate.

Well you have an inkling about me. Will be glad to hear from you again.

Sincerely,
Louis M Eilshemius

. .

46. Warren Chappell

to Isabel Bishop

27 Oct. 1982

2 PP., HANDWRITTEN, ILL.
27.9 X 21.5 CM.
ISABEL BISHOP PAPERS, 1930—85

OCT 27 1982

Dear Isabel

Fifty-one years ago—on a fast train to Paris, a most distinguished Russian emigré mistook me for one. A little later, when I was with Robinson—he felt much the same way. So, now, when I wonder if I shouldn't have had an agent—dealer—representative, or what ever, I think back and wonder how I might have made-out as a performing bear. Not well, yet, I can't help but feel that those of you who have dealers, still have a contact with your clients that is now impossible to those who dealt with publishers only to finally have a group of rather strong personalities sell-out to the most impersonal sort of conglomerate ownership.

You have been lucky in surviving a dealer you admire and managing to have one who needs you more than you need her. Of course, Harold fits in that same category. Often, when I'm angry he didn't get a Nobel Prize I say to myself— who in God's name would be up-to awarding him the so-called honor. I

recall him as having done it all without any politics.

I can't quite recall just who Parkinson was but I'll cheerfully damn him for inventing a disease to harm you, now. Of course, my damnation is not the sort that carries weight & will be of no help. But, somehow, I can't help but feel that the very Nature that afflicts you, knows that she must go slow, you are too much part of what Nature promises.

On the 16th, Lydia & I went down to Richmond for the University's "plaque" for achievements in the arts. That could be quite an honor, I suppose—but the givers have no authority to give and the "plaque" was a material testament to that fact. Why can't the organizations disband and simply let those who can't help drawing and painting go ahead and do it! Certainly there's no excuse to talk about it!

You can guess that this is simply a way of saying "hello" and sending our love

as ever
Lydia & W. C.

Isabel Bishop had a long relationship with Midtown Galleries in New York. She survived her first dealer at Midtown, Alan D. Gruskin (1904–1970), and then worked with his wife Mary J. Gruskin, who became the director of the gallery in 1970. In 1982, when this letter was written, Bishop's work was included in the Midtown Galleries' 50th Anniversary exhibition. Bishop had recently been diagnosed with Parkinson's disease. Lydia is Warren Chappell's wife.

. .

47. Samuel Finley Breese

Morse

to Elizabeth Breese

20 and 22 Jan. 1827

4 PP., HANDWRITTEN, ILL.
25 X 21 CM.
BREESE AND MORSE FAMILY PAPERS,
1772—1846

New York Jany. 20th. 1827.
Saturday eveng 10. o'clock

Dear Coz,

 I received your two epistles yesterday, and half dead with fatigue and the cold weather I sit down late this evening to doze out an answer, I say, 'doze out an answer,' for I really feel after the intense application of the past week, more like dropping asleep than writing a letter, but as it is the only time I shall probably have until next Saturday night, and as cousin's sprightly letters deserve an answer, even if it is a dozing one, I have made the attempt to say something between half asleep and half awake.—
 When I was at home remember I told you that I should not be able to write often, and I have scarcely had one moment in which I could have written I am busily engaged in painting my historical picture for the Steam boat, and am making great progress in it I hope to finish it by the middle of February.—I have relinquished the idea of lecturing at the Athenaeum this Season, as all my leisure time is devoted to our Academy, which is in a very flourishing condition. I have waited on cousin Sarah Ann to hear the lectures at the Athenaeum several times, I think her very pretty; I find my Breese cousins are very interesting fine girls, I don't know any exception, and I am quite proud of them. I certainly should cross the ferry often to Brooklyn to see cousin Sands if the weather and my engagements would permit, but it is at present out of the question.—
 Cousin, you said nothing about my dear little ones at home, but I suppose they are well, tell Susan if she loves her Papa she will gratify him by behaving so that he shall hear good accounts of her; and Charles, tell him he must not be an idle boy but learn to read so that I may give him a book; as for little Finley tell him to grow strong and learn to talk.
 I hope good mother is comfortable this cold weather, and that Brother Ned makes himself as agreeable all

round as possible, considering that he is somewhat old-bachelorish.—We have had dreadful cold weather here and I suppose you have also in N. Haven; I hope you all take care of yourselves.— But good night, I am fast asleep (krxort,) that means snoring, though in what language, I don't now remember, but you Coz, can tell no doubt, being at the seat of Science & literature. I _____ am ___ sound ___ a __ s l e e p.
 Ned Morse will understand the marginal diagram, as it is an attitude which he has practised in the greatest perfection.—Good Nigh [*incomplete*].
 Monday morning Jany. 22. 1827.
 I almost got through my letter on Saturday night, but got a sleep before I made t (not tea.) So will ow go on, being wide awake, as per mar s the merchant's say Ned Morse I think will translate this too for you as I am certain of having seen him look with such a neutral stare fifty times.—Love to all in great haste as my dinner bell is ringing.—

 Y Affectionate Cousin
 Finley.

The historical picture to which Morse refers is his painting Una and the Dwarf, *now in the collection of the Toledo Museum of Art.*

. .

48. Julian Edwin Levi

to Mrs. Julian Levi

[1932]

1 P., HANDWRITTEN, ILL.
42.9 X 24.7 CM.
JULIAN E. LEVI PAPERS, 1846–1981

When can I welcome you back to New York—the old man bores the Life out of me—all I want to do is sleep and eat— Thanks for the jelly roll—I cannot tell a lie

love
Victoria

Annotated at the bottom: "Sent to Mrs. Julien [sic] Levi by her husband, during a hospital stay. Victoria was their dog."

. .

49. Winslow Homer

to William Macbeth

17 Mar. 1893

4 PP., HANDWRITTEN, ILL.
22.6 X 14.1 CM.
MACBETH GALLERY RECORDS, CA.
1838–1968

March 17th '93
Scarboro ME

Wm Richard & Gentlemen:

 I send you to-day by American Ex—the Painting of "Murray Hill" it is for my new Frame—The "Fox Hunt" is finished & I will send it early in the week (next week)
 The "Murray Hill" I am not very particular about but want about $2000. cash for it. The "Fox Hunt" I shall not give a price on, until it has been seen—& I should like your advice about it. It is quite an unusual and very beautiful picture. Price should be no object to anyone wishing it.
 When I see the price that portraits bring—From $3000 to $6000, and consider the difference in the skill required in arranging & painting a scene in out of door light I do not see why I should not get a good price for this. I did not draw the sketch I sent you of this picture with any care—so you will be much surprised

 Yours Truly
 Winslow Homer

W. H. "hiding his light under a bushel"

. .

50. Yves Saint-Laurent
to Alexander Liberman
7 June ca. 1970

1 P., HANDWRITTEN, ILL., IN FRENCH
32.1 X 21 CM.
DODIE KAZANJIAN AND CALVIN TOMKINS
RESEARCH MATERIALS ON ALEXANDER
LIBERMAN, 1974—98

le 7 Juin
Marrakech

Mon Très Très cher Alex

Je suis ici, à Marrakech
et je pense à toi
comme toujours
à ton amitié fidélité
à tu sincerité
J'espère te voir le plus
vite possible et t'embrasse
de tout mon coeur qui t'aime

Yves.

English translation:

7 June
Marrakech

My very very dear Alex

I am here, in Marrakech
and I am thinking of you
as always
of your friendship, loyalty
and your sincerity
I hope to see you as soon
as possible and hug you
I love you with all my heart

Yves.

51. H. C. Westermann
to Clayton and Betty Bailey
17 Nov. 1963

1 P., HANDWRITTEN, ILL.
29.9 X 22.5 CM.
CLAYTON BAILEY PAPERS, CA. 1960—79
ART © ESTATE OF H. C.
WESTERMANN/LICENSED BY VAGA, NEW
YORK, NY

P.S. And I think that paint job your wife did was an herculean task & a damn good green job.
11/17/63
[*picture of sun*] DAY
"A RAY OF HOPE" FOR EVERYBODY I HOPE!!

Dear "Bill Bailey" & WIFE,

YA know → it was sort of dirty to drink up all your [*image of Shlitz beer*] like that & then bug out after it was all gone. But my little wife & I sure had a fine time & certainly enjoyed the many fine conversations we had with so many of you people!! AND you people were all so sweet to us. THANKS!!

Sincerely,
H. C. Westermann

52. George Grosz
to Erich and Eva Herrmann
ca. 1940

1 P., HANDWRITTEN, ILL.
26.6 X 17.7 CM.
ERICH HERRMANN PAPERS RELATING TO
GEORGE GROSZ, 1935—47
ART © ESTATE OF GEORGE
GROSZ/LICENSED BY VAGA, NEW YORK, NY

Here's too you Lieber Erich & Eva,
Welcome HOME

hope both of you had a nice and successful trip, and quite some excitement the last days about [*sketch of ship and pirate with knife in mouth*]
Dear Erich could you send me a one pound tin of that delicious
[*sketch of smoking pipe and Royal English tobacco*]
Love and greetings to both of you as ever yours—George & Eva & the boys

53. William Cushing Loring
to his parents
14 July 1901

6 PP., HANDWRITTEN, ILL.
21 X 14 CM.
WILLIAM CUSHING LORING PAPERS,
1899—1961

Sunday July 14 1901

My dear Parents—

How would you like to live in a country where on waking in the night you might hear an officer walking his rounds, under your window the monotonous thumps of his sword on the side walk reminding you of falling coins in the contribution box.

I feel after fencing each day in the garden of this very old house that I am not of the 19 century. Every thing is groans with age. The little narrow doorway is the entrance to my be appartement. It is just wide enough for me to enter. I walk about fifty feet in this little tunnel and then come to a winding stair-case. It is a rare bit of construction. Mounting one flight of steps my room is reached. Where I am at home, and before your photographs. How I love to look at them. Every one says that they are of handsome people. Especially the father. and mother.

This scrawl is intended to represent the French celebrating the formation of

their republic. The fete commenced last night,—and lasts for three days The streets are crowded with people, the buildings a mass of colors and at night Paris is magnificent thousands of red white and blue lights. Bands are playing in every square. All Paris seems to be dancing. I was reminded last night of our Thanks-giving Virginia reel. For in front of the Opera to splendid music many had assembled for dancing and it reminded me of home for the moment to see gentle little girls of Marion's age dancing together, worn mothers dancing with sons and daughters, Workmen dancing with their families, Young men with their beaus; it was a fine night. What a way to celebrate. Much better than blowing up dynamite.

All the cafés were crowded the side walks filled with tables, and beggars passing in front, Some swallowing sabres, canes, and singing shadily song, others merely begging. All life seemed to have become drunk with pleasure. No one was sober, and now today as I write two bands are playing in our square alternately It is a fascinating sight. I wish you were here to enjoy it with me. Sunday this afternoon a body, a mob of Frenchmen paraded the Boulevards crying down with the English. They were to busy to notice me. It was a fine smashing sight. I was with a Swiss and a German at the time. You would be astonished at the quality of the music produced by the beggars here. Some being real artists. I bought for 10¢ a cast of Rodin, made by an old student of the Beau Art who now peddles his work in the various cafes.

I am now attending another school the school of Delécluse. I made the change for three reasons. First Collin has left for the summer Second Collorossi does not pay enough for his models so the students are compelled to work from inferior types. Thirdly all the other professors could learn a few things regarding big details from me, but until I hear that Collin has returned in October I shall not go back. My cri-

tique in the new school was given by an white haired man. Who said my work was interesting in style. And that the other men should note the manner of reflecting lights as I had set them down. This school is a clean one. A trifle more aristocratic. When Bob comes over I hope to show him some good work. He will be here in two weeks time.

Collin has promised to over look my work next winter. So I am well fixed. I have arranged every thing regarding—a picker up for my studio.

The janitors wife is going to do it for me.

I have heard nothing about the portrait in Buffalo, (I only wish that in its place I might put a painting I made three weeks ago.) It is in some ways good and many bad. The hands are not finished. You know it was to hurried to be a finished polished thing. I should hate to look at it my self. I have here a very poor photo of it. Which has made the grey yellowish dress look to white and has robbed it of its modeling. I hoped they varnished it. Coffin wrote me saying he would.

My work is now a hundred times better. Always when painting I think of "Vary your values and simply color." Sargent. Don't paint to rapidly. God bless Sargent for his kindness and instructions. I have written Bob today. I write him every Sunday. I know Aunt Addie would not care for my work at Buffalo. It is too broad. To paint a work in eight days, 6 feet long can not be done like a Fortuny. Sorry it was hung so near a Sargent. It will luff along his reputation

My time is spent painting all the time I have no malarial fever nor do I fear it. I have to much exercise—You can tell father I never drink anything here except the wine at the table. And in the restaurants raspberry or citron—because I know to well that I would be compelled to sacrifice my painting—Lose my nerves and spoil the future. Got a letter from Hope today. Say she likes May Bennett and is having a good

time. I hope you are all well and hope you wont go to Buffalo to note the failings of your dear son William With love—

Collin is French painter Louis-Joseph-Raphael Collin (1850–1916); Collorissi is the Académie Colarossi. Coffin is William A. Coffin, Art Director of the Pan-American Exposition in Buffalo in 1901. Loring sent a portrait to the exposition. Sargent is painter John Singer Sargent (1856–1925). Fortuny is Spanish painter Mariano Fortuny (1838–1874).

. .

54. Alfred Joseph Frueh
to Giuliette Fanciulli
[21 Mar. 1913]

3 PP., HANDWRITTEN, ILL.
21 X 16.5 CM., LAST PAGE IS 33 X 21 CM.
ALFRED J. FRUEH PAPERS, 1909–CA. 1961

Good Friday

Dear Juliett

It would have been gooder had the boat which arrived today brought a hold full of "P's" but O well! I know it is hard for a body with lots to do and in a monotonous sort of a place, to get up enough courage, and things to write about, to write a letter. Mayhaps, I'll have better luck monday—3 boats in—

But I mustn't "kick" you've been real good to me and I'm afraid I'm a wee bit spoiled and think I couldnt get along without a couple, three, four "P's" every week

Maybe you think I would lay a "P" aside now, cause of the bunch of N Y Papers you sent me. Those Papers are good and burned up long 'go. Gee Guliette, If you ever send me another N Y Paper. By Golly Ill go back in the middle of Russia to get away from it and I wont come out till its all rotted up in the Express Office. It aint your fault though, I asked for them, Didnt I?

71 more days—What "slow-pokes" these days are. But say, Juliette, what am I going to do for "P's" when you are on the Ocean for maybe a whole week.

Weeks without "Ps" are as empty as cream puffs without cream, cause aint you the only oyster in the soup and the red, white and blue in the American flag.?—Gee, thats the kind of stuff that gives millionaires breech of promise cases. I can tell you better what you are when I see you anyway.

Hooray. Juliette. We've got a show here too with pictures in Geometry by artists who look at things through a sausage grinder The Anual Salon of the Society des Independents. There are some 2500 canvasses and about 100 "skulpts" in the show.

I remember when I was a kid back in Lima O I <u>tried</u> to ride down the Court house steps on a bicycle. I'm sure every time I hit one of the stone steps on my way down I saw a couple of these same canvasses. That was 15 years ago. and they say they are doing some thing new. There's some good stuff out there though but the average—ugh. Im going out again.

Well I gotta "hang up" now—Im one of the judges in the Easter parade next Sunday but you bet the woman that wins the blue ribbon has got to look like you.

Kin I go now?
Same ~~old~~ new.

P.S. Glorious Easter to all at "chezvous."

P.S. These two examples are not my best. One can almost guess who I tried to make.

. .

55. John Sloan

to Walter Pach

9 June 1920

2 PP., HANDWRITTEN, ILL.
28 X 21.5 CM.
WALTER PACH PAPERS, 1883–1980

big moths very common

"you want me pose?"

105 JohnSon St
Santa Fe N.M.
June 9–1920

Dear Pach—

Well! here we are again in the old town—it looks just the same we feel the altitude more this year than last I suppose because we climbed more slowly by automobile last year we took three days to get here and were delayed 5 miles east of Lamy for 3 hours very provoking, for we would have arrived on the dot of schedule time if a freight wreck in Apache canyon had not occurred ahead of us.

Dr. Hewett I have seen just once for a few minutes—he seemed glad to welcome me back

We walked out to the "Casa de Davey" last Sunday—He is going to have a beautiful place when his alterations are completed they're well under way. He has three horses one apiece for self wife & boy—Three miles up the Santa Fe Canyon—wants me to buy a place near him $900 is the price but I guess I wont indulge myself in real estate purchases.

I have started painting nearly a week went by before I felt ready—a Corpus Christi procession through the roads and over the bridge Sunday—gave me a theme.

By the way I got in to the Metropolitan Anniversary Ex before I left N.Y. and thank you for reminding me of its importance I enjoyed the special additions very much. Suppose you read Coomaraswamy's article in the Dial "Art & Craftsmanship" I thought it very concise and true didnt you?

I hope that Raymond is quite well by now remember us both to Mrs Pach

and if you have some time to kill drop us a line—we feel far away out here. Regards to "Bayley" if you see him Good luck and good health to you.

Yours sincerely
John Sloan

Dr. Hewett is Edgar L. Hewett, the founder of the New Mexico Museum; Davey is painter Randall Vernon Davey (1887–1964); the article Sloan mentions is Ananda Coomaraswamy, "Art and Craftsmanship," Dial, 68 (June 1920): 744–46; Raymond is Pach's son, born in 1914; Bayley is possibly A. S. Baylinson (1882–1950), a friend and painter.

. .

56. Antoine de Saint-Exupéry

to Hedda Sterne

ca. 1943

1 P., HANDWRITTEN, ILL.
27.9 X 21.7 CM.
HEDDA STERNE PAPERS, 1944–70

J'arrive tout juste
Êtes vous libre à dîner?
Telphonez

Merci.
A.

N-D Un désagrément ayant retardé cette lettre elle n'est pas partie mais— pour être bien sincère—je suis si fier de mon chef d'oeuvre que je t'envoie quand même.

English Translation:

I just arrived
Do you have time for dinner?
Call

Thanks.
A.

PS: A nuisance delayed this letter that did not leave but—to be very honest—I

am so proud of my masterpiece that I
send it to you anyway.

. .

57. Dale Chihuly

to Italo Scanga and Su-Mei Yu

1 Aug. 1995, 1:02 p.m.

4 PP., FACSIMILE TRANSMISSION, ILL.
27.8 X 21.5 CM.
ITALO SCANGA PAPERS, CA. 1940–2001

fax to Scanga & SuMei—both #s.

Dear Italo & SuMei

Greetings from the Campbell
Diner on Vancouver Island.—up here
for a day or 2 with Leslie at Malone's
Fishing Lodge—they're all out fishing
& I'm here starting the drawing for
Ireland Sept 25–Oct 12

love Chihuly.

All's well—Hows the teeth?

*Su-Mei Yu. a chef and restauranteur, is Scanga's compan-
ion. They met in 1992.*

. .

58. Max Bohm

to Emilie Bohm

12 May 1889

6 PP., HANDWRITTEN, ILL., IN GERMAN
21 X 13.4 CM.
MAX BOHM PAPERS, 1856–1964

Paris May 12 1889

Meine liebe Mama—

Ich habe in letzter Zeit viel gese-
hen und ein sehr bewegtes Leben
gehabt

Der Salon ist seit dem ersten Mai
offen.

Mein erster "vernisage" oder var-
nishing day verstrich sehr angenehm
und schön Wie ich dir schrieb bat ich
Lucie mit mir da hin zu gehen. Die
beau monde von Paris ist immer an
diesem Tag sehr stark ver treten und
dieser Tag ist ein Tag an welchem die
Damen und Herren sich in ihr feinstes
raus putzen.

Lucie hatte ein Kleid von Veilchen
blauem Stoff das so arrangiert war den
ein druck eines Veilchens zu geben und
dabei war das Kleid sehr ein fach aber
sie sah gerade aus wie ein kleines
Veilchen und war eine der feinesten
Toiletten im ganzen Haus selbst die
feinesten und chicsten Pariserinnen
sahen sich oft nach ihr um.

Ich war im schlichten prince
albert schwarze glacé Hand schuhe
weiße hals binde und zilinder Hut und
sah auch pas mal aus.

Wir waren funf Stunden lang im
Salon und amüsierten uns nicht zu
schlecht. Der Salon hat 38 Sälle voll
Bilder u.s.w. Ich habe den Salon schon
oft genug beschrieben besonders let-
ztes Jahr beschrieb ich ihn sehr aus
führlich so das es jetzt nicht
notwendig ist Noch nie in der Welt ist
eine solche Welt Ausstellung zu sam-
men ge bracht wie diese. Ich habe sie
schon ziemlich gut gesehen Alles ist
mit einer beinahe unbeschreiblichen
Pracht und kunst vollen Eleganz zu
sammen gestellt.

Man kann dort alles Was die Welt
an Kunst Wissenschaften
Merkwürdigkeiten und Industrien auf
zu weisen hat sehen Ihr könnt euch gar
keine Idee von der großartigkeit und
Pracht machen die man jetzt in Paris
zu sehen bekommt.

Und alles sieht man für 14 cents.

Man geht des Morgens um 10 Uhr
hin und bleibt bis 6 Uhr Abends. Ein
feines Mittagsessen bekommt man bil-
lig. Währen des Nachmittags spielen im
freien Music banden und man kann
seine Wahl unter Spanischer

Italienischer Russischer Ungarischer
Belgischer und Türkischer Music
nehmen Dann ist es auch interessant
die Wacht soldaten von den verschiede-
nen Nationen zu sehen denn alle
Nationen haben Soldaten um ihre
Austellungen zu bewachen China Japan
Alle Sudamerikanischen Staten die
Türkei usw. usw. In dem Publikum
sind alle Nationen vertreten und es ist
ein Babel von Zungen und Trachten.
Wenn man aber einen ganzen Tag ver-
bracht hat so viel zu sehen wie man
kann dann ist man am Abend Müde
genug um umzusinken

Um alles gut zu besehen wurde
wenigstens 3 Wochen unausgesetzte
Aufmerksamkeit nehmen denn das
ganze Champs de Mars und Esplanade
de Envalides ist voll von
Merkwurdigkeiten und sehenswürdigs
keiten

Ich wunschte das Ihr kommen
könntet und alles sehen was ich schon
gesehen habe Ich habe gutes Glück das
ich mich gerade jetzt in Frankreich
befinde.

In einigen Wochen werden wir auf
das Land gehen um Bilder zu malen
aber wir wissen noch nicht wo hin
denn wir haben bis jetzt noch nicht
einen Platz gefunden der interessant
und billig genug ist

Ich habe lange keinen Brief von
zu Hause gehabt und sehne mich sehr
ein mal wieder etwas von euch zu
hören. Henry seinen Brief werde ich
nächstens beantworten. Wir sind beide
sehr wohl und munter. Wir sind zu
frieden denn wir sind beide im Salon
aufgenommen.

Ich danke Euch vielmals für die
Zeitungen die so schön regelmaßig
kommen, wir lesen oft die fortgeset-
zten Geschichten darin Wie gehtes
euch da zu Hause Ich sehe euch oft in
Gedanken in dem schönen Garten. Es
wäre fein wenn du und Papa mal her
kommen könntet.

Grüße die Kinder von mir. Spielt
Gustave fleißig? denn ich will gerne
was ordentliches von ihm horen wenn

ich zurückkomme. Wie geht es Bohms
und Stuhrs Ist Allie wieder ganz gesund
Schreibt bald und sei du und Papa
herzlich gegrüßt

von Eurem
Max

40 Denfert Rochereau
Paris

English translation:

Paris May 12 1889

My dear Mama—

Lately I have seen much and I have
led a very excited life.
Since May 1st the Salon is open.
My first "vernissage" or varnish-
ing day passed in a nice way. As I wrote
you I asked Lucie to accompany me.
On this day the Paris "Beau Monde" is
always well represented and on this
day ladies and gentlemen dress in their
finest. Lucie wore a violet blue gown
which was arranged in such a way that
it had the appearance of a violet. And
yet, the gown was very simple, but she
really looked like a little violet and was
one of the best dressed in the whole
house. Even the finest and most ele-
gant Parisiennes often turned around.
I wore a simple Prince Albert, black
kid gloves, white tie and high hat and
did not look bad (pas mal). We spend 5
hours in the Salon and amused our-
selves greatly.
The Salon has 38 rooms full of pic-
tures, etc. I have described the Salon
often enough, particularly last year I
described it in detail, so it is not neces-
sary now.
Never, in the whole world, has
such a World Exhibition been arranged
as this one. I have looked at it thor-
oughly. Everything is done in almost
unbelievable splendor and artistic ele-
gance. One can see everything the
world has to offer in art, science,
curiosities and industry. You can't pic-

ture the grandeur and splendor to be
seen now in Paris.
And all that for 14 cents.
One goes there at 10 o'clock in the
morning and stays till 6 o'clock in the
evening. A good dinner can be had for
little money. Bands play during the
afternoon and one can choose music
from Spain, Italie, Russia, Hungary,
Belgium, and Turkey. It is also of
interest to watch the soldiers' guard of
the different nations for all the differ-
ent nations have soldiers to guard their
exhibits. China, Japan, all the South
American States, Turkey, etc. etc. The
public is represented by all nations, it
is a Babel of languages and costumes.
When one has spent a whole day look-
ing around as much as possible one is
tired to sink down in the evening. To
observe everything thoroughly it will
take at least 3 weeks of undivided
attention, as the whole Champs de
Mars and the Esplanade des Invalides
is full of curiosities and objects of
interest.
I wish you could come to see what I
have seen. I am lucky to be in France at
this time.
In a few weeks we will to the
country to paint pictures. But we don't
know yet where it will be, as we did not
find a place yet which is interesting and
inexpensive enough. For a long time I
have not had a letter from home and I
am longing to hear again from you.
Soon I will answer Henry's letter. We
are both well and spry. We are content
for both of us were admitted to the
Salon.
I thank you very much for the
newspapers which arrive so regular,
we often read the continuated stories.
How is everything at home? Often
I visualize you in the garden. It
would be nice if you and Papa could
come here.
My regards to the children. Is
Gustave busy playing? I want to hear
something respectable when I get back.
How are the Bohms and Stuhrs? Has
Allie fully recovered?

Write soon, to you and Papa best
regards

from your
Max
40 Denfert Rochereau
Paris

*Translation provided by Kathryn Esther Bohm Locke,
daughter of Max Bohm.*

. .

59. Winslow Homer
to George G. Briggs
[19 Feb. 1876]

7 PP., HANDWRITTEN, ILL.
20.1 X 14.2 CM.
WINSLOW HOMER LETTER COLLECTION,
1890–1909

Scarboro Me
Feby 19 1876

Mr George G. Briggs
My dear sir

I send you some frames on
Thursday by American Ex—
I never supposed that you would
take both of the pictures, as you only
called for one—so I mentioned to you
frames which I never should have
done but for the fact that I had a frame
made to finish this size picture &
concluded to send it if you made a
choice of that size as I said before I
never consider frames & do not deal in
frames but now that you have taken
both & I have given you the impression
that I am to frame them There is no
help for it & so I send you and include
in the purchase—with that wooden one
a frame that cost me $50.
You will have to get that wooden
one re-bronzed. I made that frame
& bronzed it (here in the country with
a native Carpenter) and it is a more
appropriate frame for a picture than

the other gold one.

I rec'd the book—many thanks, I never knew that Berdans sharp shooters were from Mich. I looked through one of their rifles once when they were in a peach orchard in front of Yorktown in April 1862.

This is what I saw—

I was not a soldier but a camp follower & artist, the above impression struck me as being as near murder as anything I ever could think of in connection with the Army & I always had a horror of that branch of the service.

Well Mr Briggs this is the last letter I shall have occasion to write I send you herewith a proper receipt—& if you should ever find me at home if you should be this way in the summer I would be glad to see you—but I have not been home in the Summer for five or six years and there is no chance of it but this answers this your question & with regret, I now state it—

I go to one, of two fishing clubs that I belong to. I live here four miles from the Post office & R. R.

Yours very truly
Winslow Homer

. .

60. Edgar Spier Cameron
to his parents
7 Aug. 1884

4 PP., HANDWRITTEN, ILL.
20.8 X 14 CM.
EDGAR SPIER CAMERON PAPERS, 1868—1968

Paris Aug 7 84

My Dear Parents:

I write you on the eve of my departure from Paris that I "got there" N⁰ 51 out of 80. I will stay at Veul[es] en Caux Seine Interior until about Oct. 1ˢᵗ

or 10ᵗʰ. Smith and Hall have already gone down and taken my impedimentia—Poor Smith was not received. Tolman was however, N⁰ 23. He has been studying for the last six years—I felt like getting drunk over the result to-day but there was no one of the boys in town so I went and purchased a lonesome "demie" of Munich beer and wrapped my self around it.

I have not time to write much as it is now 11 o clock and I leave to-morrow morning at 8. Now that I am in I can arrange my plans for next year. I will write more soon. I am well and needless to say happy.

Perhaps it would be a good plan to let Alberti or some of the "Journalists" know of what I have done, as it would be an advertisement which may do me some good if I ever have any pictures to sell. It is a very difficult examination you know. Another thing—I would just as soon that some of the old "cronicks" at home should know that I am able to do something when I set at it.

I received letters from both of you this week & and am glad to hear of Mamma's pleasant trip to Clifton. I will appreciate getting into the country myself. Although Paris is the healthiest city in the world. I think country air an excellent thing. At Veules there is a beach—some rocky shore picturesque streets & a forest behind the town—consequently there will be motives in abundance.

I dined with Mr Sawyer & wife last night, and met [*remaining pages missing*]

Veul[es] en Caux Seine Interior became Veules-les-Roses in 1897; Smith is possibly Alfred Everett Smith (1863–1955), who also studied with Boulanger and Lefebvre at the Académie Julian in Paris; Hall is possibly James Hall (b. 1869) from Boston, who studied at Académie Julian; Tolman is Stacy Tolman (1860–1935), who studied at the Académie Julian with Boulanger and Lefebvre 1883–1885.

. .

61. Rutherford Boyd
to his fiancée
22 June 1905

8 PP., HANDWRITTEN, ILL.
28.1 X 21.4 CM.
RUTHERFORD BOYD PAPERS, 1900—83

New York City June 22, 1905

My dear Little Girl:

Your letter I have read many times and would have answered before but I knew that I would be moving in town so I thought you would like to hear—and see—about my studio. After looking all over town for days I decided to take a studio in the same building I was in before going away—so will you be so good as to write me a nice letter about as long as your last one and send it to my old address—120 East 23ʳᵈ St? I came in town Wednesday night but it has taken all my time moving in cleaning the skylights oiling the floor unpacking etc etc. and the weather has been so hot and humid that it tired me all out and I could not write to you before last night when I began this. It seems ridiculous and quite a joke on me to think of my coming back to the same building after hunting everywheres—however it likes me very well—and—as I have worked on it yesterday arranging this print on the wall or putting up shelves etc and that it is beginning to look like a studio, my dear little girl,

You may come in
And look out!

Below is Twenty-third Street with its hurrying people, clanging trolleys, Italian fruit vendors.

"Across the way you will see" other studios some in quaint old brown stone mansions with wistaria climbing over them. Above the jumble of chimney pots roofs ventilators & a medley of them. Then the Madison Square Garden Tower looming up over the

steam and smoke and the awninged apartment houses. It is the most beautiful tower—almost—I've ever seen—and at night with the glare of the cafés skyscrapers and shops around the Square lighting up the sky—it is beautiful.

The corner of the building near the edge of the paper is part of the Metropolitan Life Building to which they are going to add the highest tower of offices in the world 560 ft. which will be higher than Billy Penn's hat under which you have so often walked.

Altogether it's very nice—how's that? My studio is about ~~17~~ sixteen by twenty-four or -five feet three windows a fine skylight which Mary the Janitress and I washed yesterday removing the filth of centuries!

I suppose at the rate I am progressing it will take months to fix things shipshape but it is so fine, Little Girl to have a proper place to work in and when you come in at night in a big dark quiet room to look up through the skylight and see the wonderful sky instead of a row of ugly brick buildings and dirty backyards which most New Yorkers have to see.

But enough for this time about myself—let me tell you how sorry I am for my last two letters for my last because it was so serious and sad and if not fault-finding, at least being almost ready to—for the one in which I told you about the picture etc. and the handkerchief episode. You see you dear little girl I get so lonely just as you do and sometimes I feel as if I must talk to you or as I cannot, to someone about you. Well I did not want my Aunts and everyone to know that I cared for you as I do and I half joked about everything I choose to tell them which was nothing very much you may imagine and left them I am sure not knowing what to think about their small nephew whether to believe him or not. As for reading them your letter I simply read the page marked "important" which was correct in every way and sensible although I believe, Dear they thought I made it all up.

About the picture I told them the girl, whoever it was (they had gotten to be very sceptical by that time of everything I said and wouldn't believe me at all whether it was true or not) was dressed in an old costume of her grandmother's which was too large for her and they didnt think any harm of it anyway. But what was not just right about it was that I should have teased them about myself telling them about some girl to tease them showing the picture as part of the fun not as a picture of you. You heaped coals—of fire—on my head when you wrote me so lovingly—that everything I did—etc—and ~~this~~ you would trust me in matters like these too.

You should know, Little Girl, how much I care for you—and do respect you and how proud I should be to introduce you to my people as my friend—more of my old bad habit of teasing at any rate I don't tease you—any more, do I? You dear little girl of mine, I hope you will forgive me for having offended you it was unintentional you must know.

Something funny—Tuesday eve. I went with Arthur Van Harnee to a sort of picnic a Mt. Vernon crowd had at Echo Bay near New Rochelle along Long Island Sound about six or seven miles from Mt. Vernon. the crowd had been in bathing, playing tennis etc all afternoon. but I didn't feel like going, still about seven Arthur dragged me over on the train and when we arrived introduced me to the crowd. One girl, his cousin, I had met once last winter at Xmas—She at once spoke up & said she had seen me at Phila. in May. I said "Where?" "Oh, out at Willow Grove, but you were so interested you could not see me!" I felt rather embarrassed you can imagine but in spite of that, am still willing to take you again in July! which is not far off now—very nice—Perhaps you have already written me at Mt. Vernon and it is being forwarded. I must go out and buy some denim for a curtain remember that red denim we bought for your apron. So glad the measles havent appeared.

remember me to your Mother, I hope she is well and resting, I wish I could tell you what a pleasure and comfort your letter is Dearest Girl because—you—do write as you would talk, I love every line of it only you are so lovely and fine about my teasing etc. that it made me feel very badly—I may tease You sometimes when we are alone but I never make fun of you to anyone dont you know, girlie? I wish today I was going to meet you at Camden but it wont be long now I hope. Yes I do get lonely, dear. So sorry it hurt you—my teasing—my Aunts as I did.

Yours John

"Billy Penn's hat" refers to the statue of William Penn by Alexander Stirling Calder (1870–1945), grandfather of Alexander Calder (1898–1976), on top of the Philadelphia City Hall.

. .

62. Lyonel Feininger
to Alfred Churchill
7 Oct. 1890

8 PP., HANDWRITTEN, ILL.
21 X 14 CM.
LYONEL FEININGER PAPERS, 1887–1939
© 2004 ARTISTS RIGHTS SOCIETY (ARS),
NEW YORK / VG BILD-KUNST, BONN

Collége St. Servaise, Rue St. Gilles.
Liége, Belgium;
October 7th 90

My dear, dear old Al!

Old man, I dreamt about you last night, and this morning I read your dear letters through, that I always carry in my pocket, and now, as if these incidents had been a presentiment, I receive, forwarded from Berlin, your "News paper". Oh! how glad I am, old man, to be again in corresponce with you, after having considered you as lost to my fur-

ther knowledge. Edit your blooming type concern as regularly and often as you can, or Ill bust your "crockery optics" for you; you hear me. What am I doing here in a french jesuit collége? I'm here for the distinct purpose of learning the french parly-voo, and to suck in as much other information along with the language as can enter my aural cavities and impress itself upon the malleable tablet of my intellect. Dear old Al! to speak plainly, the french language will be of use to me in the french capital, Paris, where I will most probably go, after I am finished here! The reason I am not in new York is principally, because my father came to Berlin on a visit of nearly two months, and we had a grand consultation, the upshot of which was that first I should get what education I could, within the next two or three years, so as to sufficiently develope me, and then I may go either to Munich or Paris. If it remains that I may still really chose when the time comes, you may rest assured that I shall go to Paris. Then, my dear old Al! if you are in Paris again, by Gimini! we will live together and work like brothers, wont we?! As it is, I am on a fair way to lose much of my drawing, for I have very little time in which to keep up my practice. Still, I have improved greatly since the Spring; have earned much cash on the papers; and what is still happier to relate, have made radical improvement in outdoor sketching! [*caption*— "Leo advocates the use of tone paper and chinese white"] Have you ever tried sketching on <u>tone</u> paper? and getting the lighter portions with chinese white? You would be astonished how simple and effective a method it is. I have tried it, only lately, here, in Liége, when I had a couple of weeks vacation before the College opened, and it has completely changed my ideas on sketching in pencil.

If I can enclose one of my smaller studies in this letter I will do so, dear Alf, but the smallest may not be just illustrative of what an exceptional

advantage one has in using the paper, for I generally draw quite large. In fantasie work, I am doing nothing except as far as fantasie or newness of pose in my caricatures goes. I am at the point where I, in order to make any further [*caption*— "<u>I</u> am at the point where <u>I</u>, in order to make any further etc"] progress, at all, other than technical, must or should throw myself at once upon nature. It is very good for me in a first class, well ordered College, as this one is, with the kind reverend fathers to look after ones spiritual and bodily welfare, and surrounded as I am by so many characters, I cannot fail to imbibe much more freedom and power of conception. To be sure I am nagged about a good-deal, but as soon as I get used to speaking the language I will get on first-rate. [*caption*—"here you see how thin I am from being worried and made fun of by the boys. aint it awful? only my feet and ears remain normal size!!"] I have only been here three weeks, and class has only commenced since a week. I can already read french (not aloud) quite readily, and have devoured several splendidly <u>illustrated</u> books of Jules Verne, illustrated principally by "[Edouard] Riou", a french artist. Do you recognise the name perhaps? I tell you those drawings are fantastic enough, and <u>just</u> in my taste. Let me tell you what I did just before leaving Berlin, which I did on the 8th September. I made several illustrations to a book of Bret Hartes, "A ship of 49" for old Werner, and finished them very highly, first with washes and afterwards with pen, but in many parts more like an etching than a pen drawing. It works first rate, and Fred is happy and going to have them bound in with the book. My dear old Al! What a selfish letter this is; all about myself, but I have not written to you for so long, and you see, much has taken place for me to write about. I must still mention that I was a week in that most beautiful old city; Brussels!! What a wonderful old place it is! Oh Al! if you could only be

with me now, and see Brussels! The streets are narrow for the most part, hilly, even mountainous at places, and winding. The stores are princely, as to the goods displayed, and the generally old buildings they addorn are rendered only subservient to the display of thier riches. At night is the time to see this Paris in miniature, as it is called, for then the streets are like the halls of a gigantic Castle, lighted up for a grand reception, and the bye streets, seem like lesser apartments in which to retreat and cool and refresh ones self before again going into the glaring thourough-fares. [*caption*—Leo in Brussels in the night-time.] The streets are used, as well as the sidewalks, and there are but <u>few</u> wagons. Then the quaint old houses, three and four centurys old, some of them, with thier huge chimneys and quaint gables, give existence in thier darker recesses to monstrous shadows from the dazzling lights, which make them, the houses, appear <u>quite</u> unlike other houses. Of course the wonderful old Rathhaus and beautiful, weather stained, weather beaten cathedral are the chief buildings, and I couldn't grow weary of gazing at them. I have a very kind friend in Brussels, in the person of Professor Rloth, with whom I remained while there; who showed me around the town every evening, and rendered my stay there like a fairy dream whenever I recall it. I cannot think of the days; but the remembrance of <u>those</u> <u>nights</u>! There! I have finished my ecstasy over this wonderful old city, although I could go on for hours, but why;? the pen is <u>cold</u>; and gives no idea. We have play times between each lesson, and what do you think we play with? as you would never guess it, I will ha-ha-ha! ha-ha-he-he-hoho, tell you! we play, man and child, every one of us with <u>hoops</u>! At first it seemed too, too, <u>too</u> utterly ridiculous, but now I am used to it I can say that I should <u>anywhere</u>, warmly defend its use as a healthy, friendly sport. We play tag, each trying to run down the others

hoop with his own, and this permits of considerable adroitness. Above, I have been trying to express the first impression of on one, of seeing a man 20 years old chasing a hoop with a stick. There are many amusing accidents, and no one is ever angry about it, either: for instance: a boy is hard pressed, while playing tag, by the fellow who is "it." All at once, the chaser will slide his hoop after the fleeing one, and the hoop mixes itself up with his legs and throws him, or, of he has luck, he staggers up to a wall and untangles himselff from the hoop as best he can. See this attempt at a sketch to illustrate the ludicrousness of the aforesaid accident but it ain't much of a success I fear. I was in a great hurry yes yes! Ludicrous indeed. You see the victim with a face like decomposed sauer kraut, awaving his leg like a liberty pole, with the hoop gyrating according to strickt centrifugal rules, and his own ring a-scattering a crowd of small fry at the other end of the playground.

Dear Al! I must stop now until tomorrow, as it is supper time and we go to bed immediately after, at 8 oclock P.M. Good night! old chap= Dear Al! I must have been a grand specimen of cube-headedness, not to have understood "la lettre," in which you told me to send the pictures (Etchings and Photos) to Berlin! Dear old fellow! be good to me! I thought it should be after heard from you in America, and even now they lie at Berlin, with mother, who has full directions for sending them on as soon as I should here from you. So be comforted! They have niether been lost in the mazes of the Einschreibeamt of Berlin, nor have they been sent and possibly on account of thier cylindrical form been bee mistaken for the Rohr post dept. Only, when I left Berlin, I had not yet received The Photoes: "Yepthas Jocher Lavinia" or the "premiere studien-Reise" —of Defregger. I have brought "Verstimmt" along with me and will send it from here, and as there are several marks (3 I think) of yours

still unlayed out, if you can direct any use for them, or still wish me to try for the other two Photoes, I will do so. But in this bally town I doubt whether they could be had. Otherwise I will send by P.O. order the change which [*caption* "Leo's cubiform head, in the New York Museum of Un-natural history."] still is due to you. How happy, old man, you must be! I feel the great change; want of friends; very keenly here. I begin to feel despondent and lonely, now that my oaken friends (no disrespect) are born away from me, but I shall cherish their memory to give me new comfort when I once more start off as an art-student. At present, old man, I am somewhat out of the race. You will be interested to hear that Noyes has gone back to New York. It happened since I have been here, so I know none of the details of his going. I only know that if our noble old freind Werner had not sacrificed himself in many ways, Noyes could not have left the country. He presents a problem to some algebric crank, for he had not only no money, but many debts. Query; how much did he not have? I myself do penance to the aria (tune) of 8 marks, which shows that I must have been doing pretty well at my newspaper work to have at one time so much in pocket. Poor old Noyes! You know of course of he lived, dependent most of the time upon Martha, the models, support? [*caption* "AL, PRACTISING UPON THE TYPEWRITER, IN A FIT OF ABSTRACTION, PLAYS A BACH PRÆLUDIUM & FUGA."]

A wretched existence! From one pawn shop to another, seedy; threadbear, without any energy to work—. I doubt whether we will ever see him again. He had almost decided, should he go to New York, to give up the art career. Better for him if He does so.................Well! I want to ask a question of you before I close! or, call it a favor! you will answer my letters, wont you old fellow! You will illustrate them also? Make use of your early Piano technique and edit me a newspa-

per once a month or still oftener if you can! You are the best artist in your Place now, a king, a prophet in your own land! Uphold the distinction and sort of keep yourself going by just occasionally dashing off a charming little sketches in your letters! You may consider me the Belgian correspondent to your Paper! Do not try to make a very satisfactory sketch with ordinary ink, however, but for your own satisfaction as well as mine, get a bottle of chinese ink! what useful, invaluable people these chinamen are to us artists! What should we do with out them? Chinese ink, chinese white! Yesterday and the day before, we listened, in the church belonging to the college, to 8 sermons, at the rate of 4 a day, each sermon lasting an hour. It was for the purpose of softening the sinners for confession, which takes place today. We caught it right hot from the bat, I tell you. But I do not confess, being a protestant. Today, I believe we only have 3 sermons. Now my dear good old man, my brother, must I close? yes! but only for want of time. Even now I am fortunate in having finished 8 Pages. You will not always get that much, I fear. I enclose a little sketch on tone paper: by the way, I use 3 shades, light, medium and dark, in keeping with the "stimmung" (A good old Berlin Academy expression that, isn't it?) I use also "Camden white ink" in bottles, costs 75 centimes, and can be diluted as much as you like. Well! your old Leo now closes, with best love to your wife and eh (excuse me, but this blamed pen gets away with me now and then. Hoping soon to hear from you, I am your old freind

Leo.

[*caption* "GOOD-NIGHT!!" "IN IMITATION OF MY OLD STYLE."]

P.S. I never rub out lead pencil marks from the sketches! they are softer so.

. .

63. Man Ray

to Julian Edwin Levi

26 June 1929

3 PP., HANDWRITTEN, ILL.
21 X 14 CM.
JULIAN E. LEVI PAPERS, 1846–1981
© 2004 MAN RAY TRUST / ARTISTS RIGHTS
SOCIETY (ARS), NY / ADAGP, PARIS

26th of June 1929

Dear Juliano:

Last year's 1928's wine harvest is supposed to be the very finest in the last fifty years. And Cyril is just sitting about anxiously waiting for it to age a bit and the other night after having laid in a small barrel of Clos Vougeot—turned his clock ahead a year or so to see if that might help.

Ill be over late this summer to fetch you back.

as always Man—over

Drop me a line—% Homer Bevans
19 Rue Dageurre
Paris XIV
I'm leaving for Bretagne in a week–10 days

Man—

The Blue light is creeping over Bld. Montparnasse and the sparrows are chirping in the trees waiting for a windfall.

Dear Julian

I have seven tall blondes with 14 big tits and one with sapphire garters

Homer

Dear Julian,

1929 and still a bit of wine left but we are getting old and have a beard and pipe

Cyril E.

. .

64. Ione Robinson

to Julian Edwin Levi

21 Jan. 1937

2 PP., HANDWRITTEN, ILL.
27.9 X 21.5 CM.
JULIAN E. LEVI PAPERS, 1846–1981

Jan. 21, 1937—

Dearest friend—

I always enjoy talking with you— and so—I am writing immediately. I have spent most of today talking of you— & most of last Wednesday—as a matter of fact I feel that you are very near me. The other evening when I saw several of your early paintings,—with the familiar Julian E. Levi in the lower right hand corner—I felt a sudden nostalgia,—Oh—darling—I wish you were here—!

Pearson Conrad & his wife—I love—& they love you—they really do Julian,— & for me it is always a joy to have people fond of me,—so I hope that it will make you happy to hear this.

Their home is lovely—very simple— & the children such nice unspoiled—children. I was amazed to find that you had carved a rather Persian-Gauguinish panel—over their fireplace. It showed—real talent,—a sensitive-one,—& that is the way I always think of you.—

Pearson—stayed by me all morning in his office—while I wrote involved legal letters;—we went to lunch across the street—& then I left for an all afternoon session with the lawyer. this evening at sun-down I joined him again for cock-tails on their terrace.—You were their with us—(In spirit.)

We both have decided that you should come down,—Julian you must do it,—I will risk my honor for you,— that is I ask you to come to Pine Shadows—Won't you come—? The sea is wonderful & the air so clean & full of sunlight,—& the sea-shells—I have never seen such beautiful colors—It would be wonderful if you could help me get Anne back to N.Y. I expect to be here until May—Please try to come,— tell me if you think it possible.—

I am painting a composition—also I did a small head of Anne—

Please answer when you get this— I wait to hear from you! Tamiris—I don't like her dancing—give my regards to the exhibition comm. I went to a meeting of the exhibition committee—of the Sarasota Art Ass. It was a scream! Old ladies & gents—who fussed around about nothing— & served iced-lemon-ade & sponge-cake afterwards—

Love—
Ione.

P.S. Are you still on W.P.A.

Pearson Conrad is a horticulturalist who designed the Sarasota Jungle Gardens; Robinson and her two-year-old daughter Anne are temporarily living in Florida to secure a divorce from John Dallett; Tamaris is dancer and choreographer Helen Tamaris.

. .

65. William Trost Richards

to George Whitney

30 July 1876

4 PP., HANDWRITTEN, ILL.
18 X 12 CM.
WILLIAM TROST RICHARDS PAPERS, CA.
1850–1914

Newport July 30 '1876

My dear Mr Whitney,

The coupon was regularly "detached" last Sunday, but I have had no earlier chance of writing—The week has been very busy—the cooler weather after our good rain of last Sunday (ending 8 weeks drought) made me feel more like working and I have success-fully laid in a 34 x 60 picture of Conanicut, made 2 drawings—spent one day on "Gooseberry Island" and received numerous calls—The Conanicut picture has interested me most of all and I send a little sketch like those in the Illustrated Catalogue

The view is from the wall of old fort Dumpling looking toward the S.W. The time afternoon rolling clouds and gray sky—High hill on the right and Kettle bottom rock a speck far off near Beaver Tail lighthouse. I mean to make this as good as I can sometime. Shall make many studys and complete it at Germantown. In the meantime it with the large sea I have commenced makes a sort of "Piece de Resistance," com-mands the attention of any chance visi-tor to the studio and often relieves me of the necessity of trotting out my drawings—You can imagine that these 2 big canvasses make my room look very much like a studio.

Had a call from the great Alfred Bierstadt and wife—He did not seem much interested in the drawings— "liked oil painting better"—Mrs B. con-descended to think the parlor was a very pretty room, was astonished at the "neatness" of the studio—fluttered a moment then sailed away with her big gipsy hat on her little head to Lafarge, and I felt thankful I had been carried through that! The big B seemed to be going around like that Lion seeking what he may devour.

Ever so much obliged for the Royal Academy Catalogue. I'll keep it for you till I return. You have last year and should have them both—What big things those fellows paint, and how much money it must take to buy the 17

ft. Leighton! There seems to ~~be~~ have been many interesting things and a good deal of thinking in Royal Academy Exhibition, and I get great enjoyment in translating these little sketches in the light of the pictures in Philadelphia— How fine Moore's life boat must be?. I would like to see Millais "Over the hills and far away" and Leighton's great pic-ture. How very ingenuous they are in their selection of the titles to their paintings?

The papers came also to hand. I am glad to find that the drawings are so well thought of, and hope they do not lose in your estimation. The Wissahickon seems to be making for itself a solid reputation, and I shall not be sorry you persuaded me to send it. Have you done anything to the Gallery?—

You must not forget that I shall not be entirely happy until you come up—and I can show you all the views and the pictures, and make you ~~as~~ enjoy Newport as much as we do.

I am glad that at last the weather as changed for you as well as for us. Some one who came from Phil[a] thought he had got into "that burn from which no traveller returns"— Now your centennial labors will be lightened by more endurable weather, and you will go to buy the rest of the China in the Exhibition? Give our warmest regards to Mrs. & Miss Whitney—

Yours very truly
William T. Richards.

Conanicut is an island in Narragansett Bay; Alfred Bierstadt is landscape painter Albert Bierstadt (1830–1902). He men-tions British painters Frederic Leighton (1830–1896); Henry Moore (1831–1895), who exhibited his painting The Lifeboat *at the British Royal Academy in 1876, and John Everett Millais (1829–1896); "that* burn *[sic] from which no traveller returns" is a reference to Shakespeare's* Hamlet, *Act III, "to that Undiscovered Country, from whose bourn no traveller returns."*

. .

66. J. Kathleen White
to Ellen Hulda Johnson
1 Sept. 1986

1 P., HANDWRITTEN, ILL.
27.9 X 21.6 CM.
ELLEN HULDA JOHNSON PAPERS, 1939–80

August...NO! September! 1st! 1986

Dear Ellen,

I'm sorry I haven't returned your call. I have often thought of it but if the truth be known, it would be an easier matter for me to jump on a plane & come to see you in person than to make a phone call.

How are you though. My phone machine now picks up on the fifth ring & if I'm home I always pick up before that.—by the third ring. Do you have a busy schedule this fall? I got nothin planned! I'm thinking about third novel though... & short essays. & I've just composed a lay-out for another chil-dren's picture-story book—a remake of the 3 Pigs. My brother who is still wait-ing for his permanent work visa to Australia (he's been at it since the last week of May! Length of wait typical for the consulates back log)—He has set up this computer at my place which is an incredible device These household pets here pictured come from computer land. My correspondent D. Pinkwater composes all his picture-books on com-puter...The method is fun because it forces a kind of spastic retardation struggle needed to make image Hope all well with you

——Luv, Kathleen

D. Pinkwater is Daniel Pinkwater, author and later long-time commentator on All Things Considered; *White's "third novel" became her illustrated book* The Weather Continues; *the book she had "just composed" was "The Three Little Wolves," as yet unpublished.*

67. Gio Ponti

to Esther McCoy

28 Apr. 1968

1 P., HANDWRITTEN, ILL.
28 X 22 CM.
ESTHER MCCOY PAPERS, 1896–1989

My dear, dear Esther

I am not able to answer with a letter so marvelous as you write me. But we are here you will come here for the Trieniale.

I am thinking always about America, your America that I love so much. America, your America is a big country, which (or that?) will go out from this bad situation of now, by the highest and the strongest, and the ideality of this civilization.

Giulia is in Italia for the "fanghi" and I, alone, kiss you also for her,

Love
Gio
28/4
68

Ponti mentions the Triennale di Milano, a triannual exhibition of Italian design, architecture, and visual arts.

68. Kenyon Cox

to his parents

7 Feb. 1877

2 PP., HANDWRITTEN, ILL.
27.6 X 43.7 CM.
KENYON AND LOUISE COX PAPERS, 1876–1975

247 Elton Lane—Phila—Feb. 7th 77

Father & Mother,

You urge me to work, dear mother. To cling at the technique when without an "inspiration", &c. The very vexation of it is that I can't work. I want to work. I know that work is everything, and I am tied down so that work to any profitable end is impossible. I spend 6 or 7 dollars for canvass and materials at the first of this month. I had several good ideas and now Brennan can't spare the time to stand. The fisher model has gone off on a cruise, and I haven't enough money left to spare, to hire a model if I knew a good one. What can be done? I must either sit and do nothing, or go back to the exasperating picking work of evolving pictures from my inner consciousness, and after being wrought up by sketching from life and seeing a good model for the last week or two, this last is almost impossible. It is not that I don't work because I am blue—I am blue because I can't work to the most advantage.

A day or two ago I was looking over a portfolio of photographs after Fortuny and realizing his amazing progress, and now I have to feel that I must crawl at a snails pace for lack of opportunity to work. I believe it would be impossible for a man to learn as fast as he should here under $100.00 a month, and that I cannot have. The Academy is an abomination. The only way for a man to learn in art, is to apply everything, to make his studies to a certain end, to work for pictures and to study coulor, composition, drawing, light and shade, everything at once, or any one separately that he feels he lacks most. Working so everything counts, and is remembered. Making academy studies is time half wasted even with good models well posed. Here it is time worse than wasted. I do not intend this for dogmatism, but for earnest expression of opinion.

I learn that if I were in Paris I could get a room for from $10.00 down. Eating $15 to $20 a month as I suppose. Good models to be had ~~from~~

at $2.00 a day of ten hours. No models charge more than this except the celebrated female models. Bargains could easily be made for much less. I should seldom want models more than five hours a day and not every day. Say $20.00 for models. All exhibitions of pictures &c. free. Also the Academy of Beaux Arts if I should find it so managed as to be of real use—which I doubt. On the whole I think that for very little more than I spend here, maybe $60. a month for everything*, I could work at something that is work and improve. I do not mean to give up trying here. I shall try to get at the best work I can and shall certainly do something. I feel much better than I did this morning when I began. It is rather dampening to get ready for good work and then miss it. But I shall improve somehow. Only I do think that another year I should be placed for my rapid advancement in art, in Paris—The next best thing I know of would be to join the Art League at New York—They have professional models there, and good ones, but I believe it would cost more than the other. Of course it would hardly be possible for you to send me to Europe next year and to Florida in the spring also, but the trip there would I believe be less valuable to me in giving me strength of body and character, and in filling me full of feeling for sunlight and brown skins—The indians down there, by accounts, must be immense.

Your Son
Kenyon Cox

*Rent included I spend $50.00 here—

69. Alexander Calder

to Ben Shahn

24 Feb. 1949

2 PP., HANDWRITTEN, ILL.
28 X 21.5 CM.
BEN SHAHN PAPERS, 1879–1990
© 2004 ESTATE OF ALEXANDER CALDER /
ARTISTS RIGHTS SOCIETY (ARS), NEW
YORK

24 Feb. /49

Dear Shahn

Apparently I "decommanded" The Sobys that evening when I met you—so I dont know what I may have said to you. I hope it wasnt too bad.

In any case I would like very much to have you come here sometime, for a weekend, or the middle of the week, which ever would suit you better.

We put our guests in the attic, to sleep, and I trust you wont mind that.

Cordially
Sandy Calder

The Sobys are James Thrall Soby (1906–1979) and his wife Eleanor Howland. Soby was a writer, collector, and intermittent chair of the department of painting and sculpture at the Museum of Modern Art.

70. Andrew Wyeth
to Robert Macbeth
23 Dec. 1937

2 PP., HANDWRITTEN, ILL.
19 X 18 CM.
© ANDREW WYETH
MACBETH GALLERY RECORDS, CA.
1838–1968

Mr. Robert W. Macbeth
New York City

My Dear Mr. Macbeth:

The large water color called "The Bay" (No. 8) I brought home with the rest of the discarded water colors.

[*caption* The composition of the water color called "The Bay"]

I will abide of your letters of November 8th and 24th 1937

Wishing you a merry Christmas and a prosperous New Year in which my father joins me

Sincerely yours
Andy

December 23, 1937

Andrew Wyeth's father was artist N. C. Wyeth (1882–1945). He wrote the foreword to the catalog of the above-mentioned exhibition, his son's first at Macbeth Gallery.

71. Walt Kuhn
to Vera Kuhn
[14 Dec. 1912]

4 PP., HANDWRITTEN, ILL.
25.4 X 20.3 CM., SECOND SHEET IS
25.6 X 16.5 CM.
WALT KUHN, KUHN FAMILY PAPERS, AND
ARMORY SHOW RECORDS, 1882–1966

122 East 25 St.—
phone 7628 Madison
If you should have occasion to write to this address, be sure to mark it PERSONAL.

Dear Chick

Every thing going gloriously—
The Sun & Herald came out today as enclosed—We gave an interview to Swift of the Sun for a Sunday article to appear about the first week in Jan Davies insists that I give all the interviews after this—young du Bois was in today and tells me all the writers are crazy for stuff—Expect to be busy all day Monday giving interviews, our list of European Stuff stupefies every body—I am simply in heaven with delight at the coming certain success. This show, It will be the greatest modern show ever given any where on earth, as far as regards high standard of merit. So far I have only seen Myers and Taylor, Everybody is loyal and willing to leave it in the hands of Davies and W.K. Clark is like a faithful dog, but very slow and draggy, however I shall shake him up—the loyalty of the men is almost touching—the meeting next Tuesday will be o.k. We have decided to have booze and lunch for the boys, tell them what has been done, and what is to be done and let it go at that. Give them a good time and not have any formal meeting at all. if G. B. gets gay the bunch is loaded to bull-moose him likewise the same with some other people we know. I expect no trouble—Have already done a raft of work, had the office telephone put in in 3 days—it's an enormous help. Noa–Noa typewritten also v.g. letters, closed deal with man to handle advertising in catalogue. We expect to realize about $2000 on that. We have adopted an emblem—Taken from the old pine tree flag of the revolution—I got the idea one morning in bed—Davies made the drawing and we'll have it on stationary, catalogues posters and everywhere—We are also going to have campaign buttons—here is the design=[*sketch*] it will be about this size and very neat we are going to get them by the thousands—give them to everybody—from bums to preachers—art students—bartenders—conductors etc. ought to make an immense hit—and get everybody asking questions—This button business is a secret, and will have to be pulled off on the quiet, as some of the fellows might kick—after they are out it's no use to kick—going to send buttons & posters to
Prendergast—Boston
Lamb—Washington
Schamberg—Phila etc—
I have convinced Davies that owing to the short time of the show, one month we must advertise, may also advertise in the street cars—He's right with me and tickled to death—I'm absolute boss in the office—will not touch comics unless

they're a cinch. Davies keeps me supplied with petty cash, and we can easily stick it out over the show. Have only been home one day since you left, except at night—consequently our phone is not in yet—cannot think of taking a day off until I get Clark and Taylor well broken in—I never realized that Davies and I are the only ones who know the ropes— The others are helpless. By the time you get back I'll be able to get off more— Looks as though I will get down to Wash. O.K. for Xmas—Hope I get a clever stenographer on monday—Have already looked around—Davies and I will be the only two men known as authorities in America on modern art. When this show is over—Pach deserves a lot of credit and I shall see that he gets it too—They all say that D and I were the lucky combination—pardon my immodesty but you've said that yourself

Love—more later—

Davies is Arthur B. Davies; du Bois is Guy Pène du Bois; Myers is Jerome Myers; Taylor is Henry Fitch Taylor; W.K. is Walt Kuhn; Clark is J. Mowbray Clarke; G. B. is Gutzon Borglum; Prendergast is Maurice Prendergast; Lamb is James E. Lamb; Schamberg is Morton L. Schamberg; Pach is Walter Pach; D is Arthur B. Davies. On Kuhn's trip home from Europe with Arthur B. Davies aboard the S.S. Celtic in November 1912, he translated excerpts from Paul Gauguin's Tahitian journal Noa–Noa. He also dictated to Davies a selection of letters from Vincent Van Gogh to his brother. The "v.g. letters" he mentions are most likely the Van Gogh letters. Excerpts from Noa–Noa were published in pamphlet form and sold at the Armory Show. The Van Gogh letters were not published as part of the Armory Show's ancillary texts.

· ·

72. Bolton Coit Brown
to his parents
25 [–27] June 1888

20 PP. [3 PP. EXCERPT], HANDWRITTEN, DRAFT, ILL.
26.7 X 20.5 CM.
BOLTON COIT BROWN PAPERS, 1882–1982

MacGregor's Temperance Hotel
Room 18
Glasgow, Scotland June 25, 1888
10 P.M.

Dear Parents,

This morning I rose at nine and breakfasted on tea at a tea room, then went to the art store again and got a complete stock of water colors and a few brushes. I also got some pens and a ball of string, a sponge, and six yards of stout unbleached cotton cloth. This I am going to tie a long string to each corner of (pardon the rhetoric) and carry it instead of a seven dollar sketching umbrella with a spike you cant stick anywhere except where the ground is soft. The idea of selecting your point of view with reference to getting a pierceable spot for your umbrella spike. Bah! I would'nt take it if they'd give it to me. Here is a picture of my scheme as I see it realized in my mind's eye

Get the idea?—Just tie your four strings to anything handy or put in pegs for them then cut a seven foot staff and hoist it up under the middle and there you are and it will be rain proof too in mild weather. This institution will cost about 19 d. string and all may be carried in the pocket.

About noon I went again to the Exhibition and again gave everything the dead cut in favor of the pictures.

I know now why I didn't see many pretty girls on the street Monday. They were all at the Ex.—that's where they keep themselves There are plenty of them,—awfully pretty too. They look like the best of Du Maurier's pictures of the English girls in Punch. The have exquisite mouths. The general type is something like this, the upper lip short and beautifully arched (Cupid's bow) and the result is something between haughty queenly look and the innocent rosebud look of childhood altogether quite irresistible. They are far ahead of the Paris women. And such complexions—crushed strawberry, peaches and

cream, "roses dipped in milk" these are all crude and coarse beside the exquisitely soft, entrancingly colored and altogether indescribable faces of some of these "bonny blue eyed scotch" lassies. There, quit. I'm going to bed. I leave to-morrow.

Du Maurier is illustrator and novelist George Du Maurier (1834–1896); the exhibition that Brown mentions is the 1888 International Exhibition of Science, Art & Industry, the first great universal exhibition held in Glasgow, Scotland.

· ·

73. Thomas Eakins
to Fanny Eakins
13 Nov. 1867

4 PP., HANDWRITTEN, ILL.
21 X 13.3 CM.
THOMAS EAKINS LETTERS, 1866–1934

Paris Nov. 13. 67.

Dear Fanny,

After a little over a week of not getting any letters, they are beginning to pile in & I only hope they will go on coming at the present rate. They do not come in the inverse order, that is last year's now & vice-versa but they don't come in anything like regular order. The last one however is all right announcing Bill Sartain's arrival. It is in its place I believe. I am glad he is home safe & so well. Among your letters is your dolorous one about your music. When you get so awful low spirited just go hear some fashionable young lady play a flash piece & then go take a walk to Fairmount or a row up the river. I don't know anything about music except it should be like other things that I do know and yet I will try to give you advice or encourage you in your own ideas by telling you mine as you seemed wanting me to say some-

thing for nearly all sisters put great faith in their big brothers. If you try right hard I think you will understand what I am going to say. When I was studying mathematics I had a good deal to ~~to~~ do with curves of a certain kind of which I forget the name. Here is an example.

Draw the straight line AB & another AC on which lay off any distance AX. Draw then ever so many lines from the point C intersecting the line AB & from the line AB keep laying off always the same distance towards C. If you then draw a line through all your dots you have the curve XY. Now the peculiarity of these curves is that they keep getting closer & closer to the straight line but would not touch it if they went on forever. There is an infinity of these curves some start almost straight for the line & wheel suddenly this way

Some might keep off a long time & suddenly go up but they all of them keep getting closer to the line all the time but can never touch it.

Piano playing is made up of hundreds of things but the whole is motion & can of course be represented mathematically. We will take some of them. Let going along this big line AB be piano playing perfect which no man ever did ever could or should ever want to. He had better cry for the moon. It would be of more use to him.

Suppose the fellow at O knows nothing at all. Now being able to trill with the third & fourth finger would certainly be a help on towards perfect playing in the line AB.

CD is perfect trill playing and the fellow is soon running close to it but if he plays forever he cant do it exactly. He is still very far though from perfect playing AB. Now knowing the scales would be a good thing & would give him another ~~hist~~ hoist & his new curve would soon be running ~~parallel~~ near parellel with CD. Then he learns Mozarts & Beethovens Sonatas Look at his curve soon running near parallel with GH & now close to it. He will

soon start up again with something else &c &c.

Now this man was very foolish to waste so much time on his trill. He ought to have started on the most important thing & kept only to those curves and parts of curves that are taking him up the fastest to AB. The important thing advances him in all the little things without his knowing it or it giving him trouble & besides as he gets right close to AB how much better is he able to judge of what he wants how much clearer does he see all the curves where they are going fast to AB where slow. & if he finds himself in want of a part of a curve to help him on why he ~~goes~~ looks back & takes a piece of it just where it is coming almost straight to AB. When you feel that you are working hard & don't seem to be improving fast, look out you are on one of these curves in its slow part where it is going on forever without touching. Look out for these beaten tracks ~~with~~ which at last are hard to get out of. Don't think that you are the only one that has been down hearted. I have often wanted to die & I feel now plain it was my stupidity. I was playing my trills drawing from plaster casts.

As you approach perfection in your playing your progress must necessarily be very slow at last imperceptible but if you see people far far ahead of you yet so that your ~~eu~~ straight line that your curve will never reach is still far behind them you must find a new curve a new way of practise. Suppose you play from memory every day. It is likely that will push you on fast for a while in a new curve. Practise reading at sight. It has been learned. All the great musicians have done. Try transposing at sight. I have heard that done. I will warrant you that if you do these things for a while you will now get on faster than by simple playing. Play duets with Charley. When at last you are near perfection I imagine that even little tricks if entirely new in going straight to AB ~~would~~ for a few minutes would help more than an

hour of old fashioned work. Skating is a very very simple thing to music & how much do I not owe to fooling on skates, to skating over rough ice, to hopping on one foot to awkward unusual motions that ~~are~~ none but the young undignified dare do but such tricks ought never to be seen especially in music.

~~To know~~ One who composes music will have a considerable advantage ~~over one who~~ in playing over one who does not & if Carl Wolfsohn makes compositions too you must not want to play exactly as well as he does without being able to do the same unless perhaps you had fifty times the practice.

Carl Wolfsohn was a prominent concert pianist, conductor, and teacher in Philadelphia.

. .

74. Alexander Calder
to Keith Warner
20 May 1947

2 PP., HANDWRITTEN, ILL.
27.9 X 21.5 CM. KEITH WARNER PAPERS, 1935–75
© 2004 ESTATE OF ALEXANDER CALDER / ARTISTS RIGHTS SOCIETY (ARS), NEW YORK

20 May/47

Keith:—

You sound like a couple of beachcombers (with car & ship, of course, thrown in)
Edna:—
Would you like something like this [*arrow pointing to illustration*] ⅛ " square gold wire.

It might be pretty <u>heavy</u> (twice as much as silver about)

Louisa has similar bracelets in silver, & slides her thumb through the opening

If you dont like this idea, I suggest something else. They can go the other way, but it isnt as elegant. Though easier to get into.

———————————————————————

Anyway send me the circumference of your wrist, and <u>approx.</u> <u>shape</u> of section

I think I'll make something in silver & send it to you to verify, & you return it with remarks.

———————————————————————

But send your dimensions!

Love to you both
Sandy

———————————————————————

<u>I</u>, am in "Cahiers d'Art"

Louisa is Calder's wife.

. .

75. Alexander Calder

to Agnes Rindge Claflin

6 June 1936

4 PP., HANDWRITTEN, ILL.
20.3 X 12.6 CM
AGNES RINDGE CLAFLIN PAPERS CONCERNING ALEXANDER CALDER, 1936–54
© 2004 ESTATE OF ALEXANDER CALDER / ARTISTS RIGHTS SOCIETY (ARS), NEW YORK

June 6/36

Dear Agnes

From your list of colours you must be a parcheesi hound. But its purple, not blue

I too, am very fond of the parcheesi colour scheme i.e. the size (area) & intensity of each colour (I guess you get it!) Please do send the things back to New York

You can have the one from Hartford for 100—

But if you make me work in pastel shades its 125—

(I hope this wont create a dilemma)

And your credit can be quite long drawn out and gentle Im too much of a truck driver already to come over—you <u>must</u> excuse me.—But there seems to be so much time spent concentrating on keeping out of the gutter that at times I hate the car.

If you go to Middletown via Hartford you certainly circumnavigate us with a vengeance!

Next time go thru New Milford and follow my map
Bring Miss Low ebb

Yours
Sandy

"Miss Low ebb" is possibly Frances Lehman Loeb (d. 1996) a member of the Vassar class of 1928, art collector, and philanthropist. In 1990 she gave Vassar $7.5 million for the construction of the Frances Lehman Loeb Art Center.

. .

76. Thomas Hart Benton

to James Brooks

5 Aug. 1933

1 P., HANDWRITTEN, ILL.
28 X 21.6 CM.
JAMES BROOKS PAPERS, 1928–83
ART © BENTON TESTAMENTARY TRUSTS/UMB BANK TRUSTEE/LICENSED BY VAGA, NEW YORK, NY

Chilmark Mass. Aug 5th '33
Dear James Brooks.—

To get a big thing to appear like a little thing—place the small sketch at such a distance from the large canvass or panel that the objects or spaces on the two appear to be the same. Even though more detail is added to the large the general effect should be ~~the same~~ alike for each.

Give my best to Bert. I wish you two the greatest success with your

undertakings. Let me know about them.

Yours
Thomas H. Benton

Bert is artist Bertram Goodman (1904–1988), a friend of Brooks and a former student of Benton.

. .

77. Thomas Eakins

to Alexander Francis Harmer

9 Nov. 1882

2 PP., HANDWRITTEN, ILL.
20.6 X 12.5 CM.
ALEXANDER FRANCIS HARMER PAPERS AND ALEXANDER FRANCIS HARMER TRUST RECORDS, 1882–1985

Nov. 9. 82

My dear Harmer,

I am very glad you got all your things at last. They went off in a great hurry. You must buy yourself a little wheel for 25 cents to cut glass with and make all your experiments of timing etc on small pieces of plates. I cut 20 square inches out of my 4 x 5 plate. I have a piece of wood, cigar box wood is easily worked, & cut it the exact size of a plate & then make a hole in the middle of it ~~the size for~~ the size ~~I want~~ of my experimental pieces & on the back I fasten 4 little strips on corner to keep the piece from dropping through. CC are little springs brass to slip over the corner to hold ~~plate but~~ piece of plate. Springs not necessary pins ~~wol~~ or tacks would do. This is a great saving of time chemicals & plates. If you have a single plate cut into 20 pieces you are not afraid to experiment.

The piece of wood you understand takes the place of the plate in the plate holder & presents instead of a

whole plate only a piece of a plate &
~~just flush of~~ in its middle its face flush
with the ~~board~~ wood.

Anything will do to make the
thing of wood hard rubber sheet brass
or most anything.

You should make yourself a drop
shutter like Tommy Anshutz's, a sim-
ple drop

[*caption* A piece of wood EE with
a hole in it & fitting on tube.

A piece of hard rubber, wood or
pasteboard with an opening in it to
slide past the opening in wood]

to make the exposure.

The slot had better be about twice
or three times as long as wide.

If it overexposes use a shorter
opening or hurry it up with a little
~~wood~~ rubber band.

If you can't get a little glass cut-
ter get a glazier to cut you with his
diamond as many pieces as you think
you will want. It will save you many a
bad exposure.

Make a little latch to release it.
See that ~~a wood~~ your shutter works
loose enough not to shake the camera
till the opening is past.

I dont want to hear any talk
about low diet. I have seen a gang only
half work because it only half fed
itself. Keep your belly full of good
wholesome food & consider my share
of the camera a present.

If at any future time your
finances are in such condition that
you want to repay, then it is a loan
all right, but it is not to be thought
of till then.

I am ashamed of this writing I
fell asleep over it two or three times
but I want it to go to night so good
bye.

Yours truly
Thomas Eakins.

Like Eakins, Thomas Anshutz (1851–1912) taught Harmer
when he was a student at the Pennsylvania Academy of the
Fine Arts in Philadelphia.

. .

78. John Sloan

to Antoinette M. Kraushaar

29 July 1945

1 P., HANDWRITTEN, ILL.
32.9 X 21.2 CM.
KRAUSHAAR GALLERIES RECORDS,
1907–68

Santa Fe July 29/45
PoBox, 1067.

Kraushaar Gallery—

Dear Antoinette:

If it is not too much trouble I
would be glad to have <u>you</u> go to the
Chelsea and have them open my studio
and get the framed painting "<u>Nude in
Bedroom</u>" for Philadelphia

Here is a sketch which will
(according to Helens catalog) enable
you to find it easily

You can show this letter to the
Chelsea Manager Mr Bard whom I
authorize hereby to let you enter and
obtain the painting

Sincerely yours
John <u>Sloan</u>

Helen is Helen Farr Sloan, John Sloan's second wife. They
married in 1944.

. .

79. John Steuart Curry

to Reginald Marsh

17 June 1942

2 PP., TYPESCRIPT, ILL.
27.9 X 21.6 CM.
WILLIAM ASHBY MCCLOY PAPERS,
1926–88

Reginald Marsh

to John Steuart Curry

ca. June 1942

2 PP., HANDWRITTEN, ILL.
27.9 X 21.6 CM.
WILLIAM ASHBY MCCLOY PAPERS, 1926–88

Reginald Marsh's responses to John Steuart Curry's letter
are featured below in italics

June 17, 1942
Mr. Reggie Marsh
1 Union Square
New York, New York

Dear Reggie:

Thank you very much for your
information. The new medium is as
clear and transparent as a piece of coal.

(1) Is this combination of black oil
mastic to be used with the yellow
varnish and gum arabic? *No—*

(2) Is the 10% litharge black oil I have
been using with the yellow varnish
and gum arabic considered dan-
gerous? *no—double this black oil
with linseed in order to reduce the
lead content to 5%—which is now the
favored rato—to paint eyelashes—mix
with a little turps—*

(3) If you have given up using gum
arabic and yellow varnish, what is
the reason?—*This is easier to handle
& more luminous*

(4) What does Rubens think now?—*He
liked it better*

(5) Is the mastic liquid or crystal
in the mastic varnish? *Crystal
naturally—*

Thank you very much. Wish we
could see you and get all this straightened
out. Our best to Felicia and yourself.

Sincerely yours,
John—

P.S. Your postcard with your maroger medium received. Again, is the mastic made from liquid of crystal in the mastic varnish? I am referring to your A medium. I suppose you *Yes*—make it from the crystal. Also, why has Maroger given up gum arabic? I thought that was the secret of Rubens. What does Rubens think now?
walnut can be used instead of—linseed throughout or in combination

I called said page, regarding Megilp—to Maroger—he said, that it was not the same—the oil being different
[drawing of a bottle]—black oil 5% litharge
[drawing of a bottle] Mastic
1—Mastic by weight
2—Turps
it is a good idea to prepare the last white coat on your canvas—using the jelly & white lead—to make a better affinity with the paint that follows
⅔ turps (by weight—soak together, sun, etc for a few days—
⅓ mastic

gum mastic costs $3⁵⁰ lb. at Fezandies—over grind your colors in linseed oil, or walnut before painting make the jelly with palette knife on your palette—mastic black oil butter around together in a minute or two a jelly forms—

1 put jelly over surface

2 paint directly into jelly with your oil colors—use plenty of paint

3 put, parts around together with a dry brush

4 blend parts together with jelly again etc etc

Maroger has worked all day long 3 weeks in this new medium doing a portrait of the archbishop of Baltimore—drys overnight no cracks

Felicia is painter Felicia Meyer Marsh (1912–1978), Reginald Marsh's wife. Maroger is painter and painting conservator Jacques Maroger (1885–1962). Meglip is an oil paint medium.

. .

80. Robert Lortac
to Edward Willis Redfield
18 Aug. ca. 1919

3 PP., HANDWRITTEN, ILL.
27.9 X 21.5 CM.
EDWARD WILLIS REDFIELD PAPERS,
1836–1973

The river "Bélon"—(See postcard N° 1)
Kergroës en Moëlan (Brittany)
August 18th

Dear Mr. Redfield

I send to you enclosed some postcards of this country in order that you see the character of the landscape—and some sketches with the same object. I know that you do not care for the figures and I do not speak about the costums and old traditions. But I think that the river Belon (see first sketch and postcard N° 1) is in the way you like to paint.

In "Kerfany en Moëlan" is a nice place (look at the card N° 2)—Here are three houses to rent. The price of the "location" of the house N° 1 is about 600 francs for all the season. It includes 3 bed rooms on the second floor and 3 (kitchen, dining room, 1 bed room) on the first floor.—The price of the house N° 2 is about 1000 francs, also [*caption* Sunset at Kergroës] the house N° 3 which is the best one with a garden around. You see on the card that the sea is very near from the three houses in question—this year the life is very expensive here but probably the next year it will be more easy.—I believe that for you seven, the house N°

1 would be sufficient, the N°s 2 and 3 being too big and you would have too much space—If you arrive here for Mars or April, in this time the three houses will be certainly vacant. And the best way for you is, when you arrive, to go here with your car and to look at. I will try in this time to go with you to show you the country for one day or two—At any rate I think that in the spring it will be easy to you to find here a home not expensive. And I would be very glad if I could help you in any way.—

We received your letter explaining all the difficulties of buying a car Ford—also the letter from your friend informing you that he will try to have the car sent by "La Savoie" on August 6th—I see that it was very difficult to you to have the car in question delivered—And I am very sorry to have asked to you such a business. Excuse me again and be sure that I am very thankful to you and will be glad to find an occasion to prove it to you.—If I could be of any help to you in France, please use of me. We hope that you succeeded in shipping the car on August 6th and that we will soon receive all the papers about that (I will let you know)—And we hope to have the car very soon now....Thank you again—and all my excuses for your trouble.—Please do not forget to let me know how much I owe to you extra—and I will send to you my check for the amount.

Please give our best compliments to Madame and to your all family—also to Mr. Minnegerode and Miss Millard when you will see them.

My wife and myself send to you and Madame our best regards.

Very respectfully and thankfully yours

R Lortac

Mr. Minnegerode is C. Powell Minnegerode (d. 1951), Director of the Corcoran Gallery of Art, in Washington, D.C. and Redfield's friend; Miss Millard is Emily P. Millard

(ca. 1880–1952), who was a secretary at the Corcoran and worked closely with Minnegerode.

. .

81. Joseph Lindon Smith

to Albert Smith

[undated]

1 P., HANDWRITTEN, ILL.
16.5 X 12.3 CM.
JOSEPH LINDON SMITH AND SMITH FAMILY
PAPERS, 1647–1965

Dear little brother,

Will you kindly take the two dollar bill from under my arm and give it to your Daddy—Pa = Put.
I—O—IT—2—HIM.

JOE.

. .

82. Ray Johnson

to "Dr. Frye"

3 July 1970

1 P., TYPESCRIPT, ILL.
28 X 22 CM.
LUCY R. LIPPARD PAPERS, CA.1940–95
©2004 ESTATE OF RAY JOHNSON
COURTESY RICHARD L. FEIGEN & CO.

July 3, 1970

Dear Dr. Frye,

Lucy Lippard has lovely legs and is a very good dancer. My little correspondance school concept of dance has to do with Quakers and Shakers and a book I once saw about the Shaker dances our first Meeting was held in a Quaker church I once attended a Quaker Meeting and a fly buzzed around deliver an Emily Dickinson sermon I saw a photo somewhere of her dress it really wasn't any different than Judy Garland's dress both had missing heads and Johanna Vanderbeek wrote from Hawaii saying there were lots of rainbows.

Is Judy Garland there Over the Rainbow?

Please send something to Marcia Ducker.

MARCIA DUCKER
Sincerely yours,
Ray Johnson

SEND LETTERS, POSTCARDS, DRAWINGS AND OBJECTS TO MARCIA TUCKER, NEW YORK CORRESPONDANCE SCHOOL EXHIBITION, WHITNEY MUSEUM, MADISON AVE. AND 75 ST., N.Y.C. 10021

This exhibition opens Sept. 17th.

Marcia Ducker is Marcia Tucker (b. 1940), then a curator at the Whitney Museum of American Art. The New York Correspondance School Exhibition was held at the Whitney Museum of American Art from September 2 to October 6, 1970. There was no "Dr. Frye" listed among the contributors. The envelope, addressed to "Dr. Hugo N. Frye," is a reference to a 1930 student prank in which letters were mailed to Republican leaders in the U.S. inviting them to a party in honor of Hugo Norris Frye (Hugo N. Frye, you go and fry), the fictitious leader of the Republican Party in New York State. None of the politicians could attend the event, but almost all sent letters expressing their admiration for Frye.

. .

83. Alfred Joseph Frueh

to Giuliette Fanciulli

10 [Jan.] 1913

3 PP., HANDWRITTEN, ILL.
17.7 X 10.8 CM.
ALFRED J. FRUEH PAPERS, 1909–CA. 1961

Paris Dec [*Jan.*] 10/13

Now Look here Juliette!—

It isn't at all fair that I should inspect all these picture galleries alone—Here you go do your share—Sorry I cant send a Louvre, Vatican or a Uffizi But you see I got here after Morgan's Raid and there isn't much left.

This will give you something to train on and put you in condition for the Gallery Marathon next Spring.

Now dont say you want a catalogue.

Got your letter of the 28th Dec in answer to mine of the 13th—Seems like the mail man between Paris & N.Y. has the Rheumatism doesn't it?

Hope the Democrats put someone in soon who wont be affected by the damp trip.

'Course I don't care If I only hear from you once a month But for "Mutt's" sake you ought to write often—He says I get awful Grouchy and Crabit if I don't hear from you every 3–4 days.

And the cake it came last week and I lived to see the last disappear—I could live forever on that kind of cake.

O, you Beggar:

I have referred your request for the Snapshot to the Charaties Dept And if you dont get what you want in a few days, let me know, and I'll have the place raided.

Havent seen any snow yet but just Rain Rain and rain—Not cold and I dont miss my fuzzy overcoat a bit.

I'll leave you here. This is ladies day and I don't want to go in. Mutt says to tell you Hello. He's still under the influence of a piece of that—cake.

Run along now
So long
Alf.

Mutt is an imaginary character in Frueh's cartoons.

. .

84. Paul Manship

to Leon Kroll

ca. 1935

1 P., HANDWRITTEN, ILL.
27.8 X 21.5 CM.
LEON KROLL PAPERS, 1916–76

Dear Kroll—

Here she is—Miss Miriam McCreedy
 64 Wash. Sq. South. Spring 7–7925.
 How are you? We're off Saturday for gay Paris—Come in & have a cocktail with me—

 Paul Manship

. .

85. Timothy Cole

to William Lewis Fraser

21 Apr. 1884

2 PP., HANDWRITTEN, ILL.
17.7 X 11.1 CM.
TIMOTHY COLE PAPERS, 1883–1931

Munroe & Co 7 Rue Scribe Paris apr 21ˢᵗ—84

My dear Fraser

I write this to keep your mind easy. I am getting along splendidly in my second block of the "Mona Lisa" if I fail in this I will only be better prepared for the third attempt, but so far it promises well.—I have obtained an excellent photograph of the "Supper at Emmaus" it is much superior to the etching, which Goupil publishes, though there are some important points in it that I should hope to improve upon. I must do a full page block of the head of christ taking in the hands though not the

table-top I give you an idea of it on the other side. I should like mightily to do the "Philosopher" by Rembrant.—I have found a hermit artist who has a store of etchings & steel engravings by the old masters, some of the finest steel engravings are ideal wood-engravings.

 Yours sincerely T. Cole.

. .

86. Michael Lucero

to Patti Warashina

[Nov. 1979]

2 PP., HANDWRITTEN, ILL.
28 X 21.6 CM.
PATTI WARASHINA PAPERS, 1961–91

Dear Patti—

Thanks for sending my slides and the beautiful skeleton cutout. I hung it in our bathroom window beneath the scarf of our Lady of Guadalupe. I love Mexican art and cant wait to visit Mexico. I've been working real hard lately and getting lots done—teaching—my own art and helping the girl upstairs on her porcelon dinner platters.—They are pretty nice for decorative stuff.—it all has its place.—She used to work for A.C.C. and knows lots of people to sell her work and also all the correct angles for P.R. I spoke to Howard last week—He sounds like hes back in the studio making new work.—I forgot to ask him about nancy carman. I told my friend Charlie from Davis, who is now in Seattle to go hear nancys lecture.—I hope he did! Hes living with his parents trying to figure out what to do with his life—I'm glad I never took to much time deciding what to do. I'm happy I'm here in N.Y. couldn't think of a better place for now except Mexico—haha! We saw Annie

Gerber here in N.Y.—She's so nice and took us to the Joseph Beuys opening at the Guginheim .—fantastic show! great opening! I love the social things—Cheryl & I are into looking real normal these days—my old look—is too common around here—butch haircuts and 503 v-necks—last year the punks were somewhat a minority—this year the disco look has meshed with the punks—the chic-punk-look!— oh well—I know it's not cool for <u>me</u>, when one can go to macys and buy a real cool looking chic-punk-outfit!

I still wear my red hat—I guess thats my honest thing—even when you can buy them in the chic shops in a variety of rainbow colors—mine gets thrown in the wash!—poor thing – – – –

What you should do is let your hair grow longer—I liked your 60's look—oh Pfannebecker loves it when I use the word 60-ish—he says its part of the Pfannebecker folk-lore—he'll tell you the story!—

 Love,
 Michael
 in New York

The "girl upstairs" is artist Dorothy Hafner; Charlie is Charles Burns (b. 1955) a cartoonist and illustrator, who Lucero had met when they were art students at the University of California at Davis; Howard is Lucero's former graduate school treacher, ceramist Howard Kottler (1930–1989) and a colleague of Patti Warashina's at the University of Washington; Cheryl is painter Cheryl Laemmle (b. 1947), then his girlfriend and now his wife; Pfannebecker is art collector Robert L. Pfannebecker (b. 1933).

. .

87. Andy Warhol

to Russell Lynes

[1949]

1 P., HANDWRITTEN, ILL.
27.9 X 21.3 CM.
HARPER'S MAGAZINE RECORDS KEPT BY
MANAGING EDITOR RUSSELL LYNES,
1946–62
© 2004 ANDY WARHOL FOUNDATION FOR
THE VISUAL ARTS / ARTIST RIGHTS
SOCIETY (ARS), NEW YORK

Hello mr lynes

thank you very much
biographical information
 my life couldn't fill a penny post
card i was born in pittsburgh in 1928
(like everybody else—in a steel mill)
 i graduated from carnegie tech now
i'm in NY city moving from one roach
infested apartment to another.

 Andy Warhol

. .

88. Gio Ponti
to Esther McCoy
ca. Oct. 1966

1 P., HANDWRITTEN, ILL., IN ENGLISH AND
FRENCH
28 X 22 CM.
ESTHER MCCOY PAPERS, 1896–1989

to Esther McCoy

Dear Signora Esterina

thanks for your nice
letter of 26 august
I beg you pardon I am
so late to write you
but I was in Holland.
Dont think the Pontis
are always so kind
and full of goodness
and generosity as you write me.
We are so ONLY towards
the Very Nice Persons we
like and love et que
nous estimons beaucoup

pour leur intelligence
et sagesse
C'est difficile pour moi de
continuer en english, et même
sans dictionary. I am in Venice.
J'ai eu encore occasion
de revoir Nathan
et j'ai posé toute ma
confiance [*line inserted*] pour l'exposi-
tion Ponti dans la sagesse
du Professeur Wight.
S'ils iront demander vôtre
aide
j'en serai ravi,
mais il faut attendre ça.
Moi je serai a Los Angeles
le 13 novembre
pour le opening
heureux de
vous revoir.
Tita vous salue
Lisa et
Marianne vous
remercient de votre souvenir
et vous saluent
avec Giulia
et moi.

English translation:

to Esther McCoy

Dear Signora Esterina

thanks for your nice
letter of 26 august
I beg you pardon I am
so late to write you
but I was in Holland.
Dont think the Pontis
are always so kind
and full of goodness
and generosity as you write me.
We are so ONLY towards
the Very Nice Persons we
like and love and that
we hold in very high regard
for their intelligence
and wisdom
it's difficult for me to
continue in english, especially

without a dictionary. I am in Venice.
I had occasion
to see Nathan again
and I have a lot of
faith [*line inserted*] for the exposition
Ponti in the wisdom
of Professor Wight.
If they ask for your
help
I would be delighted,
but we must wait for that.
I will be in Los Angeles
November 13
for the opening
happy to
see you again.
Tita sends you her greetings
Lisa and
Marianne
thank you for your souvenir
and sends you their greetings
with Giulia
and me.

*Nathan is Nathan Shapiro, who organized the Gio Ponti
exhibition at University of California, Los Angeles, Art
Galleries in 1966 in association with. Professor Wight—
Frederick S. Wight, director of the galleries; Tita
[Letizia], Lisa, and Marianne are Ponti's daughters;
Giulia is Ponti's wife.*

. .

89. John Steuart Curry
to Margaret D. Engle
11 Mar. 1942

1 P., HANDWRITTEN, ILL.
27.8 X 21.5 CM.
MARGARET D. ENGLE LETTERS FROM
ARTISTS, 1937–43

March 11 42.

Dear Mrs. Tomah;

 My writing is improving—made
some changes which I think I shall
let stand—The Pope was Pious the XI—
If you don't like any thing about

my work say so—

JSC

. .

90. Frida Kahlo
to Emmy Lou Packard
24 Oct. 1940

6 PP., HANDWRITTEN, ILL.
19.7 X 14.5 CM.
EMMY LOU PACKARD PAPERS, CA. 1900–90

88. Central Park West
New York City
Oct. 24 1940.

Emmy Lou my darling,

Please forgive me for, writing you in pencil—can't find any fountain pen or ink in this house.

I am terribly worried about Diego's eyes. Please tell me the exact truth about it. If he is not feeling better I will scram from here at once. Some doctor here told me that the sulphamil-amid some times is dangerous. Please darling ask Dr Eloesser about it. Tell him all the simptoms Diego has after taking those pills. He will know because he knows about Diego's condition in general. I am so happy he is near you. I can't tell you how much I love you for being so good to him and being so kind to me. I am not happy at all when I am away from him and if you were not there I wouldn't leave San Francisco. I am just waiting to finish one or two paintings and I'll be back. Please darling, make any effort you can to make him work less.

That affair with Guadalupe is something that makes me vomit. She is absolutely a son of a bitch. She is furious because I will marry Diego again, but every thing she does is so low and dirty that some times I feel like going back to Mexico and kill her. I don't care

if I pass my last days in a prison. It is so disgusting to feel that a woman can sell every bit of her convictions or feelings just for the desire of money and scandal. ~~that~~ I can't stand her anymore. She divorced me from Diego just in the same dirty way she is trying to get some dough from Knoff and Wolfe. She realy doesn't care what she does as long as she is in a front page of the papers. Some times I wonder why Diego could stand that tipe of wench for seven years. He says it was only because she cooked well. Perhaps it was true, but my god, what kind of an excuse is that? I don't know. Maybe I am getting cookoo. But the fact is that I can't stand any more the phony life those people live. I would like to go to the end of the world and never come back to any thing which means publicity or lousy gossip—That Guadalupe is the worst louse I ever met, and even the damn law helps her to get away with her rotten tricks. This world is "somethin" kid!

The letter Donald wrote is beautiful. I am sorry I didn't see the spiting bussines between Philip and him. Tell him I would of done the same thing in his case. His "charro" dress will be ready soon and Cristina will send it to you. Darling, Julien Levy liked very much your drawings but he can't give you an exhibition because he says he only shows surrealist paintings. I will talk to Pierre Mattisse about it and I am sure I can arrange some thing here for you next year. I still like the first one you made of me better than the others.

Give my love to Donald and to your mother and father. Kiss Diego for me and tell him I love him more than my own life.

Here is a kiss to you and one for Diego and one for Donald. Please write to me when ever you have time about Diego's eyes.

Emmy Lou Diego. Donald

Mi cariño
Frida.

Guadalupe is Guadalupe Marín, Rivera's second wife; Kahlo was also in New York to testify in a lawsuit brought against Bertram Wolfe and his publisher for maligning her in his biography The Fabulous Life of Diego Rivera (*New York: Alfred A. Knopf, 1939) and she mentions Knoff [Knopf] and Wolfe; Julien Levy and Pierre Mattisse are art dealers in New York; Donald is Emmy Lou Packard's son.*

. .

91. David Carlson, Jr.
to Miss Jackson
6 Jan. 1952

1 P., TYPESCRIPT, ILL.
26.7 X 20.3 CM.
HARPER'S MAGAZINE RECORDS KEPT BY
MANAGING EDITOR RUSSELL LYNES,
1946–62

Châteauroux, France
January 6, 1952

Dear Miss Jackson:

Do you accept belated thanks? I am thoroughly ashamed of myself for having been so negligent about thanking you for accepting the drawings, which Max accompanied with his short story, and for the check which I was delighted to receive. The day after I rendered the illustrations for Max, I reported for work with the Air Force here at Chateauroux; and life has been a melee since. Being a firm believer in punctuality, however, I feel that I owe you my most sincere apologies...

Just returned from Barcelona, Spain, where I spent a brief holiday; and ran into Max my last day there. He reported that he had received the proofs for his story. I'm anxious to see it in print, as well as the illustrations, and feel deeply grateful to Max, to you, and to your magazine...

David Carlson, Jr.

Max is writer Max Steele.

. .

92. Edith Schloss
to Philip Pearlstein
25 Mar. 1981

2 PP., HANDWRITTEN, ILL.
21.5 X 15.7 CM.
PHILIP PEARLSTEIN PAPERS, 1949–96

Thanks & much love to all of you my dears who have been loving, helpful & encouraging to me while I stayed in the U.S.: Anne & Anne, Barbara & Barbara, Ce, Dorothy, Eadie, Edwin, Elliott, Ernie, George, HELEN, Jacob, José, Kosughi, Lisa, Louis, Martin, Maryanne, Mutti, Philip, Rackstraw, Rudy, Yoshiko & Yvonne—to all of you THANKS & much love TWA flight 840 midnight, midatlantic, March 25, 81, Edith.

for Dorothy & Philip

April 26. 81

This in a fit of sentiment in the middle of the night (and flight)—I am busy tidying up everything here—I wish we had a national archives here to give all my junk & diaries to—I'm not good at throwing a way things.—I am still "chewing the cud" of my "New York experience," so to speak.

Much love to both
of you Edith

. .

93. Philip Guston
to James and Charlotte Brooks
[1949]

2 PP., HANDWRITTEN, ILL.
28 X 21.7 CM.
JAMES BROOKS PAPERS, 1928–83

Wed.—Woodstock

Dear Charlotte & Jim,

I've never enjoyed both of you more than last week-end. It was the most wonderful visit—extended far longer than I had hoped for, but then I felt so relaxed and you are so gracious and real.

I am up here alone, getting started etc, and will come in for Musa this coming week.

The inch-worm plague seems to be over. Where are they, gorged with all those leaves? It is typical Woodstock weather—overcast and mountain gloom. Too much of the past around me.

Much love, ever, Phil

Jim—this is a local type. Much less fashionable than at East Hampton.

Phil.

Musa is Philip Guston's wife. His daughter, also named Musa, was born January 18, 1943.

. .

94. William Wegman
to Athena Tacha
[1974]

1 P., HANDWRITTEN, ILL.
28 X 21.7 CM.
ATHENA TACHA PAPERS, 1974–97

ATHENA AT OBERLIN

Thanks for the invitation—I can't figure out the date yet—probably May anything around Thanksgiving in Nov—I might be driving to Chi and could stop off.

Bill Wegman 49 Crosby St

. .

95. Red Grooms
to Elisse and Paul Suttman
and Edward C. Flood
[1968]

1 P., HANDWRITTEN, ILL.
42 X 35 CM.
PAUL SUTTMAN PAPERS, CA. 1968

DEAR ELISSE & PAUL & ED

WELL, HERE WE ARE BACK IN BUSINESS....GOING OVER THE SUMMER MAIL.....
GEE, THANXS FOR THE GREAT STAY AT YOUR PLACE.
LOOKING FORWARD TO YOU BEIN HERE IN FEB. YOUR MAP AND TIPS WERE VELLY HELPFULL IN BARCELONA.
WE STAYED IN THE PENCONIE IN THE GAUDI HOUSE. THRILLING. AN ATE AT SNAIL PLACE. ELISSE THANXS FOR BEAUTIFUL THOMPSON.

LOVE...RED & MIRIAM

Elisse was Paul Suttman's third wife; Ed is sculptor Edward C. Flood (1944-1985). Flood was part of a group of people who came from Chicago to help Red Grooms and Mimi Gross install City of Chicago at the XXXIV Venice Biennale in June 1968. After the opening of the biennale, Grooms, Gross, and Flood visited Elisse and Paul Suttman, who were at the American Academy in Rome. Afterwards Ed stayed on with the Suttmans for a time. The "beautiful Thompson" is an aquatint etching that Elisse made of their friend painter Bob Thompson (1937–1966) soon after he died.

. .

96. Gladys Nilsson
to Mimi Gross Grooms and
Red Grooms
[postmarked 4 April 1969]

1 P., HANDWRITTEN, ILL.
27 X 19 CM.
MIMI GROSS PAPERS, 1960—81

dear red and mimi,

as you can see, all the friendly people on this page are helping to convey messages of thanx from the Nuthouse to the gromhouse, from the bottom of nuttharts, for letting us stay at your plase.

no plain crashes, all arrived safe without mishap except for Claude who got an earcold, and it is as ever very hard to "get back to work" after tripsville. (we deplained in Denver and Reno. the latter imediatly offering row upon row of slots upon steping ofa playn. IT IS FUN TO FLY.

good to sea u Both—

Love GLADYNESS

Index

All letters are from the Archives of American Art, Smithsonian Institution. For more information visit the archives online at www.aaa.si.edu